Springer Series on Cultural Computing

T0292552

More information about this series at http://www.springer.com/series/10481

David England • Thecla Schiphorst
Nick Bryan-Kinns

Editors

Curating the Digital

Space for Art and Interaction

 Springer

Editors
David England
Department of Computer Science
Liverpool John Moores University
Liverpool, UK

Thecla Schiphorst
School of Interactive Arts and Technology
Simon Fraser University
Surrey, BC, Canada

Nick Bryan-Kinns
School of Electronic Engineering
and Computer Science
Queen Mary University of London
London, UK

ISSN 2195-9056 ISSN 2195-9064 (electronic)
Springer Series on Cultural Computing
ISBN 978-3-319-28720-1 ISBN 978-3-319-28722-5 (eBook)
DOI 10.1007/978-3-319-28722-5

Library of Congress Control Number: 2016937976

Printed on acid-free paper

This Springer imprint is published by Springer Nature
The registered company is Springer International Publishing AG Switzerland

Acknowledgements

There are many people to thank in the production of this volume. Our co-workshop organisers, Celine Latulipe, Ernest Edmonds and Linda Candy were invaluable in the lead up to the workshop, at the workshop itself, and later in negotiating with SIGCHI; the ACM SIGCHI Executive committee for their continued support of Arts initiatives within the CHI Community; all the participants in the CHI2014 workshop for their enthusiasm and hard work. Liverpool John Moores for their support of the first editor. And the various arts organisations, artists and curators we have worked with and spoken to who have been sources of inspiration and motivation for this work, in particular the staff at FACT, Liverpool.

Contents

Contributors

M. Antona Foundation for Research and Technology – Hellas (FORTH), Institute of Computer Science, Heraklion, Greece

Camille Baker School of Communication Design, University for the Creative Arts, Epsom, UK

Clare Brennan School of Arts, Media and Computer Games, University of Abertay Dundee, Dundee, UK

Matthew Carrasco Texas A&M University, College Station, TX, USA

Yvonne Chen University of Washington, Seattle, WA, USA

David England Department of Computer Science, Liverpool John Moores University, Liverpool, UK

Henry Gardner Research School of Computer Science, The Australian National University, Canberra, ACT, Australia

S. Guynup Hayfield-Isovista, LCC, Wellsville, NY, USA

Donna Holford-Lovell Fleet Collective and NEoN (North East of North), Dundee, UK

Kade Keith Texas A&M University, College Station, TX, USA

Andruid Kerne Texas A&M University, College Station, TX, USA

Caroline Seck Langill Liberal Arts and Sciences and the School of Interdisciplinary Studies, OCAD University, Toronto, ON, Canada

Rhema Linder Texas A&M University, College Station, TX, USA

Nic Lupfer Texas A&M University, College Station, TX, USA

Jeni Maleshkova Cognitive Science Research Group, Electronic Engineering and Computer Science, Queen Mary University of London, London, UK

Charles Martin Research School of Computer Science, The Australian National University, Canberra, ACT, Australia

Peter W. McOwan Cognitive Science Research Group, Electronic Engineering and Computer Science, Queen Mary University of London, London, UK

Lizzie Muller Art and Design, University of New South Wales, Sydney, NSW, Australia

Nora O. Murchú Interaction Design Centre, Department of C.S.I.S, University of Limerick, Limerick, Ireland

N. Partarakis Foundation for Research and Technology – Hellas (FORTH), Institute of Computer Science, Heraklion, Greece

Matthew Purver Cognitive Science Research Group, Electronic Engineering and Computer Science, Queen Mary University of London, London, UK

Yin Qu Texas A&M University, College Station, TX, USA

C. Stephanidis Foundation for Research and Technology – Hellas (FORTH), Institute of Computer Science, Heraklion, Greece

Department of Computer Science, University of Crete, Heraklion, Crete, Greece

Deborah Turnbull Tillman New Media Curation, Sydney, Australia

Mari Velonaki The Creative Robotics Lab, National Institute of Experimental Art, University of New South Wales, Sydney, Australia

Andrew M. Webb Texas A&M University, College Station, TX, USA

Tim Weyrich Virtual Environments and Computer Graphics Research Group, Department of Computer Science, University College London, London, UK

Chapter 1
Art.CHI: Curating the Digital

David England

Abstract Art.CHI is the name for the movement that grew out of the Curating the Digital workshop. Art.CHI aims to bring together the tools, techniques, methods and approaches of both Human Computer Interaction and Digital Art making. In this chapter we consider the history of digital art from a Human Computer Interaction perspective and give an overview of how the chapters in this volume contribute to developments in multidisciplinary collaboration. Finally we consider where this movement might go in a Post-digital area, where digital technology is ever present but mundane.

1.1 Introduction

This volume, in the Springer Cultural Computing Series, has its origins in a workshop that took place in Toronto, 2014, as part of the ACM SIGCHI CHI 2014 conference. "Curating the Digital: making space for art and interaction" (England et al. 2014) brought together, artists, curators and Human Computer Interaction (HCI) researchers; to explore the challenges of curating digital art works. Art-related submissions had until that point played a small part in the mainstream CHI community. However, external developments have prompted greater inclusion of arts-related work at CHI. Firstly, there have a been series of more art-focused fora such as ISEA, Ars Electronica, the ACM Creativity and Cognition conference, and the ACM SIGGRAPH Exhibition, where digital artworks are discussed and presented. Simultaneously ACM SIGCHI has seen its own evolution through three waves of development, starting with a focus on the psychology of usability in the 1980s, moving on to more social considerations in the 1990s, and today having to consider the full range of User Experience or UX, as digital technology becomes ubiquitous and all-encompassing. So it hardly surprising that, art, as one of human kind's oldest and most rich form of expression, should eventually find itself in conversation with Human Computer Interaction. HCI concerns itself with the quality and value of interacting with the most modern of technologies. It is more

D. England (✉)
Department of Computer Science, Liverpool John Moores University, Liverpool, UK
e-mail: d.england@ljmu.ac.uk

© Springer International Publishing Switzerland 2016
D. England et al. (eds.), *Curating the Digital*, Springer Series
on Cultural Computing, DOI 10.1007/978-3-319-28722-5_1

1

surprising that it took 30 years for this to develop. This can be ascribed in part to HCI trying to establish itself as a scientific discipline in the face of the engineering demands for computational function. Collaborations between artists, scientists and technologists have long flourished in small pockets prior to this, but the growth and spread of digital technologies has presented far greater possibilities for the disciplines to meaningfully interact, and also to open up dialogue on the different challenges that the disciplines face, in dealing with technical advances, and being able to express their own goals, for the mutual benefit of all parties.

The Curating the Digital workshop is then, part of that ongoing dialogue. This started in CHI with the Digital Arts and Interaction Special Interest Group (England et al. 2015) discussion at CHI2011. The SIG was followed by the founding of the Digital Arts Community, which met at CHI2012, Austin, TX and CHI2013 Paris, France. It was noticeable that by CHI2014, the interested attendee could create a schedule for the 4 days of the conference, entirely from arts-related submissions.

The ongoing challenge now is how to sustain this activity and continue the dialogue between HCI research and practice, and artists using digital technologies as their chief medium. The discussions so far have followed two tracks, the issues raised by both parties, and the mechanisms to support collaboration. So in previous SIG meetings we have discussed some of the tensions between a "scientific" approach to HCI and how art is judged and appreciated; we have also looked at the mutually beneficial synergies between HCI and digital arts. In terms of mechanisms we have discussed the value of the art catalogue and art exhibition to artists. So the CHI2014 workshop took the design of the Art.CHI catalogue as its unifying theme, to underline the new Art.CHI movement. The first Art.CHI catalogue (England et al. 2016) appeared at CHI2015 in Seoul, South Korea, documenting workshops submissions and art submissions to the CHI Interactivity Exhibition. At the time of writing the next catalogue will accompany the first full Art.CHI Exhibition, in San Jose, CA, 2016.

So in the rest of this chapter we will go further back in looking at the origins of curating digital works from a human computer interaction perspective. We will then give an overview of the contribution of each chapter to this volume. And we will end by looking to the future of the Post-Digital era where digital technology is simultaneously everywhere, taken for granted, invisible and embedded.

1.2 Origins of Curating the Digital

There has been, of course, much earlier work in Art and Interaction, prior to the emergence of HCI. Karlheinz Stockhausen (1989) began experimenting with electronic music in the 1950s. The Fluxus (2015) movement used mixed media including electronics in their art from the 1960s. Hence there is a strong conceptual foundation for artist's involvement in modern technology. Coming to interactive art Myron Krueger developed his first interactive work, "Glowflow" in 1969 (Krueger 1991) and went on to develop the first camera vision interactive art, "Videoplace" in

1975 (Krueger 1991). This inspired other artists such as David Rokeby to develop, and evolve, interactive works such as "Very Nervous System" since 1982 (Rokeby 2015).

These latter artworks were being produced just as the first interactive windows and mouse system was being development by Douglas Engelbart in 1967 (Engelbart 1995). So we can see that the first strong conceptions of what Human Computer Interaction should be were developing in parallel, and separately in the late 1960s and early 1970s. HCI as a discipline, formally, emerged in the 1983 with the first formal conferences such as ACM SIGCHI and the British HCI/(Re)Actor conferences. Here the dominant voices were formal computer science and experimental cognitive psychology. As such there was little room for the consideration of culture or art as aspects of interaction. There were early collaborations between artists and technologists but usually outside the mainstream HCI framework.

Art and Interaction were more properly linked in Candy and Edmonds' first volume of Explorations in Art and Technology in 2002 (Candy and Edmonds 2002). Simultaneous there were more foundations and institutes focusing on Art and Technology, such as FACT in Liverpool and V2 in Rotterdam. These institutes were also exploring new ways of curating interactive exhibitions. For example Blais and Ippolito (2006) explored how to curate art when the art spread beyond the gallery, and out, onto the Web. More recently, Graham et al. (2015) has proposed as rethinking of the curation of interactive art to meet the new challenges it poses. And from HCI, Bardzell (2009) has moved HCI from the majority, logical positivist stance on interaction, to take a more humanities-based approach, assessing HCI concepts through formal interpretation and critique.

1.3 Concepts Explored in Curating the Digital

So what then can HCI and Digital Art offer each other, and how are these offering explored in this volume. From HCI over the last 30 years we have had many developments in tools and techniques for the design and creation of interactive systems, of all scales. These include

- Requirements capture techniques to gather the needs of end users and incorporate them in our designs
- Iterative and participatory approaches to design, which include end users as the system develops, rather than adding their concerns as an afterthought when development is almost complete
- Evaluation methods, ranging from focus groups to video analysis, protocol analysis, formal experimentation, design reviews and heuristic evaluation so that all stages of a design can be reviewed to ensure we are meeting the users' needs
- Prototyping tools ranging from paper-based prototyping with end users, to sophisticated tools which support creativity.

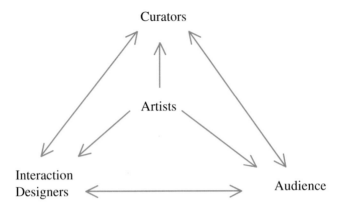

Fig. 1.1 Multiple lines of communication

The chapters that follow cover many of these techniques in a curatorial and art-making context. And from Art, HCI can gain many insights into a variety of creative processes, which feedback into HCI practice and research, to make that discipline more responsive and reflective of the increasingly cultural role HCI is expected to play.

The papers in this volume take a multidisciplinary approach to curating digital media. Starting with conventional curation and its challenges, drawing in practices from artists in their processes of creating digital art work, involving methods and knowledge from Human Computer Interaction, and finally, looking at the computational aspects of new media. Figure 1.1 shows how these various disciplines interact to deliver interaction to an audience.

The widespread adoption of digital technology since the 1980s has certainly brought new possibilities to the curation of artwork, with new avenues for inter-action with devices and new platforms for art. Indeed, fine art has now gone beyond the traditional white (or black) cube, and is now available where ever devices can connect. However, this brings in several new challenges. Graham et al. (2015) highlights several of these challenges from a curator's viewpoint. Here, from a Human-Computer Interaction viewpoint we can summarise them as

- A need to pay attention to the needs and scope of the audience and their reaction to digital devices
- The inclusion of the visitors' own devices as part of their interaction
- Concerns about the technical set up, maintenance and robustness of digital hardware and software in public settings
- Ways of assessing (or measuring) audience reaction to exhibitions. Though the term "measure" is loaded with negative connotations, as discussed in the chapters that follow
- Means of documenting and preserving digital arts works.

In this volume Mucrhu (2016, this volume) looks at a design approach to curation, which brings in several HCI techniques such as, prototyping to use technology as developer and deliverer of an artwork, and participatory design where audience members are part of the design process of an interactive artwork. Brennan and Holford-Lovell (2016, this volume) consider the preservation challenges of digital media, or "disobedient objects" that defy preservation. Their conclusions echo those of the software development industry. Here, if we expect software (or artworks) to have an extended life, we must design for maintainability. Otherwise we have to be selective in our digital preservation tools and either look for ways to transfer old digital works into new formats or platforms, or accept that they will suffer digital decay. Langill and Muller (2016, this volume) consider digital artworks as lively objects, which demand a new approach to curation. They appeal to the psychological notion of "affordance" which is also explored in Human-Computer Interaction by Norman (2002). Martin and Gardner (2016, this volume) focus on the preservation of improvised musical performance. They develop protocols and visualization techniques, which could be applied to other types of artistic performance, especially now we can instrument so much of human movement and action.

Moving from general issues of curation and preservation, Webb et al. (2016, this volume) provide a free-form tool for audience members to provide their own rich and lively documentation of exhibitions. The IdeaMaˆche′ allows end users to draw in multimedia clippings at different levels of abstraction to overcome some of the limitations of the standard networked approach to Web documentation of exhibitions.

Baker (2016, this volume) takes a much broader approach and considers the outcomes of the European FET-Art project, which supported Art-Technology collaborations across the European Union. One of the main challenges in curating the digital is finding the right partners and then supporting the collaborations between different disciplines. Even then it is not guaranteed that artworks produce will be critically challenging rather than just "good" pieces of technology.

Maleshkova et al. (2016a, this volume) covers some of the foundations of Human-Computer Interaction in an artistic context, illustrating HCI ideas with artworks that rely of HCI developments. These are explored further in a quantitative study that uses standard HCI experimental techniques to compare different modes of interacting with an exhibition pieces. In their second chapter Maleshkova et al. (2016b, this volume) switch modes to take a qualitative approach towards studying visual artworks. Taken together the chapters should how HCI evaluation techniques can inform the presentation and interaction design of artworks.

Guynup (2016, this volume) explores the design of 3d and Virtual Worlds as gallery spaces. Virtual Reality has long promised but failed to deliver truly accessible and immersive experiences. However, 3D design of games has taught us new lessons in interaction. Guynup explores what these lessons might mean in terms of navigation, space and search for the virtual art gallery.

Finally, Partarakis et al. (2016, this volume) explore another promise of digital technology, that of personalization to the viewer's subjective experience. They

explore the concept of ambient intelligence and ontological languages in driving artworks that adapt to the needs of their viewers.

1.4 Art.CHI in a Post-Digital World

The chapters in this volume point to a more inclusive approach to digital art where HCI techniques are increasingly used in the service of art for artists to achieve their aims. Of course artists are free to reject these methods or to even subvert them to present their own message, as with JODI Computer 101B (Jodi.org) and their destruction of the Macintosh desktop. And as with previous developments in technology there are discussions of the limitations and dangers that technological developments may present. So currently there are discussions about moving to a Post-Digital world. These are in some ways, tongue in cheek; commentators make fun of our over reliance on digital technology, but it also points to new challenges for HCI and digital art. Thus, as some discuss digital detoxes or slow technology movements, we can discuss, more seriously, where we are going with technological developments. We can discuss the role art and HCI may play in those developments, and the discussions over who controls our technology and our information. So we are in an age where digital technology is ubiquitous and pervasive but also mundane and everyday. The developments seem, now, to be incremental rather than surprising. Perhaps we can use this time to explore new ways of approaching HCI and digital art, such as Worth and Value-based design as discussion by Cockton (2004). We can also consider how digital technology is now embedded, controlling and serving other technological developments such as Maker tech, Synthetic Biology and Bioinformatics that will present the next set of challenges and opportunities to our work.

References

Baker C (2016) ICT&ART connect: connecting ICT & art communities project outcomes. In: England D, Schiphorst T, Bryan-Kinns N (eds) Curating the digital. Springer, Dordrecht

Bardzell J (2009) Interaction criticism and aesthetics. In: CHI '09 proceedings of the SIGCHI conference on human factors in computing systems. ACM, New York, pp 2357–2366

Blais J, Ippolito J (2006) At the edge of art. Thames and Hudson, London

Brennan C, Holford-Lovell D (2016) Dealing with disobedient objects. In: England D, Schiphorst T, Bryan-Kinns N (eds) Curating the digital. Springer, Dordrecht

Candy L, Edmonds E (2002) Explorations in art and technology: intersections and correspondence. Springer, London

Cockton C (2004) Value centred HCI. In: NordiCHI '04: proceedings of the third Nordic conference on Human-computer interaction. ACM, New York

Engelbart D (1995) Toward augmenting the human intellect and boosting our collective IQ. Commun ACM 38(8):30

England D, Spence J, Latulipe, C, Woolford K, Edmonds E, Candy, L, Schiphorst T, Bryan-Kinns, N (2014) Curating the digital 2014: space for art and interaction. In: CHI EA '14: CHI '14 extended abstracts on human factors in computing systems. April, ACM, New York

England D, Edmonds E, Sheridan J, Pobiner S, Bryan-Kinns N, Wright P, Twidale M, Diana C (2015) Digital art and interaction SIG. In: CHI EA '11: proceedings of the annual ACM conference extended abstracts on human factors in computing systems. April, ACM, New York

England D, Candy L, Latulipe C, Schiphorst T, Edmonds E, Kim Y, Clark S, Kerne A (2016) Art.CHI 2015 catalogue, www.art-chi.org. Last access Jan 2016

Fluxus (2015) Fluxus portal. http://www.fluxus.org. Last accessed Jan 2015

Graham B, Cook S, Dietz S (2015) Rethinking curating: art after new media. MIT Press, Cambridge, MA

Guynup S (2016) Virtual reality, game design and virtual art galleries. In: England D, Schiphorst T, Bryan-Kinns N (eds) Curating the digital. Springer, Dordrecht

Krueger M (1991) Artificial reality 2. Addison Wesley, Reading

Langill C, Muller L (2016) Curating lively objects: post-disciplinary affordances for media art exhibitions. In: England D, Schiphorst T, Bryan-Kinns N (eds) Curating the digital. Springer, Dordrecht

Maleshkova J, Purver M, Weyrich T, McOwan P (2016a) Interactivity and user engagement in art presentation interfaces. In: England D, Schiphorst T, Bryan-Kinns N (eds) Curating the digital. Springer, Dordrecht

Maleshkova J, Purver M, Weyrich T, McOwan P (2016b) Investigating design and evaluation guidelines for interactive presentation of visual art. In: England D, Schiphorst T, Bryan-Kinns N (eds) Curating the digital. Springer, Dordrecht

Martin C, Gardner H (2016) A percussion-focused approach to preserving touch-screen improvisation. In: England D, Schiphorst T, Bryan-Kinns N (eds) Curating the digital. Springer, Dordrecht

Murchu N (2016) A designerly way of curating: reflecting on interaction design methods for curatorial practice. In: England D, Schiphorst T, Bryan-Kinns N (eds) Curating the digital. Springer, Dordrecht

Norman D (2002) The design of everyday things. Basic Books, New York

Partarakis N, Antona M, Stepanidis C (2016) Adaptable, personalizable and multi user museum exhibits. In: England D, Schiphorst T, Bryan-Kinns N (eds) Curating the digital. Springer, Dordrecht

Rokeby D (2015) Very nervous system. http://www.davidrokeby.com/vns.html. Last accessed Jan 2015

Stockhausen K (1989) Stockhausen on music. Marion Boyars, London

Webb AM, Kerne A, Linder R, Lupfer N, Qu Y, Keith K, Carrasco M, Chen Y (2016) A free-from medium for curating the digital. In: England D, Schiphorst T, Bryan-Kinns N (eds) Curating the digital. Springer, Dordrecht

Chapter 2
A Designerly Way of Curating: Reflecting on Interaction Design Methods for Curatorial Practice

Nora O. Murchú

Abstract This chapter examines how interaction design methods can be applied in the curating of (new) media art in particular by developing new practices of networked curating and audience activities. These practices reflect on changes in the modes of cultural production, particularly those related to the Internet and the impact on the work of the curator. They aim to both reflect the content of the exhibition and extend the artworks by including their behaviors and characteristics. They examine how curating can occur *with* the use of technologies and offer new modes of engagement for audiences. In the following sections I discuss these issues drawing on two examples from my curatorial practice. The first example explores the use of augmented reality as part of the curatorial process, which is used to present artworks simultaneously online and within a gallery. The artwork necessitated that the audience interact via the use of their smartphones. The second uses scenarios – a methodology from interaction design – as part of the curatorial process to engage the artists and audience to the conceptual narrative of the exhibition.

2.1 Introduction

The impact of digital technologies such as the Internet and portable networked devices have profoundly transformed the work of the artist in the past few decades. As contemporary artists adopt digital tools and techniques as part of their process, the impact of this has transformed traditional activities such as painting and sculpture, while entirely new forms (such as net art, software art, glitch, and virtual reality) are becoming increasingly recognised as artistic practices. The implications of these technological changes have not only transformed the modes of production for artists but also the modes in which they disseminate their work to an audience. As a consequence many have adopted not only new tools and

N.O. Murchú (✉)
Interaction Design Centre, Department of C.S.I.S, University of Limerick, Limerick, Ireland
e-mail: nora.omurchu@ul.ie

© Springer International Publishing Switzerland 2016
D. England et al. (eds.), *Curating the Digital*, Springer Series
on Cultural Computing, DOI 10.1007/978-3-319-28722-5_2

technologies to create work, but also assumed online platforms as a means to publish their work, experimenting with the methods by which it can be interacted with and viewed. Social networking platforms such as Tumblr,[1] Google+[2] and Facebook[3] provide means by which artists can share interactive media eliciting direct audience interactions. These platforms have allowed artists to interact and build direct relationships with their audience or "followers[4]" and provide space for them to post their artwork. The artists work within these spaces allow their audience to reciprocate using the technical capabilities of these platforms – commenting, liking and retweeting posts, while engaging in conversations and interactions with the artist. This relationship between artists and audience allows the artist to disseminate their work directly to the public, bypassing traditional modes of exhibition including galleries and festivals, where curators would select work for public display. This transformation in modes of public display allows the artist to become "active" in not only the production of their work but also in how, where and how many times it is viewed.

As the online audience has become particularly significant for the artist's work, artists have not only experimented with platforms for the dissemination of their work but also with the format their audience receives and experiences. Artists have pushed the boundary of how art is seen online and the format in which an audience can encounter it. Online gallery spaces such as "CERMÃ",[5] "The Widget Art Gallery"[6] or "Domain-Gallery"[7] mimic "real life" galleries, holding curated exhibitions of work made to be experienced at the browser interface. These online galleries play with technical capacities of the interface, allowing users to experience and navigate through virtual galleries of digital work. These spaces, often initiated by artists, highlight how artists are increasingly driven to engage with their audiences by taking ownership over how their work is displayed and accessed. Furthermore, it demonstrates an awareness of the networked characteristics of their work and how they take advantage of new means of dissemination that technologies make possible. For example, "Screensaver gallery"[8] – an online curated website – invites and commissions artists to create downloadable screensavers. The gallery curators invite artists to experiment with the technical and aesthetic characteristics of a screensaver including duration, variability and animation. Visitors to the site can – for a limited

[1] www.tumblr.com – a social networking website that allowed for it's users to create and share content easily through an online dashboard.

[2] Plus.google.com – A social networking site created by Google.

[3] www.facebook.com – an online social networking website that allowed users to interact with one another and post content.

[4] On social media sites such as Facebook and Twitter, users can gather friends or followers, whom act as audience for artists.

[5] www.cerma.de/ – an online art gallery experimenting with 3D virtual space.

[6] www.the-widget-art-gallery.blogspot.ie – a mini art gallery designed to be exhibited on a smartphone.

[7] www.domain-gallery.net – an online gallery curated by artist Manuel Fernández.

[8] screensaver.metazoa.org/.

time – download the artwork, saving it and installing it on their computer. Thus, in order to view the artwork, users must wait for their computer to go into power saving mode or force power saving mode through the use of the computer settings. Additionally the "Widget Art Gallery" invites artists to create artwork for a virtual gallery. The "WAG" gallery mimics a Kunsthall – showing temporary exhibitions, while maintaining – an archive of previous exhibitions online. The gallery is a web-app and is designed to work across devices and platforms. Visitors to the site can download the app to their smartphone or a widget for their dashboard or view the artwork through a browser. Both these examples illustrate how artists are engaging in cultural production that shifts our understanding of art making, display and audience participation. Potentially interactive art allows forms of navigating, assembling, or contributing to the artwork that are driven by familiarity with interfaces and navigation paradigms (Paul 2008). The strategies discussed here show how artists are responding to networks and systems and developing new modes for the production and dissemination of art. Furthermore, it highlights a way of working for the artist that challenges the role museums and curators play in the exhibition making process.

The term "curator" has moved beyond any singular definition and now occupies a much broader sphere of activities, practices and professions. The curator, once, a caretaker-like figure, functioned solely within the museum, and as such, would have been entrusted with the overseeing of a particular collection or display. However, as artists continue to engage with networked and distributed processes within their practice, there is a necessity for the curator to respond to and question the act of curating and exhibition making (Graham and Cook 2010). As outlined above artists working with technology have created a new set of conditions by which they make their work and how their audiences encounter them. This has resulted in a shift in curatorial practices and the work of the curator has diversified and extended beyond the scope of the museum to include the space of the Internet (Funken 2004; O'Neill 2007; Von Bismarck 2004). Consequently, the focus of curatorial attention has been extended from the object to processes to dynamic network systems. As a result, curatorial work has become "more widely distributed between multiple agents including technological networks and software" (Krysia 2006). This chapter reflects on these changes and asserts that the practice of curating cannot be dissociated from social and technological developments. By integrating technology into curatorial practice and choosing to represent networked artwork using everyday devices such as smart-phones or websites, it allows for new possibilities of experiencing and engaging with art for audiences. Furthermore, it requires the curator to act and demonstrate their understanding of the complexity of social relations in distributed systems, which in turn allows, new forms of "power and control to be conceptualised and new contradictions to be revealed" (Krysa 2006).

Studies of HCI and interactive art have focused on the artist and the experience of the user and understanding, and evaluating user experience has been a central concern for both HCI researchers and interaction designers. While historically HCI focused on measuring usability and efficiency (Sweeney et al. 1993; Harker 1995), recent developments within HCI have focused on techniques for more open-

ended engagement and scenarios (Preece et al. 2002; Crabtree 2003). As a result, many have argued that issues pertaining to HCI could be considered useful for the development of interactive artwork (Candy and Ferguson 2014). While the work of interactive artists and designers are often still quite different in terms of aims and outcomes, often the tools and methods used are similar. The main concerns of interactive art are about creating an experience for its audience, who must adopt an active role in order for this experience to occur. Part of the design process of interactive art, therefore, often involves considering how to motivate an audience so that they will interact and engage with the artwork. This has made it more common for interactive artists to take a user-centered approach to the process of designing artworks. In doing so, some artists have borrowed or adapted user evaluation methods from design, HCI and social science research. However, this hybrid area of interactive art and HCI needs to be carefully negotiated as the fundamental conflicts in worldview and methodology are negotiated (Hook et al. 2003). Much attention has been given to the role that interaction design methods play in the work of the artist, however, there has been little consideration as to how the work of the curator could benefit from using interaction design tools as their work becomes distributed and process oriented. In the next section, I will describe a case study that aims to highlight how interaction design methodologies could be of potential use to curators when curating with the use of technologies.

2.2 Curating with Technology

In 2013 I began a postdoctoral research position with CRUMB (Curatorial Resource for Upstart Media Bliss) at the University of Sunderland. The position focused on audience engagement and the key focus of the research was to develop a curatorial project from an audience perspective. During my time at CRUMB, I developed an exhibition – Run Computer Run – that focused on the economic, political and cultural factors that are shaping the Internet. In particular I wanted to examine how artists were increasingly responding to these "offline" factors that were affecting how the Internet was developing. The exhibition aimed to dispel the view that our activities online were not connected to the "real world" and aimed to create a critical awareness from the perspective of the audience of how actions taken in the "real world" were increasingly connected to online activities. I also wanted to show a critical view of these developments and how they were being addressed through artistic work. The background behind the exhibition sought to examine the increase in the commodification of digital practices and tools, and it is an impacting concern around access, control and privacy. Four strands were developed with each strand focusing on a different issue – aesthetics, privacy, economics and collaboration. The exhibition extended online and included a symposium, workshops and screenings. It took place in a public gallery at Rua Red in Tallaght in Dublin. The gallery had previous experience with computer-based artworks and had previously established a new media festival that had been successful with its audience.

Consequently, the audience familiarity with technology allowed me to experiment with the curatorial methodologies I employed in the development of the exhibition. Having a background in computer engineering and interaction design gives me an understanding of both the technical and the interactive specificities of interactive art. This background directly informs my curatorial approach and allows me to easily integrate technology as part of an exhibition for an audience to interact with.

In Run Computer, Run a selection of net artists were selected from an open call. The call, which was circulated internationally, asked for digital submissions, which would be displayed using augmented reality markers in the gallery. In order to view the artwork, the audience would have to download a free app or use the tablet supplied by the gallery. Once the app was opened the user could view a series of gifs, videos and 3D models – these digital works were connected to an online web-shop where visitors could purchase objects designed by the artists. The exhibition was designed in this way for three reasons: Firstly to connect to the original premise of the exhibition – to dispel the myth of online and the "real world" being separate spaces; Secondly to experiment with curatorially how online work could be displayed within the gallery; and finally to raise a critical discussion about the value of digital work. Digital art poses significant challenges to the traditional methods of presentation and documentation. Due to it's inherently "time-based, dynamic, interactive, collaborative, customizable and variable art form, new media art resists "objectification" and challenges traditional notions of the art object" (Paul 2008). As a result, digital art has been somewhat maligned from art history and the cultural value of the digital medium, due in part to its "immateriality", is often deemed as being less than that of traditional art objects. The exhibition aimed to raise questions around these issues and was designed to guide the audience through a set of interactions that would have them perform some "immaterial labor"[9] (Lazzarato 1996) in order to view the artwork. After downloading a custom app[10] to their smartphone, the audience could purchase goods (t-shirts, posters, postcards or a tote bag) that featured the artwork with the profit going to the artists participating in the exhibition.

The exhibition aimed at creating an experience for the audience, who needed to adopt an active role for the experience to occur. Thus, a user-centered design process was undertaken. A design workshop and two prototyping test sessions took place, and feedback from each of these was used to guide both the development of the app and the layout of the exhibition. Throughout the process I was concerned primarily with how to motivate the audience so that they would interact and engage with the AR markers. It was also important that the app be designed in a way that would support audience engagement and allow them to explore the exhibit easily. Thus, it was essential that I examine both the layout of the space, the placement of the AR

[9]Lazzarato outlines the term "immaterial labor" as the immaterial forms of production that involves information systems and communication networks.

[10]The curator designed a custom app using the developer tools for the augmented reality app Layar – www.layar.com.

markers and the design of the app. Initially I held a small design workshop with eight participants. The participants included gallery staff, a member of their audience and a software developer. All participants had previous experience with using smartphones or tablets and regularly attended exhibitions and gallery openings. The workshop took place in the gallery studios and lasted 6 h. The structure of the workshop was divided into two parts – the first half of the workshop focused on the interactions and experience in the gallery and the second half focused on the design of the app. Prior to the workshop I drafted four use scenarios and a series of paper prototypes. These were used to engage participants in a discussion about interactive artworks in the gallery, and to communicate visually what the experience might look and feel like. In the first half of the workshop, I outlined the activities for the day and discussed the scenarios in detail. An initial discussion about the scenarios took place, discussing them in detail and provided an opportunity for participants to recall their own experiences. The participants were then divided into groups of two, with each group body storming their scenario in the space where the exhibit would be installed. Body storming – a technique used in interaction design – is often used to engage users with creative design activities in the context that the design will change (Strömberg et al. 2004). The method is based on a scenario and acted out in a real life context so that designers can understand behaviours and interactions that would take place. The scenarios aimed to act as a guide for the sessions and participants were encouraged to improvise as they saw fit. After the body storming sessions, a discussion took place. Feedback was given about each of the sessions and issues surrounding the space and how the layout of the exhibition might be executed. In the second half of the workshop, the group examined the paper prototypes and feedback on the layout and functionality of the app was discussed. The concept behind the exhibition was discussed and the participants considered how the app might support the interactions with the AR markers. Finally, the workshop ended with a discussion about technology in galleries and participants recounted their previous experiences (Fig. 2.1).

Following the design workshop, the curator drafted a medium fidelity prototype. This prototype allowed users to scan the AR markers in any order, and upon loading would feature information about the name of the artist and the artwork and displayed an icon that linked to the e-shop. The artwork would load and automatically play on the users device. Five users were recruited and asked to participate in a testing session with the prototype. The users were selected from the gallery's visitors – three of the users were experienced with smartphones and two did not use them regularly. All participants attended galleries and museums on a regular basis – often visiting them recreationally and for educational purposes. In the test session the participants were asked to complete a short task list and provide feedback on the look and feel of the app. While the participants who used smartphones on a day-to-day basis completed the task list easily, those who were unfamiliar with the technology struggled and needed guidance. After the task list, participants engaged in a discussion with the curator about the interface, functionality and interactions with the app. Overall, the feedback was positive with the participants commenting on the novelty of using their smartphone as part of an exhibition.

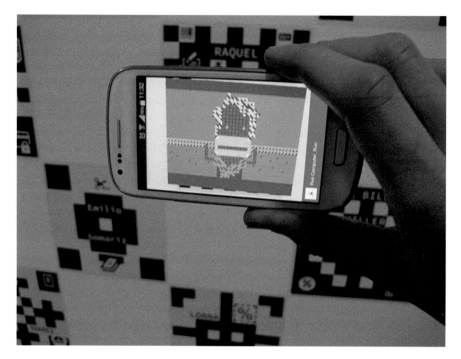

Fig. 2.1 The custom Layar app (developed for the exhibition allows visitors to view artwork on their smartphones) shows Dansa in by Raquel Meyers

However, participants requested a more minimal interface so as not to distract from the experience of watching the artwork. They also commented that the purchase icon that linked to the e-shop should only appear when the artwork finished playing. Based on these responses – a high fidelity prototype was developed for use in the exhibition. The final prototype allowed users to scan an AR marker, which would display the related artwork on their phone. The final UI design consisted of a minimal interface that displayed the name of the exhibition, the artist name and the name of the artwork. An icon that linked to the e-shop pertaining to the artist would display after the video finished playing or after a period of 30 s for a gif or 3D model. The icon linked to an ecommerce website with links to purchase objects related to the artwork.

2.3 Speculative Scenarios for Curating

Resonate is a digital art and technology festival that has been held annually in Belgrade, Serbia since 2011. The festival provides a critical overview of current practices in the field of music, visual arts and digital culture. In 2015 I was invited to participate in their programming and curate the exhibition. The festival director

requested that I engage a number of artists in a commissioning process, as was part of the yearly festival strategy to engage in new artistic research in digital culture. Additionally, the director encouraged an experimental approach that looked at current issues related to digital culture and engaged both artists and audience in an innovative manner. For the festival I developed an exhibition – The New Black – that addressed the conditions that make up the social and civic infrastructures that we currently live in. The curatorial statement proposed that in today's age of mass communication and collaborative media we are often told that digital platforms provide users with opportunities for empowerment and control. For example, tools developed by open source communities offer the resources and means to control aspects of user privacy, browsing behavior and activities. In contrast the monetisation of user data drives the commercial development of technical systems. For example, social platform track and record users actions for financial purposes of selling and delivering an individualised filtered online experience. In this exhibition I wanted to draw on these conflicting forces and speculate how the automation of our everyday lives affects people. Additionally, I aimed to engage artists in the exhibition in a commissioning process where their work would reflect on these central themes and produce artwork in response to them.

In order to engage the artists into this commissioning process, I adapted an established approach from HCI – scenario-based design. Carroll (1999) describes scenarios as a tool and media for interacting with other people in which narrative descriptions provide description of a person's usage of an interactive system. These narratives are used to focus design efforts on the user's requirements, evoke reflection in design, and guide the development of the system that will enable use experiences (Carroll 1999). Furthermore, they enable open-ended processes that exemplify particular themes and concerns in work and activity situations. For The New Black I developed a scenario that uses creative fiction in order to imagine a female worker in the near future.[11] In the scenario, the worker describes her work as a content moderator and details the work-life context in which she lives in. She also discusses the conditions that lead to the development of her role and the algorithmic culture upon which it is based. This narrative retained the same components that constitute traditional scenarios: context, challenges, a theoretical framework, events, actions, results and reflections (Carroll 1999). However, the scenario presented to the artists also reflected a possible future state of the world and described a context in which technology, the commodification of data and the automation of work practices have introduced new work conditions. The scenario was left open-ended, and artists were encouraged to reflect upon the themes, the character or the emerging challenges for the future of work and life in society. Additionally, the artists were told that any interpretation of the scenario was applicable including the possibility of ignoring the narrative and the exploration of the themes in an abstracted manner was encouraged. The resulting artworks responded and reflected to varying aspects of the themes pertinent to the show. These included an interactive

[11] The full scenario can be read at: http://resonate.io/2015/projects/the-new-black/.

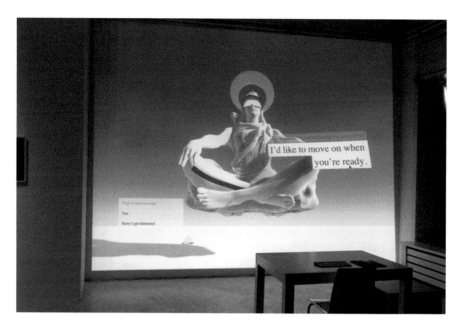

Fig. 2.2 A thousand plateaus by FIELD

3D rendered game (Fig. 2.2) that examined AI, the ownership of data and the ethics of design to a video work by Eva Papamargariti that rendered the environment for the female worker in the scenario. Finally, the scenario also become central to the public broadcasting of the exhibition and was made available to the audience as part of the documentation of the show. This allowed the audience to gain insights into the thought process of the artists and an understanding of the possible ways these visions might interestingly inform possible futures.

2.4 Reflections

As an increasing number of artists use technology within their process of cultural production, new challenges emerge for curators. Media and technology enable a multitude of possibilities for interaction and significantly impact on the audience. Furthermore, as technology becomes a significant part of our everyday it becomes essential that the curator reflects and extends these artworks by including their behaviors and characteristics as part of the exhibition making process. This is an emerging context for curatorial work and opens possibility for a culture of critical, informed and reflective practice that incorporates new strategies and critical approaches for a more open and *"designerly"* way of curating. Reflecting on the examples above, it is evident that user-centered design techniques could be of potential use to curatorial work. Within the domain of HCI and Interaction Design

there is a well-defined and articulated understanding of the relationship between users, technologies and the sensitivities of context in which they are embedded. The case studies above highlight how methods such as user testing, role-play and scenarios could be of potential use in shaping the research and development of an exhibition. The exhibitions discussed in this chapter detail an experimental curatorial approach that is particularly focused on how an audience engages with an exhibition. In Run Computer, Run an interactive app is used to interact with artwork and aimed to integrate technology as part of the exhibition. This resulted in a user centered design process that guided the design and development of an augmented reality app. In The New Black scenarios were adapted (Carroll 1999; Bødker 2000) and used as a tool to engage artists and audience into a dialogue about the future conditions that impact our work and social lives. The scenario was constructed as creative fiction and served as a concrete context for developing ad supporting different perspectives and interpretations of possibilities. Furthermore, it permitted a range of varying artworks to emerge in response to the themes of the exhibition.

Like design work, curatorial work occurs in many overlapping contexts: technical, artistic, and institutional. Each context introduces new concerns and constraints on possible methods and audience engagement. The exhibitions discussed in this chapter are part of a trajectory of growing critical curatorial practice that engages directly with the various characteristics of new media. Furthermore, they propose a model of curating that reflects the changing nature of technology and the diversifying role of the curator. Finally, these practices demonstrate emergent practices that open up new modes for curatorial work.

References

Bødker S (2000) Scenarios in user-centred design – setting the stage for reflection and action. Interact Comput 13(1):61–75

Candy L, Ferguson S (eds) (2014) Interactive experience in the digital age: evaluating new art practice, Springer series on cultural computing. Springer, London. ISBN 978-3-319-04509-2

Carroll J (1999) Five reasons for scenario-based design. In: Proceedings of the 32nd International conference on System Sciences in Hawaii, USA. IEEE Proceedings of the 32nd Hawaii International conference on System Sciences, Five Reasons for Scenario-Based Design, John M. Carroll

Crabtree A (2003) Designing collaborative systems: a practical guide to ethnography. Springer, Secaucus

Funken P (2004) Curators – just more lice on the artist's Bum. In: Tischler U, Tannert C (eds) MIB-men in black: handbook of curatorial practice. Revolver Books, Berlin

Graham B, Cook S (2010) Rethinking curating: art after new media. MIT Press, Cambridge, MA

Harker S (1995) The development of ergonomics standards for software. Appl Ergon 26(4):275–279. ISSN 0003–6870, http://dx.doi.org/10.1016/0003-6870(95)00032-8 (http://www.sciencedirect.com/science/article/pii/0003687095000328)

Höök K, Sengers P, Andersson G (2003) Sense and sensibility: evaluation and interactive art. In: Proceedings of the SIGCHI conference on Human Factors in Computing Systems (CHI '03). ACM, New York, NY, USA, 241–248

Krysa J (ed) (2006) Curating immateriality: the work of the curator in the age of network systems. Autonomedia, New York

O'Neill P (2007) The curatorial turn. In: Rugg J, Segdwick M (eds) Issues in curating contemporary art and performance. Intellect, Bristol

Lazzarato M (1996) Immaterial labor. Generation Online. Available at: http://www.generation-online.org/c/fcimmateriallabour3.htm

Paul C (2008) New media in the white cube and beyond. MIT Press, Cambridge, MA

Preece J, Rogers Y, Sharp H (2002) Interaction design: beyond human-computer interaction, 2nd edn. Wiley, New York

Strömberg H, Valtteri P, Veikko I (2004) Interactive scenarios – building ubiquitous computing concepts in the spirit of participatory design. Pers Ubiquit Comput 8(3–4):200–207

Sweeney M, Maguire M, Shackel B (1993) Evaluating user-computer interaction: a framework. Int J Man Mach Studies 38(4):689–711. ISSN 0020-7373, http://dx.doi.org/10.1006/imms.1993.1032, http://www.sciencedirect.com/science/article/pii/S0020737383710321

Von Bismarck B (2004) Curating. In: Tischler U, Tannert C (eds) MIB- men in black: handbook of curatorial practice. Revolver Books, Berlin

Chapter 3
Dealing with Disobedient Objects

Clare Brennan and Donna Holford-Lovell

Abstract Establishing an archival strategy for digital artwork is key in preserving our digital heritage, safeguarding knowledge and stimulating future creative inquiry. NEoN (North East of North) uses a festival platform to disseminate its aim of promoting digital and technology driven art. Through 6 years of festival activity NEoN holds many digital assets and valuable documentation of digital artworks. We are now investigating the importance of preservation, dissemination and legacy of these digital assets and considering the values and resources required to develop an archiving strategy. This chapter discusses the journey of that investigation and reflects upon the diverse approaches to archiving digital arts.

3.1 Introduction

The collecting, archiving and preservation of digital and technology driven art presents a great global challenge for artists, curators, galleries and museums (Paul 2011). These artworks can be categorised as having an ephemeral nature containing hybrid elements, live performative qualities and are often dependant on technology destined for obsolescence. However, the challenge is an important one and one which cannot be ignored if we are to preserve our digital arts heritage.

NEoN Digital Arts Festival is Scotland's first and only festival dedicated to technology driven arts, providing a seven day festival platform to disseminate national and international digital arts through a programme of exhibitions, performances, workshops, screenings and symposium across the city of Dundee, Scotland. NEoN was established in 2009 commissioning over fifteen new works and helping to

C. Brennan (✉)
School of Arts, Media and Computer Games, University of Abertay Dundee, Dundee, UK
e-mail: c.brennan@abertay.ac.uk

D. Holford-Lovell
Fleet Collective and NEoN (North East of North), Dundee, UK
e-mail: donna@northeastofnorth.com

© Springer International Publishing Switzerland 2016
D. England et al. (eds.), *Curating the Digital*, Springer Series
on Cultural Computing, DOI 10.1007/978-3-319-28722-5_3

stage many temporary art works. We have commissioned and generated new digital content that includes:

- Game based apps
- Visualisation software controlled by gaming technology
- Animations
- Sound works
- New music
- Documentation footage (interviews with international artists and industry professionals)
- Video of one-off performances
- Coverage of discussions and talks

Over time the festival has grown to recognise the importance of preserving these assets, but has never had the resources to adequately archive the materials and make it available to an audience. Following a small successful funding bid we are now exploring what NEoN's digital archiving strategy might look like and considering the values and resources required moving forward.

In 2012 NEoN commissioned a new piece of work by Jaygo Bloom. In collaboration app developers Me and the Giants and illustrator Dr Simpo he created 'Boombaze', an augmented reality app that allowed participants to comment on public art in a city. At the end of 2014, after an IOS, update the app no longer worked. This was the first moment when we really realised that many of NEoN's commissions could become obsolete, unusable, and impossible to re-stage. This raised questions – should we be concerned? Is it our job to make sure this doesn't happen? Many of our commissions have been realised with public money so do we have a moral obligation to preserve them as well?

Currently NEoN faces the challenge of being able to offer access to our content and our experiences have taught us that this can be a barrier to effectively communicating with new collaborators. We have no way of opening up our assets to other artists, technologists, audiences and potential funders around the world. It became clear that the quality and longevity of the NEoN festival is very much dependent on the development of a well-designed strategy which informs an accessible workable archive. Without understanding and being able to communicate our festival activity we will ultimately impede our own progress (Figs. 3.1 and 3.2).

3.2 Challenges

NEoN proposed to publicly disseminate its activities and programmatic history, making available all of its digital content. The intention was that the six years of festival activity would be archived and made available to the public. We planned to edit, catalogue, manage and publish online NEoN's collection of digital assets. Our ambition was to create a formal system for archiving which would be produced

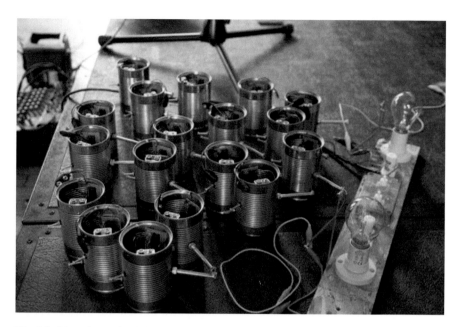

Fig. 3.1 Dirty electronics, NEoN Digital Arts Festival 2011

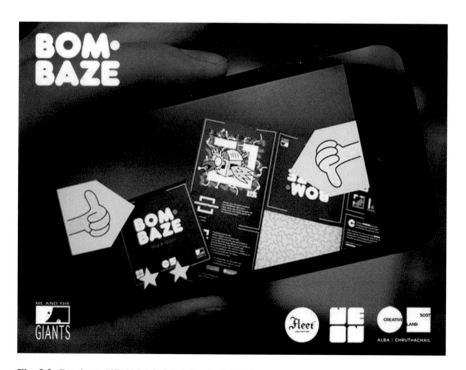

Fig. 3.2 Bombaze, NEoN Digital Arts Festival, 2012

based on best practice research and would be suitable for archiving all future material and assets. Our digital legacy would be preserved via this system and form part of NEoN's development strategy.

The Dead Sea scrolls were discovered in the 1940's. They are thought to be over 2000 years old and the parchment and papyrus are still readable. In contrast, today many of us would find it difficult to find a machine capable of reading a 20 year old digital floppy disk. The preservation problem of digital art or technology driven art is multi-layered. The physical media or storage on which it resides needs to be preserved. We have to be able to trust it to be capable in the future to re-stage, re-play and power the art in the way we expect it to. Next is the data itself and we need to consider whether it will be comprehensible in the future. Even if the storage survives it will not be useful unless it can be understood, as with all digital media it needs to be translated into an understandable form. So then the media which translates, hosts, plays, creates, or powers the work has to be preserved. It is guaranteed that the hardware underlying all digital art will become obsolete (Becker et al. 2007).

The concerns and challenges that NEoN faces are shared by many other individuals and institutions all over the world and many have sought to find solutions and strategies to tackle them (Au Yeung et al. 2008). The NEoN team recognised that establishing an accessible and workable archive offered the opportunity to develop knowledge exchange activity. To share and learn from the projects we have commissioned, to characterise and promote NEoN on a national and international scale and to develop new audiences and networks by disseminating existing works.

So if we consider a digital archive it has to be a living archive. We envisage that every five years everything in a digital archive needs to be copied and transcoded, with both the original and transcoded version saved. Being copied can prevent data degradation and transcoding makes the source material (data) functionable in the most up to date format. Beginning to understand this task alone was proving too difficult and its extent would become an unenviable task.

This NEoN archive project would also form the basis of a larger ambition to look at digital heritage. Once we had the foundations of a digital archive we intended to develop a bigger collecting strategy and look at helping other organisations and artists consider their digital legacy, using the knowledge we had gained. Research and experimentation was required to identify best practice in this area. In theory this sounded great, but in practice it became more difficult to see how to systematise the work and still contain the authenticity under which it was created. It also became necessary to question our documentation and whether it presented a true picture of the artwork.

So there are wider issues and impacts to be considered (Au Yeung et al. 2008). Artists have always shaped and reflected on their culture by documenting, challenging and interpreting major historical events and social movements, mass and individual human experiences. For many contemporary artists technology is the medium and language of their practice. If this language is not preserved and

understood by future generations then we are at risk of creating a future in which these digital artworks are lost and do not become part of art history. Cultural Amnesia – a profound silence interrupting our voluminous art history. The long term ambition became to develop an archival strategy that could contribute to the historical legacy of digital arts practice, preserving our digital heritage and enabling future generations to engage with artwork from this period of transformation, innovation and creative dynamism.

So how do we safeguard against this cultural amnesia? How do we future-proof our assets in a way which is meaningful and effective? How can a curated archive be used to leverage new opportunities, stimulate new collaborations and strengthen our reputation? As technology evolves at a rapid rate how do we ensure that the work we commission continues to be accessible? Through our investigations and experiences we hope that our reflections and findings will support other individuals and organisations to consider their own digital legacy.

3.3 Disobedient Objects

Initially we tried to conform to the traditional nature of the archive, bound by the inherent systematics and taxonomy. However, we discovered that this systematic approach distracts from the often multifaceted, evolving and ephemeral nature of the work. We are commissioning disobedient objects which are complex in nature, evolving and changing over time. It is therefore no surprise that our approach to archiving will also have to involve a level of complexity and dynamism.

How can we archive (disobedient) objects that are constantly in flux? The first reason is simply that there has never been more data produced and stored than now – and the amount is increasing. The second reason is that data is being stored in more formats and more media than ever. The third reason is that we haven't yet collected enough data regarding the reliability of these new formats and media over an extended period of time. And these reasons combine exponentially. It can be argued that most critical data needs to be archived using several formats and media since we can't predict their long-term reliability (Au Yeung et al. 2008). How do we organise our thinking and create a system we can work within? We need to change the characteristics of the archive to fit the artwork, not try to squeeze the artwork into the conventions of a 'traditional archive'. We must recognise that a singular system for archiving won't work.

The realisation was that we would need multiple approaches and perspectives to draw upon. Through our investigation we discovered a spectrum of approaches; from the individual to the institutional, from the practical to the philosophical. It became clear that it we needed to design a more flexible framework to reference and work within.

3.4 No Longer Standard

The preservation of our digital assets can no longer rely on standard archiving formats but neither can we design absolute frameworks for archiving digital material. We must define our basic values but also be aware that our archiving strategies must evolve as rapidly as the technology itself. If we are to secure the successful dissemination of our work then our plans for documenting and archiving our digital assets should not be resolved post-project but must be an integral part of the thinking behind the commission and imbedded in the process of creating the work.

Throughout this evolution it has been important to observe the subtle and unique characteristics of the festival to develop an approach to preservation and archiving which is bespoke, reflecting on our nuances and individualisms. But we continue to look up and out, connecting and consulting, drawing upon best practice internationally, inviting practitioners and specialists in the field to contribute to the discussion and inform the best way forward based on real experience and research.

3.5 Strategic Discussions

To this end we actively pursued and coordinated a series of research activities. In 2014 we hosted a mini-symposium called Show Us Your Assets to help us to consider the complexities and potential solutions to the problem. The event was programmed as part of the NEoN festival programme, inviting art historians, academic researchers, archivists and artists to debate tactics for ensuring legacy for moving image and media art in all its analogue and digital manifestations. In 2015 our participation in the professional development course Curating Art after New Media, brought us together with curators, artists and educators to critically examine how contemporary curating can evolve in response to contemporary art practices. And through our festival programming we have strategically selected artists to work with whose practice reflects upon self-preservation and legacy to encourage co-learning and a solution focused journey, bringing multiple perspectives into the mix. With six years of festival activity to draw upon we have a broad and diverse range of experiences to learn from and a varied collection of digital assets to manage and consider. Collectively, these experiences have led us to discover a spectrum of archival approaches, learning from the perspectives of artists, curators, galleries and museums (Fig. 3.3).

Independent curator and researcher Annet Dekker encourages us to capture more than just the technological requirements of an artwork telling us that we "need to think differently about how we archive media art – looking at the behaviour of the artwork instead of just the technical aspects" (Dekker 2014). This places more focus and importance of documenting the process and journey of the work, enabling us to have a deeper understanding of how it is made, the root concepts and the decision making that happens as the work evolves.

Fig. 3.3 Curating art after new media short course, 2015 http://www.macurating.net/shortcourse. htm

It is critical that we understand the heart of the work if we cannot guarantee the preservation of the body. However, perhaps it can be argued that we can only truly appreciate the work if it is preserved in its physical entirety. So as curators should we be commissioning the process and not the product since the product (the artwork) can be temporal? Or maybe the responsibility of this should lie with the artist since they have the most incentive to preserve the legacy of the work and understand the process of creation best.

3.6 Methods

Thomson and Craighead's approach to making and archiving their work adds another layer to preserving the essence of the artwork. When they are commissioned to create work for (semi) permanent display or their work is acquired by museums or national collections, it is accompanied by a chapter-based written score, written by the artists themselves (Cook and Thomson 2011). This in-depth instructional outlines the meaning, technological requirements and exhibition specifications for the artwork in an attempt to future-proof it. However this instructional is not just an

add-on to the artwork but an integral part of the artwork itself. It is embedded in the process of making and is the responsibility of the individual (artist).

What about the responsibility of the institution? Jon Ippolito's 'Variable Media Variable' offers a considered and pragmatic framework for the preservation of new media arts. As associate curator at the Guggenheim, Ippolito developed an interactive form, which was designed to enable museums to capture information regarding artworks, which are digital, performative or complex in nature (Depocas et al. 2003). This feeds into a database allowing for this information to be collated in a formal, systematic way.

The Museum of Electronic Games and Art takes this idea beyond the realm of information gathering, choosing to focus on the physical collection of digital cultural artefacts and the conservation, preservation and accessibility of hardware and software. Their expansive collection of machines and devices support their ambition to "transfer knowledge via cooperation in education and research" and to share "digital cultural heritage (via) public events and publications" (Hastik 2012).

So should we be concerned with the preservation of the artworks' native hardware? And should we find a way to capture the technical and conceptual aspects of the work in such a formalised manner? Or is it enough to gather a sense of the work; accepting that the work is akin to that of a time-based performance; temporal and for the audience to experience in the moment. Perhaps Otobong Nkanga makes a point when she states that "some things are meant to be lost. You can't collect emotions" (Elderton 2014).

Artist group Blast Theory are somewhat reluctant to translate their work into written documents, as this could have a "tendency to ossify and capture your thinking" (Feuchtwang 2010–2011). Neither are they concerned with the potential to restage their works in the future but rather feel that it's more important to be reminded of the ambience of the work. Matt Adams, co-founder of the group thinks that good documentation should be about "getting that atmosphere correct where you can imaginatively engage with what it must have felt like to do that or be there" (Feuchtwang 2010–2011). So whilst documentation is important to their practice the intention, nature and way the information is captured responds directly to the artwork itself. This could be in the form of a video piece (trailer), a recorded conversation or a collection of anecdotal audience commentary – whatever is deemed most appropriate by the artists. Ultimately, however, it seems that they value that fact that their work offers a unique experience for their audience, a one-off ephemeral moment in time to absorb and be part of.

3.7 Break the System

So whilst NEoN has been searching for a one-size-fits-all system it appears that we in fact have to alter the archive and change the way we think. A 'system' that we believe will work for us is the ability to sample from a pool of tools; a range of preservation methods which sit across the spectrum, from process to product,

individual to institutional. Therefore it is not about settling on a single way of doing this, but rather it is about creating a culture whereby the artist and/or commissioner consciously considers their approach to preservation (whatever form that may take) within the process. The appropriate way to do this is decided on a case-by-case basis, ensuring that the archiving process is sensitive and meaningful to the work itself.

There is a collective responsibility to introduce this in to our practice, whether we are artists, curators or part of a larger institutional body. If we can imbed this in to our thinking and way of working then the consequence will be that more work is captured and remembered. All we are doing is trying to mitigate against loss and assumption, so whether this is achieved by restaging the work in its original format or by reviewing anecdotal evidence of those who experienced it, is something we can aim for.

3.8 Conclusions

The assessment and evaluation of the festival's archival approaches has been explored in a number of formal and informal way through trial and tribulation, in light bulb moments and sustained investigation, through individual and collective research, and in lively debates. Programmed activities and serendipitous happenings have seeded and shaped the first flickers of a formalised strategy. And the unfolding strategy is this: firstly, to develop and encourage a culture of preservation which is considered and rooted in the process of making and commissioning; a collective responsibility. Secondly, to determine the most appropriate method of archiving the artwork in a way which is responsive and meaningful; whether this involves the preservation of the native hardware or choosing to capture the ambience of an ephemeral work. Thirdly, to make these archived works available to the public, virtually or physically (online or via re-staging). In this way NEoN believes that it can fulfil its aim to advance the understanding and accessibility of digital and technology driven art forms and to encourage high quality within the production of these mediums.

References

Au Yeung T, Carpendale S, Greenberg S (2008) Preservation of art in the digital realm. University of Calgary, Calgary, http://www.bl.uk/ipres2008/presentations_day1/06_Au%20Yeung.pdf
Becker C et al (2007) How to choose a digital preservation strategy: evaluating a preservation planning procedure. In: JCDL '07 Proceedings of the 7th ACM/IEEE-CS joint conference on Digital libraries. ACM, New York, pp 29–38
Cook S, Thomson J (2011) Curating, commissioning, and conserving – digital art in practice. The 276 digital preservation coalition

Dekker, A (2014) Enabling the future, or how to survive FOREVER. A study of networks, processes and ambiguity in net art and the need for an expanded practice of conservation. Centre for Cultural Studies, Goldsmiths, University of London

Depocas A et al (2003) Permanence through change: the variable media approach. Guggenheim Museum Publications, New York. The Daniel Langlois Foundation for Art, Science, and Technology, Montreal, Quebec

Elderton L (2014) Interview with Otobong Nkanga. http://www.thewhitereview.org/interviews/interview-with-otobong-nkanga/

Feuchtwang R (2010–2011) Virtueel platform research: Bast Theory. http://aaaan.net/wp-content/uploads/2015/05/blast-theory.pdf

Hastik (2012) Mission. http://www.m-e-g-a.org/mega/profile/

Paul C (2011) The myth of immateriality – presenting new media art (Chinese transl.) in Contemporary Art Investment, Issue 57, 09 2011 (Beijing)

Chapter 4
Curating Lively Objects: Post-disciplinary Affordances for Media Art Exhibition

Caroline Seck Langill and Lizzie Muller

Abstract Theorists and practitioners in the overlapping fields of media art and Human Computer Interaction have been working together for many years to understand digital objects, which often display a kind of "liveliness". However there has been less joint consideration of the curatorial implications of these lively objects – many of which challenge traditional disciplinary distinctions, museological categories and display conventions. This chapter examines the ongoing separation of media art from mainstream art contexts, and argues that "lively objects" call for a more integrative curatorial approach that creates connections not only with other kinds of art, but with all other kinds of objects. We examine two case studies – *thelivingeffect* curated by Caroline Seck Langill at the Ottawa Art Gallery in 2010, and Lively Objects curated by Lizzie Muller and Caroline Seck Langill at the Museum of Vancouver in 2015, which demonstrate two approaches to curating media art in an integrative "post-disciplinary" way. Drawing from J.J. Gibson's concept of "an affordance" as a quality shared between the perceiver and the object of perception, we consider what a post-disciplinary approach offers for the potential meaning making generated between lively objects and audiences in their exhibition environments.

4.1 Introduction

As this current volume recognizes, theorists and practitioners in the overlapping fields of media art and Human Computer Interaction have been working together for many years to understand digital objects – and perhaps most productively to understand the way these objects operate in human experience (Muller 2009). A key aspect of this shared enquiry has been an interest from both communities in the

C.S. Langill (✉)
Liberal Arts and Sciences and the School of Interdisciplinary Studies, OCAD University, Toronto, ON, Canada
e-mail: clangill@ocadu.ca

L. Muller
Art and Design, University of New South Wales, Sydney, NSW, Australia

© Springer International Publishing Switzerland 2016
D. England et al. (eds.), *Curating the Digital*, Springer Series on Cultural Computing, DOI 10.1007/978-3-319-28722-5_4

"liveliness" of these objects – their intriguing capacity for independent behavior that seems to demand new ways of thinking about the relationships between humans and things.

In an ethnographic study of early computer users that has been influential in both the media art and HCI communities, Sherry Turkle (1984) described the computer as an "evocative object" that causes us to ask profound philosophical questions about what it means to be alive, and provokes reflection on our beliefs about subjectivity, consciousness and agency. The evocative nature of these lively objects has been the basis of much shared theorization in HCI and media art, but there has been less consideration at the intersection of these two fields of its curatorial implications. In this paper we explore curatorial strategies for dealing with "lively objects" – seductive things that seem to possess, or to be possessed by life. In particular we examine how "liveliness" invites us to curate media art in an integrative way that overcomes the ongoing separation between media art and contemporary art, as well as between art and other kinds of objects.

The growing acknowledgement in philosophy and aesthetics of the vitality and agency of all things productively disrupts media art theory and curatorial approaches. It challenges the specialness of media arts' claims around categories such as interactive, responsive, autonomous and generative art. Simultaneously, it allows for an expanded field of enquiry and exchange in which media art can escape the exhibitionary margins, and form productive and provocative connections with an unlimited world of things. In this chapter, we explore the curatorial possibilities of integrating new media art not only with other kinds of artworks but with *all* other kinds of objects.

We consider two of our own curatorial projects that attempt an integrative curatorial treatment of media art. Both exhibitions deal with the quality of "liveliness", and can be seen as companion exhibitions, each testing different curatorial approaches. In 2010, Langill curated *thelivingeffect* at the Ottawa Art Gallery. Pioneering robotic artist Norman White has cautiously avoided suggestions that his work attempts to replicate human life. Instead, he refers to his artworks as paying homage to living things, to create what he has termed a "living effect".[1] *thelivingeffect* interrogated this phenomenon using White's work as a point of departure. In 2015 we jointly curated *Lively Objects: Disruption and Enchantment at the Museum of Vancouver*. This exhibition displayed nine artworks that came to life through mechanical, magical or mythical means. The works were installed throughout the historical tableaux of the permanent galleries of the Museum of Vancouver amongst a vast and eclectic array of different kinds of things.

In both cases we consider the liveliness of these objects in terms of their relationships to the audience, the other objects around them and the disciplinary and museological structures they inhabit and disrupt. We argue that such lively objects are often situated across, between and after disciplines, and lend themselves

[1]Norman White. Interview with Caroline Langill conducted in Durham, Ontario, Canada on May 31, 2006.

to an approach to curatorial practice that we have described as "post-disciplinary". In this chapter we briefly examine the broader phenomenon of "post-disciplinary curating" which we have expanded on elsewhere (Muller 2015), and through our two example exhibitions, explore its affordances for media art exhibition. In this analysis we are consciously deploying JJ Gibson's rich concept of the "affordance" as a possibility for action that is generated by the shared and dynamic relationship between a living creature and the objects and features (including other "lively" humans and non-humans) in its environment (Gibson 1979). The concept of the affordance has been popularized and widely used in Human Computer Interaction through Donald Norman's work, which expanded the original concept to include "perceived" affordances that may not only be physical but also cultural or semantic (Norman 1990). The idea of the affordance as a shared property that inheres jointly in both the perceiver and the object of perception, offers a potent basis for examining the possibilities for meaning-making generated between lively objects and audiences in their exhibition environments. It is one of the most useful ideas to emerge from the HCI literature in terms of the aesthetics of interaction and also offers a valuable tool for thinking about exhibitions – allowing insights from the fields of HCI to flow into curatorial practice and analysis.

4.2 The Parallel World of Media Art Exhibition

It is widely acknowledged that media art has, for over 30 years, been displayed in a kind of parallel exhibitionary universe to "mainstream" contemporary art. It has thrived in purpose-built centres like ZKM, Karlsruhe and Ars Electronica, Linz and in countless dedicated festivals and symposia across the world. It has commandeered, generated and hacked online spaces. It has flourished in science museums, and in the hybrid spaces of technologically oriented interdisciplinary research – such as MIT Media Lab, SIGGRAPH and CHI. However apart from a few circumscribed incursions through dedicated programmes or curators – notably Barbara London at Museum of Modern Art, New York, and Christiane Paul at the Whitney Museum of American Art, New York – media art has been largely ignored by contemporary art museums (Shanken 2009).

Many practical arguments have been given for this ("it is technically too difficult, it is too interactive, it is too ephemeral"), which even upon cursory examination are revealed to be untrue. All of these issues are dealt with on a regular basis for other forms of contemporary art. The real problem seems to be that curators and theorists of contemporary art do not recognize media art as art – or at least not the kind of art that they are concerned with (Bishop 2012). We have argued in detail elsewhere that one cause of this blindness is the fundamentally "undisciplined" nature of media art objects (Muller 2015). Much of the knowledge or aesthetic value they contain cannot be accounted for through an art-historical perspective that insists on the specialness, separation or self-sufficiency of the art object. The fundamental integration of media art with science, technology and design often takes it too far into the realm of the "useful" – media art becomes "artifact" rather than art.

The separation of media art is also to some degree self-imposed – a strategy both of resistance and self-protection. Media artists and theorists have historically focused their attention on media art festivals and specialist galleries and centres. This strategy has pros and cons. On the one hand it has led to a robust and supportive community of practice, but not necessarily to greater understanding or recognition – either at the level of the general public, or in terms of a sophisticated, broad and integrative critical discussion. Shanken has traced the many interconnections between the seemingly parallel historiographies of contemporary and media art, and has argued that less silo thinking would lead to richer theorization. He has suggested a revisioning of the art historical record in order to acknowledge the role of science and technology, both theoretically and practically and he has also called for more integration in exhibition contexts (2007).

Currently media art is undergoing what could be considered an identity crisis. As the "newness" of new media aged, the "new" was dropped from common parlance (following the previous fade out of "digital" and "electronic"). As the cohesion and identity of the field wavers, the marginalized exhibitionary position becomes less a source of strength, community building and resistance, than a risk of increasing obscurity and solipsism.

4.3 Post-disciplinary Curating

Disciplinarity has been the foundation of museum and curatorial practice since the nineteenth Century – but that is changing. Shifting knowledge formations and the emergence of a "post-disciplinary" sensibility are having a huge impact on curatorial practice, and museum collections and displays. The boundaries between traditional disciplines are not just shifting, but inevitably eroding entirely. Post-disciplinarity, as we have previously argued (Muller 2015) suggests the inevitability of a way of being and of knowing beyond disciplinary organisation. The term has been in currency since the 1980s across existing disciplines, and particularly in new and emerging fields (see MacCannell and MacCannell 1982; Jessop and Sum 2001; Menand 2001; Camic and Joas 2004).

Contemporary changes in knowledge formations demand new ways to combine organize and experience things (Muller 2015). The traditional divisions that have separated the aesthetic from the useful, art from artifact, are dissolving. Whilst science and technology museums were quick to open up to these possibilities (the Exploratorium in San Francisco and the Science Museum in London being strong examples), art museums have remained resolutely mono-disciplinary in their programming, perhaps due to contemporary art's strong link to the market. But over the past 5 years numerous examples of a "post-disciplinary" sensibility have emerged in contemporary art strongholds. For dOCUMENTA (13), Carolyn Christov-Bakargiev curated a disciplinarily inclusive exhibition that engaged physicists and philosophers as well as artists. Drawing from natural science, design, and ancient collections, dOCUMENTA (13) signaled and embraced different kinds of

knowledge for the display of contemporary art (Christov-Bakargiev 2014). For the 55th International Venice Biennale, Massimiliano Gioni created the *Encyclopedic Palace* adopting an anthropological approach to the study of images produced by professional artists, amateurs, outsiders and insiders, including diagrams by educationalist Rudolf Steiner, and images from psychiatrist Carl Gustav Jung's "red book". In Australia the innovative private Museum of Old and New Art (Mona) has created an integrative and fertile context for new media and interactive artworks by collapsing the distinctions between high and low culture, and between art and artifact (Muller 2015).

This post-disciplinary sensibility is well suited to the nature of the "lively object" (of both old and new media) that frequently combines different kinds of disciplinary knowledge. The increasing juxtaposition and integration of things kept apart through the traditional taxonomical logic of display, allows vitality, behavior, agency and energy to flow amongst and between things and people. In the following two examples, we trace this flow, and the different kinds of liveliness it reveals. In the first example we look at an exhibition that combined traditional artworks with new media artworks – emphasizing the shared qualities between them. In the second example we look at an exhibition that combined media artworks with an eclectic collection of hugely diverse things, creating networks of resonance, allegiance and cross-pollination.

4.4 *Thelivingeffect*; Ottawa Art Gallery, 2011

There are moments in our day when a non-human object appears to stir, often in our peripheral view, in such a way as to suggest it might be a living thing. This perceived "living effect", which can be enchanting, uncanny, destabilizing and compelling, has always been a strong current in new media aesthetics and the philosophy of technology. Its theorisation has recently coincided with emerging discourse on the Anthropocene. In Jussi Parikka's recent linking of geology, computers, and our collective futures in *The Anthrobscene* (2015), he argues, "[The] deep time of the planet is inside our machines, crystallized as part of the contemporary political economy: materials histories of labor and the planet are entangled in devices, which however unfold as planetary histories." For Parikka "Digital culture starts in the depths and deep times of the planet." There is a renewed need for consideration of the way liveliness is distributed through networks of objects and people that fundamentally includes machines and computation, but does not separate them off from other kinds of technologies, materials and phenomena.

The Ottawa Art Gallery exhibition *thelivingeffect* brought together works of media art and traditional practice in order to interrogate aliveness in silicon and carbon-based lifeforms. Norman White's term for paying homage to living things anchors *thelivingeffect* and its particular approach to liveliness. His electronic media sculpture *First Tighten up on the Drum* was produced in 1968 in response to a call for artworks by Experiments in Art and Technology (E.A.T.) for the exhibition *Some*

More Beginnings. Held at the Brooklyn Museum of Art, it ran in parallel to Pontus Hulten's *The Machine in the Mechanical Age* at the Museum of Modern Art. *First Tighten up on the Drum* is an early example of cellular automata and as such is not necessarily an emulation of carbon-based life. The genesis of Cellular Automata systems is typically attributed to Stanislaw Ulam and John von Neumann, both of whom were based at Los Alamos National Lab in New Mexico, but who were also respectively interested in the growth of crystals and self-replicating robots. Cellular automata is a computation model where cells are set up in a grid formation and each cell is either on or off depending on its neighbouring cells and has the capacity to change depending on the algorithm influencing its evolutionary process. The changes occur according to the rules set out, resulting in a pattern not predictable by the observer. *First Tighten up on the Drum* acted as a touchstone for the other works in the exhibition by bringing relational questions of perception and interaction to the forefront of audience experience. The juxtaposition of photography, sculpture, animation, digital art and kinetic sculpture, was intended to open up a dialogue between the works and permitted the vitality of the kinetic work to influence, or perhaps infect, all the work in the gallery. Code-determining rules in White's work act like a benevolent virus giving the viewer license to animate adjacent objects whether they actually move or not.

Liveliness in cellular autonoma is fundamentally distributed and shared – arising from interaction between cells. This sense of networked agency was echoed in Steve Daniels's *Sessile* (2008) – an array of kinetic automata resembling a colony of co-dependent creatures. Like sea anemones, these small fragile robots were immobile except for their spindly appendages, which opened and closed depending on the movements of their neighbours and the audience who were invited to wave their hands over the individual actors in order to elicit a response. Networked together, these agents sent information to each other, communicating external stimuli and demonstrating a sophisticated level of interaction. The complex "hive minds" of *First Tighten Up on the Drum* and *Sessile* both offer complex affordances to the viewer. Understanding their particular form of animation invites biological, but non-human comparisons – such as simple marine organisms or insects. In this they are both familiar, and doubly strange – a silicon life-form aping an unknowable organic sentience. The viewer's interaction with them and attempts to understand their behavior, veer towards that of the zoo visitor, or for more systematic viewers, the biologist or natural historian. They invite experimental gestures and attentive observation of their behaviours, reactions and patterns. In the case of *Sessile* they invite a kind of delight when a gesture is seen to elicit a response – even a brief sense of empathy or communication.

The distributed will of the "hive mind" is not necessarily alien to the human species. In *Cave Rave* (2009), a video installation by Philip Blanchard, it re-emerged in an atavistic twist on "techno- tribalism". Blanchard is known for his humourous animation and installation works that challenge the viewer's perception of what they are witnessing. In this instance, the Mac flurry screensaver appeared to emanate from the center of a circle of crudely illustrated cave dwellers who looked as if they were celebrating a brand-inspired message from the future. Accompanied by

a trippy Tangerine Dream soundtrack the work plays on 1960s commune culture, evoking Fred Turner's assertion that there is no way to disengage cyberculture from counterculture (2008). In this work a simple and ubiquitous technological artifact becomes a ritual object – imbued with life. These imagined humans, from another time or space, are engaged in an abdication of individual agency through mass ritual or worship.

In these three works we see the way "signs of life" cross over and disturb the boundaries of carbon/silicon, human/non-human, machinic/organic, profane/sacred. The viewer, as an empathic, interactive sense-making creature, is invited to find affinity across these lines.

From the animal to the vegetable – the work of Marie-Jeanne Musiol raises the question of communicative cross-pollination between humans and plants that are sentient (or lively) in ways we have yet to learn to perceive. Over the past decade, Musiol has been making the electromagnetic fields of plants visible through electrophotography. *Thelivingeffect* featured a number of works from her *Mirror of the Cosmos* (2010) series titled *The Radiant Forest* (*States of Matter – African Violet and Vine*). The technique Musiol engages for her *energy botany* allows the artist to "speak to the importance of magnetic fields as carriers of information and speculate on the holographic nature of the universe."[2] Musiol's spectral works make clear the untapped potential for communication and knowledge-sharing via the electro-magnetic radiation interpolating carbon-based life forms. Musiol's work, albeit photo-based, provided a visible representation for the audience of the same electronic field utilized for communication by the autonomous agents in *Sessile*.

If Musiol gave the audience an energetic view of our botanical companions, then Laurent Gagnon offered an aesthetic and biological perspective on the impact of human inhabitation on the ecosystems that surround us. Gagnon's intricately crafted tableaus of miniature constructions, moss, lichen and minute living plants positioned on barrel-like plinths modeled evidence of human domestication of the land. *The Pond* (2008) and *The Well* (2008) displayed the detritus of the built environment, with a fence running along the bank of a pond, and an abandoned well. These tiny dioramas changed and decomposed over time emphasizing their liveliness through their slow decay.

In the centre of the gallery sat *Untitled* (*buck*) (2008), a sculpture of a small bronze deer by Wendy Coburn (see Fig. 4.1). Facing the viewer as they entered the space the innocence of the deer's gaze was swiftly belied by a suicide pack of dynamite, strapped to its left flank. If Musiol shows us how we are, "like a leaf,"[3] then it is Coburn who shows us how we are like animals (Donna Haraway 2000).

[2] See Marie-Jeanne Musiol's website for further insight into her work, http://www.musiol.ca/bio-en.php. Accessed on July 31, 2015.

[3] In an interview with Thyrza Goodeve, Donna Haraway states "…I am fascinated with the molecular architecture that plants and animals share, as well as with the kinds of instrumentation, interdisciplinarity, and knowledge practices that have gone into the historical possibilities of understanding how I am like a leaf" (132). Haraway's recognition of the constellation of attributes that we share with all living beings was a key influence on *thelivingeffect*.

Fig. 4.1 *The living effect*, Ottawa Art Gallery, installation view. *Left* to *right*, *The Radiant Forest*, 2010, Marie-Jeanne Musiol; *First Tighten up on the Drum*, 1968, Norman White; *Untitled (Buck)*, 2008, Wendy Coburn; *The Pond*, 2008, *The Well*, 2008, Laurent Gagnon (Photo courtesy of David Barbour)

We all share an electromagnetic field responsible for the firing of our synapses and for balancing our moods, but we also share a fragility that binds us together as a community of organic lives. The five works in this gallery form a network of liveliness derived from differing media and disciplinary positions. They invite the audience to reconsider the boundaries of disciplinary knowledge and afford surprising interactions with things drawn from artificial intelligence to robotics, from botany to natural history, from animation to politics.

A central and separate gallery housed a large complex and durational work titled *Push/Pull* (2009). A collaboration between artist Nell Tenhaaf and computer scientist Melanie Baljko, the work employed cellular automata to produce an installation informed by artificial life, and included responsive agents similar to those employed by White. Experienced in darkness, *Push/Pull* featured an array of autonomous artificially intelligent agents represented by LEDs sparkling and cascading across and around a cylindrical copper structure. In addition, a soundscape synched and choreographed to the lights followed the viewer around the room, expanding as the interaction progressed. This immersive experience contrasted to the traditional display strategies of the surrounding galleries that maintained a distance between viewer and object. In this case, the artist considered the viewer to be a participant in the system or organism, a co-creator of the negotiating and competing forces shaping its behavior.

Fig. 4.2 *Philippe Blanchard, Closed Circuit*, 2009, Cell animation, digital projector, DVD player, power bar and electrical outlet (Courtesy of the artist)

A third gallery brought together additional works by Philippe Blanchard and Wendy Coburn. *Closed Circuit* (2009), Blanchard's naively rendered animation of a small blue smurf, was projected in close proximity to the floor (see Fig. 4.2). The position of the projection (50 × 38 cm) was selected based on the inclusion of an electrical outlet into which the projector was plugged. In an attempt to unplug himself, the smurf strained, stretched and jumped at the outlet only to be forever frustrated by his inability to pull the plug, leading to a final fit on the floor of his tiny cell. *Closed Circuit* explored the line between physical and virtual worlds, and our uncanny ability to empathize with fictional characters. A small but compelling presence the smurf was presented as a pitiable prisoner – powerless to effect change in the real world. A desire to laugh at him or to help him equally reveal our willingness to attribute intentionality and emotions to created entities.

This tendency is more tragically explored in a single-channel work by Wendy Coburn. An analysis of psychologist Harry Harlow's scientific experimentation with rhesus monkeys, *Die Trauernde* (2003) consisted of a slow-motion image of an infant monkey leaping and grasping onto a cloth effigy of a mother with a chilling clown-like face. As it clung to this inanimate object believing it to offer the sustenance it so desperately required, a painfully moving soundtrack of Jesse Norman singing Johannes Brahms's *Die Traurende* (*The Mournful One*) provided accompaniment. Outside this gallery, in the hallway exiting the site, sat a related work, *Feral Science* (*After Harry Harlow*) (2007), a bronze sculpture of

the cloth mother – monumental, cold, hard and lifeless. In this case, the viewer was confronted with an uncanny absence of life, in stark contrast to the seductive animated gesture of the bronze deer in *Untitled* (*buck*). By materializing the ersatz mother from Harlow's lab in this manner, Coburn provided the audience the chance to examine the lack of resemblance to a real monkey and consider the psychological mechanism as well as the ethics of teaching a young *Macaca mulatta* to not only attach itself to this fake object, but to expect sustenance from it.

Curatorially, the juxtaposition of Coburn's and Blanchard's work emphasized the questions raised by the exhibition regarding the conflicted relationship we find ourselves in as humans confronting our own aliveness and that of our companion species whether they be flora or fauna. The network of artworks in *thelivingeffect* revealed the essentially distributed, but interwoven agency of people, animals and things in the fragile world we co-habit. By combining digitally based artworks with analogue objects the exhibition attempted to speak to the fact that technology is the warp to the weft of the everyday, inescapable and ever-present, facilitating communities as easily as it contributes to their destruction. There were numerous points of entry for the audience to affectively experience the way we are all implicated in our shared environments – wild and built. Placing objects that occupy different disciplinary positions in juxtaposition with each other – while acknowledging techné as instrumental to how we understand aliveness today – afforded a new way to consider curating the digital object, as well as a possible approach to facilitating dialogue between artworks more generally.

4.5 *Lively Objects* at the Museum of Vancouver

Lively Objects: Enchantment and Disruption was installed at the Museum of Vancouver (MoV) as part of ISEA 2015. ISEA is one of the most important annual gatherings of the media art community, and is characterized by numerous large-scale media art exhibitions. These shows range from high profile to makeshift, but are largely curated and branded as high-tech, futuristic and distinctively "new media", primarily aimed at the international professional media arts community gathered for the event. One of the aims of *Lively Objects* was to explore the potential for a more integrated kind of media art exhibition that established a dialogic relationship with other kinds of things, and with the city in which it was situated. The MoV provided an ideal and unique setting for this experiment.

Devoted to the social history of Vancouver and environs, the MoV collection includes all manner of artifacts reflecting the private, professional and public lives of the people of Vancouver and their location in an emerging city in Western Canada. Established in 1894, the institution was initially called the Art, Historical and Scientific Association – signaling the eclecticism and universality of its earliest intentions. With its first donation – a taxidermied trumpeter swan – the museum began the diverse and idiosyncratic collection that exists to this day. It is now housed in a spectacular structure, purpose-built in 1967, which resembles a landed flying

saucer, but is in fact a representation of a Musqueam hat, an acknowledgement of the traditional indigenous territory upon which the museum now sits. The heterogeneity of the museum's collection and its role as the keeper of the city's objects and histories created a fertile site for an experiment in integrative post-disciplinary curating.

The artworks selected for the exhibition were all created by faculty or alumni from OCAD University in Toronto or Emily Carr University of Art and Design in Vancouver. As in *thelivingeffect* the selection of works drew upon the inheritance of Norman White (who taught many of the artists in the exhibition) and his influence on Canadian media art practice over the last four decades. Once again, the works were united by an illusive but compelling sense of "liveliness", and included kinetic, interactive and electronic elements, as well as sculpture, video and special performances which happened on the opening night.

Rather than occupying its own separate gallery *Lively Objects* infiltrated and inserted itself throughout the extensive History Galleries of the Museum. These galleries – housing the permanent collection – are arranged chronologically in a series of dramatic historical dioramas beginning with the founding of the city in the mid-nineteenth Century and continuing into the twenty-first. In placing the works we looked for resonances and ruptures with the surrounding objects and themes. We looked for different ways to insert the works into the flow of the audience's experience, as described in the catalogue:

> Like a game of hide and seek, visitors can hunt through the museum to find the objects, or drift through and take their chances. Some objects are hiding in plain sight, speaking only to those who really stop to listen. Others are deliberately pulling focus and making a ruckus. (Langill and Muller 2015)

This game-like approach allowed the audience to search out and discover the art with the help of an illustrated guide to the exhibition available at the museum entrance, to stumble upon it, to miss it altogether or assume it was part of the normal exhibition. We saw all of these different reactions in our time watching audiences move through the galleries.

Germaine Koh's *Topographic Table* (2013) was placed in front of a large picture window with views of the mountain ranges to the north that were echoed in the intricately 3D-rendered topographic landscape on its plywood surface (see Fig. 4.3). Sensors and internet-connected electronics embedded in its frame caused the table to tremble in response to nearby vibrations and Twitter news about earthquakes in the Pacific Northwest. This unstable piece of furniture modeled both the geology and psychic condition of living near the Juan de Fuca fault. This lively effect was amplified by the *Topographic Table's* placement at the corner between *c̓əsnaʔəm, the city before the city*, an exhibition devoted to the relationship between the Musqueam and the history of Vancouver, and the first history gallery exploring British Columbia's foundational relationship to the lumber industry (see Fig. 4.4). The gallery included a historical topographic map of the B.C. coast that echoed the table's surface, and a massive cross section of a Douglas Fir, echoing its material texture. At the crux between these two galleries the table's vibrations resonated

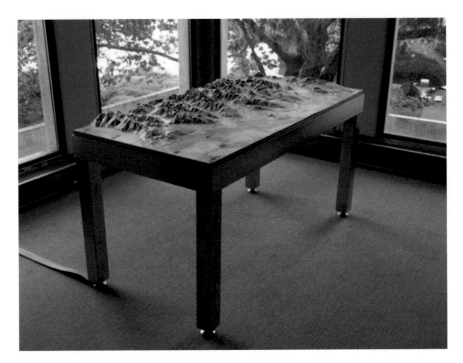

Fig. 4.3 Germaine Koh, *topographic table*, 2013, CNC routered Baltic birch plywood table top, steel frame, sensors and internet-connected electronics, 30 × 36 × 60 in. (Photo courtesy of Caroline Langill)

both with the geological beauty and instability of the land, but also the shockwaves of first contact and the ongoing impact of the industrial exploitation of its natural resources.

The gallery charting the expanding domestic frontiers of the early to mid twentieth Century offered a poignant home for two sculptures by Wendy Coburn (see Fig. 4.5). As Vancouver pushed outwards, picket fences demarcated the cultivated gardens of the city's inhabitants from the wilds beyond. These little pockets of domesticated landscape are testament to the human desire to create safe and protected spaces, and the accompanying urge to control, subdue and exclude nature. Coburn's *Silent Spring*, 2008 is a bronze replica of a pesticide sprayer that she found in her neighbourhood, upon which the artist has etched the names of loved ones – a found object recast as weapon, monument, and talisman.

The sculpture takes its name from Rachel Carson's 1962 book, which warned of the dangers of synthetic pesticides. It was placed with its handle nearly touching the handle of a vintage pushmower in a display of original 1920s garden tools. To think in terms of affordances, handles like this invite grasping, and in doing so imply human presence. These tools look "graspable", and invite the viewer to identify with the person whose hands have held and used this tool. These technological objects are extensions, and participants in the human desire to care for our own

Fig. 4.4 Germaine Koh, *topographic table*, 2013, installation view (Photo courtesy of Caroline Langill)

loved ones – a desire possibly accompanied by dire consequences for the wider ecosystem. Leaning against one another these two handles – one belonging to a historic object, the other to a bronze sculpture – shared an eloquent affinity, and a palpable sense of latent energy, in which the viewer was potentially made complicit.

Next to the sprayer Coburn's *Fable for Tomorrow* (2008) consisted of two Victorian ceramic babies, hands aloft, modified by the addition of small black insect silhouettes swarming all over their imploring bodies. The sculpture is named after the first chapter of Carson's *Silent Spring* – an allegory describing a rural village that falls prey to a strange silence as white dust covers the countryside. The babies were placed close to a cabinet displaying clothes, toys and other artefacts of early twentieth Century childhood. These tiny, treasured objects offered sympathetic and poignant companions for the fragile bodies of the babies – creating a compelling sense of care and tenderness, given edge by the uncanny presence of the infesting insects.

Moving into the 1950s, Judith Doyle's *Phantom House* (2010) was one of the most "embedded" of the works (see Fig. 4.6). Mounted on the wall within a tableau emulating a 1950s suburban home, a flat-screen monitor replaced a bucolic landscape painting. After the sudden death of her mother and father, Doyle began building models of her family home in game engines and virtual environments. *Phantom House* is a ghostly suburban dwelling, constructed in SecondLife.

44 C.S. Langill and L. Muller

Fig. 4.5 Wendy Coburn, *Silent Spring*, 2008, 47 × 16.5 × 13 cm, bronze (on the *left*) and *Fable for Tomorrow*, 17.8 × 17.8 × 14 cm and 17.8 × 17.8 × 14, bisque-fired clay (Photo courtesy of Lizzie Muller)

The luminous structure is suspended between real and virtual, remembered and forgotten, inhabited and abandoned. Revolving on the wall of the "ideal home" of the 1950s the house echoed the period's illusory fantasies of domestic futurism, which fuelled a consumer culture of convenience and social conservatism. The house appeared as a ghostly apparition of the future that belied the original 1950s advertising film – *Dorothy's Dream House* – that played on a television at the centre of the stage-set living room.

One of the most appealing elements of the Museum of Vancouver from our perspective was its interactive nature. Visitors are invited to touch things on display in a way uncommon to art museums. In fact, at the MoV the expectation is that unless something is behind glass you can lay hands on it. In many exhibition contexts it is a challenge to guide the viewer to become an interactant. As curators we embraced the interactive nature of the museum taking cues from the existing displays to create invitations to interact in what were sometimes unorthodox ways.

Two works that particularly benefitted from this were Norman White's *Splish Splash One* (1974) and Kate Hartman's *Go-Go Gloves* (2005). Continuing with this strategy of allowing the chronological references within the artworks to inform their placement, these two works were located within a re-creation of a 1970s hippy lounge. *Splish Splash One* was originally produced as a prototype for a

Fig. 4.6 Judith Doyle, *Phantom House*, 2010, an architecture with hand-drawn and streaming media textures, built in the SecondLife virtual world, with technical assistance from Ian Murray (Photo courtesy of Lizzie Muller)

light-based mural at the CBC offices in Vancouver.[4] A cellular automata mimicking the revolving patterns formed by droplets in water, it is an early example of an artistic exploration of the complex effects that emerge from the simple lifelike system. In the gallery we installed the work in the middle of a velour three-piece lounge suite, housed on the floor in a transparent low-lying plexiglass case where it replaced an existing coffee table. From the vantage point of the sofa, audiences could contemplate its intricate circuitry, immersed in the trappings of 1970s pyschodelia, that are the historically appropriate milieu of the work's original creation.

Nearby, a closet of 1960s and 1970s clothing was available for visitors to try on in front of a mirror. Next to the closet we placed Hartman's *Go-Go Gloves*, an interactive piece that allows the audience to manipulate two animated 1960s dancers through the use of wearable electronic gloves. Like a digital puppeteer the user could control the movement of the dancers onscreen, including the soundtrack and the costumes – which were made up of images drawn from 1960s McCall Needlework and Crafts magazines. Positioning the work in the dress-up corner lowered barriers

[4]*Splish Splash II*, was commissioned by the CBC in 1975 for its Vancouver offices. It remains in place and functioning within the Audience Lounge.

of expectation and behaviour that might ordinarily prevent audiences from putting on and experimenting with the gloves. At the same time the positioning of the work subtly drew attention to the ways in which the female body has been manipulated and objectified through fashion – even at historical moments of social liberation.

Steve Daniels's *Device for the Elimination of Wonder* (2015) was placed just beyond the history galleries, in a small glass atrium overlooking English Bay and the Museum's physical plant – a conglomeration of industrial scale pipes, machines and electrical rigging. A simple kinetic system, *Device for the Elimination of Wonder* is a machine obsessed with quantifying its environment. A metallic bob takes measurements, which the device renders in grey scale, dropping pages of data constantly to the floor below. This single-minded machine inhabits the gallery with a useless intensity, rolling back and forth along two guy wires. Informed by centuries of obsession with quantification and codification, the machine was composed of brass and aluminum elements that strongly referenced nineteenth Century technologies, and the seductive power of the automota. On its underside a mass of visible wires evidenced its contemporary roots in physical computing and maker culture. Its industrial form mirrored the structures and materials of the machinic infrastructure of the museum visible beyond the window. This turned the work into a comment not only on machinic measurement, but also on museological systems of atmospheric stasis and quantification that are a key element of their conservational mission.

Just beyond the galleries, Simone Jones and Lance Winn's *End of Empire* (2011) was placed in a large room normally used for education programs. This kinetic sculpture/video work was in dialogue with perhaps the most peculiar object in the museum's collection: the mummy of a 10 year-old Egyptian boy, Panechates, who died around 300 AD. Donated to the museum by a Vancouver resident in 1922, the mummy is an anachronistic, but popular object – and the centerpiece of educational programs that focus on Egyptian history. In a glass case, usually covered by a large cloth, the mummy was revealed and dramatically lit during the exhibition – an evocative counterpoint to *End of Empire*, which also speaks of the downfall of cultures and civilizations. The work revisits Andy Warhol's 1964 film *Empire* – a single shot of the Empire State Building that lasts 8 h and 5 min – with a post 9/11 and post-GFC twist. In *End of Empire* a large, metal, custom-built machine – resembling a search light or camera dolly – projects a video image of the Empire State Building onto the gallery wall, panning up to reach its pinnacle. Panning down again, it slowly reveals the disappearance of the building from the Manhattan skyline with an eerie, mechanical neutrality. In dialogue with the mummy this dreamlike contemplation of the fragility of things also becomes a poignant reminder of the fragility and humanity of those living with and within the icons of empires.

Sitting outside of the galleries, located adjacent to the information desk in the lobby, *Phone Safe 2*, by Vancouver-based Garnet Hertz, was a custom-built safety deposit box for cellular phones. The public was invited to deposit their phones in the apparatus where it would be locked away for the amount of time they designated – between 1 and 1000 s. The public location and inherent friendliness of the artwork itself – a rectangular white metal box with a red slot for the phone, a bright red

button and a shiny metal hand crank to ease your precious cellular appendage into the machine – invited interaction. Echoing other machines and objects in the foyer – lockers for your belongings, an ATM kiosk – Hertz's work situates itself outside of the exhibition proper, and in fact, outside of art. The work is a piece of provocative design – a machine that invites audiences to contemplate their increasingly close relationship to ubiquitous and converging mobile devices. As either the first or last work encountered in *Lively Objects* the work serves to emphasize the underlying enquiry of exhibition: to understand the ways our relationships with such lively objects have impacted on our experience of being in the world.

4.6 Conclusion: Enchantment and Disruption

Enchantment and disruption were the thematic underpinnings for *Lively Objects* as indicated in the title. On one hand this recognized the way that digital objects can productively 'disrupt' our assumptions and conventions, on the other it recognized how the pervasiveness of digital technology is bringing about a new age of enchantment – a kind of "techno-animism", in which things seem to come to life. Enchantment, that "strange combination of delight and disturbance" (Bennet 2010), offers a means to re-think and to re-feel the liveliness of objects. As Jane Bennett emphasizes, enchantment connects objects and people bi-directionally: Objects are enchanted and we are enchanted with them. Anthropologist Alfred Gell conceived of artworks as re-enchanted technologies both tools for thinking through, and agents participating fully in social practice (Gell 1992).

Taking our lead from Sherry Turkle we assumed the progeny of computers – all types of digital devices – to be evocative in their affect, challenging us to think through our relationship with technology, and to rethink the boundaries that we draw between animate and inanimate. Since technology is part of the world, we also understood this affect to reverberate beyond the boundaries of overtly technological or "media" objects themselves, and instead to be embedded in the unbounded network of people and things that makes up our day-to-day interaction with the world. Curatorially this suggests to us that the enchantment and disruption of digital technology in contemporary experience could best be revealed and explored by integrating digital and analogue, new and old media, art and artifact. Objects in museums often seem lulled by predictable taxonomies and display strategies. Held apart from the flow of exchange, interaction and decomposition, they become caught in suspended animation. A post-disciplinary approach that dissolves categories of objects, offers curatorial strategies for "waking up" objects through mutual enchantment.

In both case studies, *thelivingeffect* and *Lively Objects*, artworks were chosen based on their affinity with Norman White's concept of the living effect – the idea of liveliness instilled in an object by virtue of its agency and/or behavior. For us this concept of liveliness usefully intersects with J.J. Gibson's concept of an "affordance", which shifts agency from a discrete and individual property to a

shared, relational property that can exist between animate and inanimate objects. Thinking about affordances allows us to explore the opportunities for meaning making that arise in situ between audiences and objects and within assemblages of post-disciplinary object juxtapositions. Curatorially it allows us to consider the theoretical and critical outcomes of object juxtaposition as well as the broader environmental experience for an audience engaged with real things in real time, regardless of the objects' disciplinary underpinnings.

These exhibitions demonstrate that media art has much to gain from integration with other kinds of art as well as with artifacts from social and natural history. Key works in both exhibitions demonstrate how potential energy held within art can lead to the perception of aliveness, but is not dependent on actual movement within the work or audience interaction.

In the same way that Human Computer Interaction as a field of study has, in the past 20 years, moved out of the laboratory and into the world (Dourish 2001), these exhibitions suggest that there is much to be gained from integrating media art more closely not only with art in its broadest sense, but with all other objects of material culture. This, we believe, will lead to a more nuanced and reverberant experience of media art where its objects can simultaneously, and without contradiction, fully participate in artistic and art-historical knowledge, as well as embracing, engaging and representing other forms of knowledge. This is undertaken with the understanding that the treatment of objects derived from disparate disciplinary categories requires different protocols and so comes with responsibilities that must be carefully considered.

New ways of curating give us new ways of understanding digital objects and vice-versa. Curatorial experiments can be rich sites for exploring human-computer interaction in culturally and conceptually complex ways. To get the most out of these opportunities we must go beyond a techno-deterministic approach to exhibiting media art, and instead look for collaborative opportunities, with cultural partners like the Ottawa Art Gallery or the Museum of Vancouver that can facilitate an integrative post-disciplinary curatorial method.

References

Bennet J (2010) Vibrant matter – a political ecology of things. Duke University Press, Durham
Bishop C (2012) Digital divide: contemporary art and new media. Artforum. Sept 2012. https://artforum.com/inprint/issue=201207&id=31944
Camic C, Joas H (2004) The dialogical turn: new roles for sociology in the postdisciplinary age. Rowman and Littlefield, Lanham
Christov-Bakargiev C (2014) Worldly worldling: the imaginal fields of science/art. Mousse Magazine, Issue 43, Mar 2013, http://moussemagazine.it/articolo.mm?id=1095
Dourish P (2001) Where the action is: the foundations for embodied interaction. MIT Press, Cambridge, MA
Gell A (1992) The technology of enchantment and the enchantment of technology. In: Coote J, Shelton A (eds) Anthropology, art and aesthetics. Clarendon, Oxford, pp 40–66
Gibson JJ (1979) The ecological approach to visual perception. Houghton Mifflin, Boston

Haraway D (2000) How life a leaf. Routledge, New York

Jessop B, Sum N (2001) Pre-disciplinary and post-disciplinary perspectives, New Polit Econ 6(1):89–101

Langill C, Muller L (2015) Lively objects: enchantment and disruption. In: Armstrong K (ed) ISEA 2015 art and disruption. New Forms Art Press, Vancouver, p 117

MacCannell D, MacCannell JF (1982) The time of the sign: a semiotic interpretation of modern culture. Indiana University Press, Bloomington

Menand L (2001) The marketplace of ideas. American Council of Learned Societies. Occasional Paper No. 49. http://archives.acls.org/op/49_Marketplace_of_Ideas.htm. Accessed 18 Mar 2016

Muller L (2009) The experience of interactive art: a curatorial study, PhD Thesis, University of Technology, Sydney

Muller L (2015) The return of the wonderful: Monanisms and the undisciplined objects of media art. Studies in Material Thinking 12. www.materialthinking.org/papers/185. Accessed 18 Mar 2016

Norman DA (1990) The design of everyday things. Doubleday, New York

Parrika J (2015) Conclusion: cultural techniques of material media. In: The anthrobscene. University of Minnesota Press, Minneapolis. Available at: https://store.kobobooks.com (downloaded July 2015)

Shanken E (2007) Historicizing art and technology: forging a method and firing a canon. In: Grau O (ed) Mediaarthistories. MIT Press, Cambridge, MA, pp 43–70

Shanken E (2009) Art and electronic media. Phaidon Press, New York

Turkle S (1984) The second self: computers and the human spirit. Granada, London

Turner F (2008) From counterculture to cyberculture: Stewart brand, the whole earth network, and the rise of digital utopianism. University of Chicago Press, Chicago

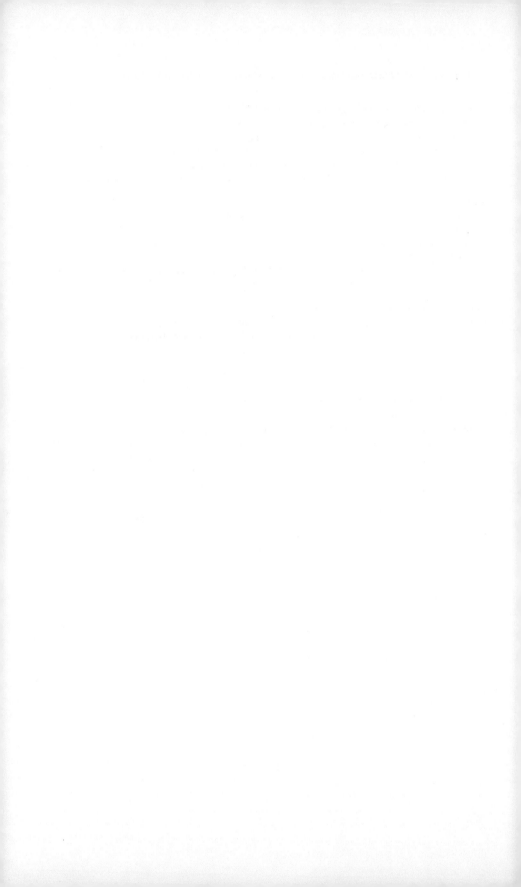

Chapter 5
A Percussion-Focussed Approach to Preserving Touch-Screen Improvisation

Charles Martin and Henry Gardner

Abstract Musical performances with touch-screen devices can be recorded by capturing a log of touch interactions. This object can serve as an archive or as a basis for other representations of the musical work. This chapter presents a protocol for recording ensemble touch-screen performances and details the processes for generating visualisations, gestural classifications, and graphical scores from these logs. Our experience of using these new representations to study a series of improvised ensemble performances with iPad-based digital musical instruments leads us to conclude that these new-media artefacts allow unique insights into ensemble interactions, comprehensive archiving of improvised performances, and the potential for re-synthesis into new performances and artworks.

5.1 Introduction

As an artistic experience, musical performance is fleetingly temporal and the history of music abounds with technologies and traditions to grab hold of musical performances, recording them in some format to be archived, understood, and developed. All of our traditions of musical recording, from notation, to the phonograph, to digital audio, have contributed to the ability of performers to create new musical works and to the place of music in our cultural landscape.

While western classical music is often defined by the score (Davies 1991), and popular music by the song or the recorded version (Kania 2006), the practice of free improvisation often defies the identification of a canonical "musical work". In free-improvised ensemble music, all decisions about the notes to play are made in the moment by individual musicians with the work ending only when all performers have stopped playing (Cahn 2005). With each performance equally identifiable as a different work, the output of free-improvisation ensembles is often represented as audio recordings with liner notes that document changes in personnel or instrumentation. These notes are frequently the main indicator of difference between

C. Martin (✉) • H. Gardner
Research School of Computer Science, The Australian National University,
Canberra, ACT, Australia
e-mail: charles.martin@anu.edu.au; henry.gardner@anu.edu.au

© Springer International Publishing Switzerland 2016
D. England et al. (eds.), *Curating the Digital*, Springer Series
on Cultural Computing, DOI 10.1007/978-3-319-28722-5_5

works. Such archives of free-improvised performances can be time-consuming to browse, due to the temporal nature of the recordings, and difficult to analyse, particularly when performers use similar-sounding electro-acoustic instruments. When performing with computer-based instruments, however, musicians have the opportunity to record a musical work in an extremely detailed form by capturing a log of their interactions as well as audio or video recordings. The log itself can serve as a kind of score but also affords the creation of other representations of the performance giving curators of free-improvisation new perspectives on the musical works and the improvisers, themselves, ways to develop and preserve their artistic practice.

In this chapter, we present a protocol for automatically documenting performances of free-improvised music made on touch-screen computers. Our protocol, and the touch-screen instruments with which it is used, are designed from a percussionist-centred perspective. Rather than particular notes and rhythms, the focus of traditional musical notation, our protocol records detailed touch movements in absolute time and abstract touch gestures identified during the performance by our computer software. Given that ensemble interactions are one of the most interesting aspects of free-improvised music (Borgo 2006), our protocol is designed to connect to multiple touch-screen devices engaged in ensemble performance over a local network or the internet.

We argue that our protocol can serve as an archival format and addresses many of the issues with curating improvised music. We also argue that these recorded logs satisfy Manovich's principles of new media objects (Manovich 2002); their numerical representation allows them to be automatically varied and transcoded into new artefacts allowing new characterisations, analysis, and appraisal of performances. Statistical analysis of the logs can abstract the form of improvisations away from particular instruments and players, providing a broader understanding than can be gained from audio recordings. Algorithmically generated visualisations and gestural scores created from the logs leads to new perspectives on our performances and feeds back in to the process of developing an improvised practice.

The protocol and techniques we describe in this chapter bring improvised musical interactions onto an equal footing with other artforms that are more easily catalogued and curated in spaces for art and interaction. We envision that the gestural scores, visualisations, and other artefacts derived from our performance logs could allow improvised musical interactions with touch-screens to be curated in a much more significant way than is possible with acoustic instruments.

We will describe our protocol for capturing touch interactions and how it has developed from previous schemes for capturing and controlling musical performances. We will also present the classification and visualisation tools used for analysing and comparing performances documented with our protocol. Our protocol and these tools were developed as part of a series of research projects in touch-screen musical performance and we will discuss how they have influenced the research and artistic outcomes of these projects. In particular, we will discuss the experiences of using these systems with Ensemble Metatone, a free-improvisation percussion group that participated in a longitudinal study over 18 months performing with our touch-screen instruments.

5.2 Percussive Improvisation on Touch-Screens

The development of our touch-screen instruments and performance logging protocol was a percussionist-centred process. Performances and rehearsals of Ensemble Metatone, a free-improvising percussion ensemble, were conducted to explore and evaluate instruments. Our performance logging protocol was developed over this process to document and analyse these activities. The same instruments and tools were introduced to other experienced percussionists for subsequent performances and have only been used with non-percussionists relatively recently. Before detailing the protocol and instruments, it is worth considering why percussive improvisation is a useful process for characterising musical interaction.

Percussion is an artistic practice defined by an approach to interaction rather than by any particular instrument that percussionists play. Percussionists perform by "striking, scraping, brushing, rubbing, whacking, or crashing any... available object" (Schick 2006). Blades (1992) discusses the earliest percussion instruments, idiophones, where the body of an instrument creates the sound, rather than an air column or string. He divides them by their method of interaction: "shaken", "stamping" (played with the hands or feet), "scraped", "concussion" (two parts struck together), and "struck" (with a stick or non-sounding implement). These descriptions match taxonomies of modern instruments (such as Cook 1997) and focus on the mode of interaction for the instruments rather than their physical design.

Modern percussionists are accustomed to exploring non-traditional objects to create music and use these percussive gestures to coax wide varieties of timbres and musical gestures from simple instruments. Performers of Xenakis' *Psappha* (1975) or Feldman's *King of Denmark* (1965) must design their own multi-instrument setup to fit the composer's specifications. To meet the requirement for metal instruments, for example, a performer might find a car's suspension spring, a saw-blade or create a unique object from scratch. This percussive approach to investigating new instruments can be applied to touch-screen computers which can also be struck, scraped, and rubbed with fingers and hands.

5.2.1 Composing with Gestures

While traditional musical notation specifies sonic outcomes – pitch, articulation and rhythm – it is possible to compose music by specifying gestures used for interacting with instruments. For percussionists, where gestures are transported across a variety of instruments, this is a popular way of notating music for particularly unconventional instruments. Thierry de Mey's *Music de Tables* (1987) is written for three percussionists who perform on the surfaces of regular tables. de Mey defines a vocabulary of notation for gestures that are used with standard rhythmic notation in the score. Burtner's *Syntax of Snow* (2011) asks the solo

Fig. 5.1 An excerpt from Matthew Burtner's *Syntax of Snow* (Burtner 2011) for solo glockenspiel and bowl of amplified snow. The composer defines a vocabulary of gestures for interacting with the snow with one hand represented by symbols below a regular staff for notes on the glockenspiel (Score Excerpt © M. Burtner 2010, reproduced with permission)

performer to play a glockenspiel with one hand and a bowl of snow with the other. The score sets out a complex scheme of gestures for "playing" the snow, with a pair of symbols (see Fig. 5.1) for each gesture, representing the type of gesture as well as hand position in the bowl.

Although Burtner's vocabulary of gestures is specific to the particular case of performing with snow, some of the gestures (e.g. "touch with finger", "swish with palm", "draw line") could generalise to other instruments and to touch-screens. For documenting performances on touch-screens it is necessary to characterise a vocabulary of gestures that is common to many different types of instruments that can be implemented on touch-screen devices and can express a wide variety of playing styles.

It is notable that many of the gestures indicated in Burtner's score could be interpreted as being continuous rather than ceasing after following the instruction. For example, "fingers tapping" should probably be interpreted not as one or two taps but as a continual tapping until the performer reaches the next instruction. In Human Computer Interaction (HCI) research, gestures on touch-screens are frequently characterised as having a short and finite expression such as the "unistroke" gestures described by Wobbrock et al. (2007). These gestures are usually designed to execute a command in software (e.g. double tap to open a menu) rather than to create an artistic expression. For this reason, characterisations of touch gestures that already exist in the HCI literature are unsuitable for characterising performative touch gestures which mainly consist of continuous interactions.

5.2.2 Free-Improvised Performance

Free-improvised performance has been defined as the performance of music "without any restrictions regarding style or genre and without having predetermined what is to be played" (Stenström 2009). This definition is typical of many, but it frames free-improvisation subtractively: improvisation is "regular" performance minus restrictions. To understand what is really exciting about free-improvisation as a mode of artistic expression and as a methodology for researching unfamiliar interactions, we must look at what free-improvisation *adds* to performance. Bill Cahn, member of the pioneering percussion group, Nexus, writes that improvisation encourages "a deeper knowledge of the instruments and their sound-making possibilities" (Cahn 2005). Digital media theorist Aden Evens writes that when improvising with an unfamiliar instrument "the musician generates novel and surprising results even when applying familiar technique." (Evens 2005)

Although it is rare for free-improvisations to be subjected to an internal musical analysis, unlike other forms of music including jazz improvisations, some characterisations of the internal structure of these performances have been published. Pressing (1988) has developed a model of improvisation that divides performances into a series of non-overlapping events separated by trigger points during the performance that initiate each event. Stenström (2009) proposes a terminology for free ensemble improvisation, including concepts such as "transitions" between musical ideas and "attractors" such as a steady pulse that encourage similar playing from other performers. Nunn (1998) similarly argues that a "segmented form" divided by "transitions" is the fundamental structure of free improvisation.

Much free-improvised music is performed by ensembles of performers rather than solo artists Stenström (2009). In fact, definitions of free-improvisation have emphasised this aspect with Mazzola and Cherlin (2009) writing that one of the free improviser's primary roles is "to negotiate (while playing) with their fellow players every single item they bring into play... as if partaking in a dynamic and sophisticated game."

5.2.3 Ensemble Metatone and Improvising iPad Ensembles

In the present research, an improvising percussion group was not only used to create new music but to explore and evaluate touch-screen instruments running on Apple iPads. Ensemble Metatone was brought together in Canberra, Australia, to study the process of performing free-improvised music starting with a prototype app and, through a process of iterative design, eventually presenting concerts with multiple apps. The members of the group (including one of the authors) were all highly qualified in classical percussion and had significant experience as improvisers (Fig. 5.2).

Fig. 5.2 Ensemble Metatone performing *MetaLonsdale* at the ANU School of Art Gallery in October 2013 (left to right: Jonathan Griffiths, Charles Martin, Christina Hopgood, Yvonne Lam)

Ensemble Metatone undertook a series of studio rehearsals throughout 2013 to develop a repertoire of free-improvised music with our iPad apps (Martin 2014). Using a process of "creative music making" (Cahn 2005) where improvisations are followed by critical listening and discussion, the performers developed a vocabulary of touch interactions inspired by their percussion training. Notably, they also discovered novel sounds from the instruments that could be created with unusual or atypical interactions and were not foreseen by the app designer (Martin et al. 2014a). The performers of Ensemble Metatone settled on a combination of iPad and acoustic percussion instruments allowing them to choose from a wide palette of sound colours in their performances. The initial series of rehearsals was followed by a recorded research concert with a live audience, and a series of performances at experimental art events. The recording of Metatone's research concert was released as a digital album in March 2014 (Martin et al. 2014).

Other percussion performers were also invited to work with our touch-screen apps in a variety of improvised and semi-composed performances in Australia and the USA. In 2014, a number of Metatone apps were made available for free in the Apple iTunes App Store and the authors are aware of several performances using the apps unrelated to our work.

In 2015, the Metatone apps were used as part of the educational activities of the New Music Ensemble at the ANU School of Music including rehearsals and

performances and in activities with high-school students. In this setting participants had a range of instrumental experience so iPads were used as the only instrument. A formal study was conducted with four iPad quartets, including members of the New Music Ensemble and volunteers from the local music community, who performed several improvisations with different combinations of software features.

The majority of these rehearsals and performances were audio and video recorded and also documented using our touch-screen performance protocol. To date, we have archived over 100 performances of our iPad apps using these tools, forming a highly comprehensive corpus of work for studying improvisation on touch screens. In the following sections, we will describe forms of analysis and derivative works that can be generated from this archive of performance documentation.

5.2.4 Curating the Improvised

Although the field of improvised performance has a developing theoretical background and many highly-regarded practitioners, particular artistic expressions tend toward the ephemeral. We advocate an expanded method of documenting improvised music that encodes not just the sounds made in the performance space, but performers' music-making gestures and ensemble interactions.

It is widely recognised that both musical works and new media artefacts can have a number of interacting representations (Rinehart 2007). Musical works might be directed by a score; might be "thick" or "thin" depending on the the freedom of interpretation afforded the performers; be represented in live performance, studio recordings, or by computer generated renderings; and may be composed or improvised (Davies 2005). Combinations of these representations are often collected together to form an archive of a musical work.

Free-improvised music, where performers do not follow a set musical structure, is usually preserved using only audio and video recordings. While the improvised solos of famous jazz musicians are often transcribed, this is extremely uncommon for free-improvised ensemble performances. Audio recordings of free-improvised performances capture the sonic results of the performers' explorations of musical gestures and interactions with other ensemble members but the original performance gestures are lost. For performances with electro-acoustic instruments, audio-recordings can be inadequate for detailed analysis as it is often difficult to discern which musician is creating each sound.

When improvised music is performed on touch-screen instruments, a log of touch-interactions captured during the performance can supplement traditional recordings and could take the place of a musical "score". While scores are generally used for composition, their use as documentation for new media artworks has been acknowledged (MacDonald 2009). Such a log would also satisfy Manovich's principles for a new media artwork (Manovich 2002). In particular, the log of touch-interactions is variable, forming the basis for derivative artworks that also represent aspects of the original performance.

Borgo has drawn parallels between the swarm-like collaboration in free-improvised performances and the community collaborations that define the field:

> One of the particular challenges of contemporary improvisation, for both players and listeners, is to remain aware of and sensitive to the many musical gestures and processes circulating between members of the group in the moment of performance and between members of the community as ideas circulate via recordings, impromptu meetings, and the overlapping personnel of various working groups. (Borgo 2006)

These communities of practitioners, listeners, and concert organisers are the curators of the free-improvised music world. We argue that the ability to thoroughly document touch-screen movements of improvising ensembles enhances the ability of such a community to develop this artistic practice through archiving, replaying, and re-synthesising performances. In Sects. 5.3 and 5.4, we describe our approach to recording improvised touch-screen performances and transforming such transcriptions into animations, gestural scores, and new artworks. These multiple representations of musical performance allow the curation and analysis of an emerging improvised practice.

5.3 Towards a Protocol for Touch-Screen Musical Performance

Musical data has been abstracted from the temporality of performance for centuries since the development of musical notation. Mechanical instruments such as music boxes and barrel organs, developed in the eighteenth century (Fowler 1967), first allowed music to be "programmed" rather than performed. More refined mechanical instruments such as the "reproducing piano", which appeared at the turn of the twentieth century (Kapur 2005), allowed a musician's performance to be automatically transcribed and converted into a paper "piano roll" that could be re-played many times. All of these technologies have had an impact in the study of music as well as its performance. Musical notation enabled the field of musicology, where the musical score has traditionally been privileged as the canonical representation of a musical work. The piano-roll performances of many famous pianists were made before audio recording was widespread and have been used to analyse their performance styles.

An important antecedent of our work was the MIDI (1996) (Musical Instrument Digital Interface) protocol, which was developed in the late 1970s to connect electronic music *controllers*, such as electronic versions of keyboards, drums and wind instruments and new musical interfaces such as "THE HANDS" (Waisvisz 1985), with electronic synthesisers or digital recording systems. While this standard was intended as a control interface for live performance or recording, it was subverted by digital artists and researchers who recognised that the MIDI trace of a musical performance could be used for other purposes. MIDI was originally

designed to be used with a physical serial connection, however virtual MIDI connections are commonly used to connect multiple pieces of software and to other computers over a network (Lazzaro and Wawrzynek 2004).

While the success of MIDI is ongoing, the semantics of the protocol is mostly restricted to a keyboard-and-note perspective on musical data. The typical MIDI interactions are "note on" and "note off" messages, each of which contain a pitch and dynamic (volume) value. Changing parameters while a note is playing can be achieved by simultaneously sending one of a limited number of "continuous control" messages while the "note on" is held. In an effort to develop a semantics-free format for musical control that better reflected the needs of modern computer music systems, OSC (Freed and Schmeder 2009) (Open Sound Control) was developed. This standard defines a message format but with the specific content of the messages up to the application developer. The flexibility of OSC has contributed to its success not just in computer music, but in professional applications such as show control (Schmeder et al. 2010), although it is not commonly used in commercial electronic instruments.

Some have attempted to define protocols using OSC to standardise interaction with certain types of interface. TUIO (Kaltenbrunner et al. 2005) is one such protocol designed for table-top interfaces where fiducial markers and finger touches can be tracked. Unlike MIDI, TUIO does not define the purpose of messages but communicates only information about basic components that the designers expected would be common to most table-top interfaces. The TUIO protocol sends groups of messages together that encompass the state of the whole table-top interface. Most importantly, one set message is sent for each object on the surface that has changed position. A set message includes identification and position information about the object being tracked as well as pre-calculated data such as velocity, acceleration, and rotation. This simplifies the requirements for software receiving TUIO which does not have to keep track of objects in between bundles of messages and does not need to worry about errors due to messages arriving out of order.

As described in Sect. 5.3.2 below, our protocol for logging touch-screen performances needed to capture the fundamental interactions occurring on the touch-screen, not how these interactions are interpreted by the application currently running on the device. In Apple iOS devices, data collected from the multitouch digitiser in front of the screen is interpreted by the operating system which keeps track of individual touches and divides the incoming data into events (Apple 2015). Software developers can implement a set of callback functions to access these events individually. So-called UIEvents track the state of touches on the screen – they "begin", "move", "end", and may be "cancelled" if they are mis-recognised (Fig. 5.3). For the purposes of designing software for free-form touch improvisation, only the first three states are of interest. The touch-data objects described by these events have a record of their current as well as previous location on the screen. A value proportional to instantaneous velocity of moving touches can be easily calculated by finding the length of the vector from the previous location to the new.

Fig. 5.3 Callback methods for accessing touch events in Apple iOS (Apple 2015). Our Metatone apps log each touchesBegan, touchesMoved, and touchesEnded event

```
- (void)touchesBegan:(NSSet *)touches
    withEvent:(UIEvent *)event;
- (void)touchesMoved:(NSSet *)touches
    withEvent:(UIEvent *)event;
- (void)touchesEnded:(NSSet *)touches
    withEvent:(UIEvent *)event;
- (void)touchesCancelled:(NSSet *)touches
    withEvent:(UIEvent *)event;
```

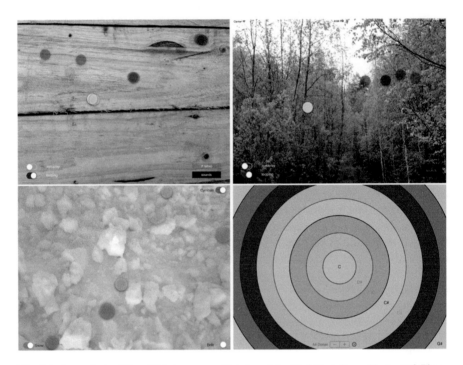

Fig. 5.4 Screenshots of four Metatone apps: *MetaLonsdale, BirdsNest, Snow Music,* and *Phase Rings. MetaLonsdale* and *BirdsNest* allow free-form touch improvisation over the whole screen with a looping function that repeats tapped notes. *Snow Music* allows performers to create snow sounds supported by algorithmically generated soundscapes. *PhaseRings* is an annular interface for performing with pitched percussion sounds selected from configurable scales

5.3.1 Metatone Apps

The touch-screen device chosen for our performances was the Apple iPad. A variety of apps, including the four shown in Fig. 5.4, have been developed for performances by Ensemble Metatone and other groups. All of the Metatone apps share the same fundamental mode of interaction: a tap triggers a single sound with a percussive envelope (i.e. a sharp attack and long decay), while swiping plays a continuous sound with volume related to the velocity of the moving touch. Apart from this

commonality, the Metatone apps feature different palettes of available sounds and modes of synthesis, different arrangements of sounds on screen, a variety of special features, and different kinds of networked interactions between the iPads themselves as well as with a server application.

The earliest Metatone apps, *MetaTravels* and *MetaLonsdale* were both designed to allow percussionists to control combinations of field-recordings and pitched percussion instruments (Martin et al. 2014b). *MetaTravels* used field-recordings from around the world and all chromatic pitches were available in the interface simultaneously. *MetaLonsdale* limited performers to field-recordings from a Canberra café and pitches from a rotating sequences of scales. A related app, *BirdsNest*, allowed performers to create a soundscape reminiscent of northern Swedish forests, with samples of bird calls and field recordings from the location as well as xylophone and woodblock samples. These three apps used UI switches to control a looping feature that would repeat tapped notes and UI buttons to shuffle the sounds available to the player from a palette of sonic material. *Snow Music*, originally developed with the percussion group *Ensemble Evolution* (Martin 2012), allowed percussionists to manipulate samples of snow sounds (similarly to Burtner's amplified snow) and to switch on algorithmically-produced backing soundtracks to accompany themselves. *PhaseRings* is the latest Metatone app and consists of an annular interface for performing with pitched percussion sounds. Each ring in the interface corresponds to a different pitch. Performers configure the app with a sequence of musical scales and the app displays a subset of pitch-rings taken from those scales with changes in the ring setup triggered by network interactions or UI elements.[1]

In performances with our iPad apps, all touch interactions during the performance are transmitted over a Wi-Fi network. Our server software has evolved from a simple script in early rehearsals to a Python server application, Metatone Classifier,[2] that can run on a local network or on a remote virtual server. Communications between the apps and server are accomplished using the OSC (Freed and Schmeder 2009) (Open Sound Control) message format. Data is transmitted either through Unix sockets using the UDP protocol (as is typical for OSC messages) or through WebSockets (Fette and Melnikov 2011), which is the preferred method due to increased reliability of transmission and the ability to easily open a bi-directional connection with a remote server. The Metatone apps automatically find the server and other active Metatone apps on their local network using Bonjour (zero-configuration networking). The app-to-app and app-to-server interactions have been documented elsewhere (Martin and Gardner 2015; Martin et al. 2015). While the designs of these interactions are outside of the scope of the present chapter, it suffices to say that our goal has been to introduce features that synchronise changes

[1]The Metatone apps are available on the iTunes apps store and links can be found on http://metatone.net. This website also includes videos and audio recordings of performances with these apps.

[2]http://metatone.net/metatoneclassifier/

Table 5.1 Scheme for OSC messages from the Metatone iPad apps. The touch and touch ended messages record touch screen interactions directly from the iOS operating system (see Fig. 5.3). The "device" parameters are unique identifiers for each iPad in the ensemble

App to Server Messages:	
OSC Address	Parameters
`/metatone/online`	device
`/metatone/touch`	device, X, Y, velocity
`/metatone/touch/ended`	device
`/metatone/switch`	device, name, position
`/metatone/app`	device, name, state
Server to App Messages:	
OSC Address	Parameters
`/metatone/classifier/gesture`	device, gesture type
`/metatone/classifier/ensemble/event/new_idea`	device, measure value
`/metatone/classifier/ensemble/state`	type, value 1, value 2

in the app's functionality throughout performances in response to individual and ensemble interactions. These features have been designed to emphasise and enhance the sense of group-mind that has been observed in performances of ensemble free-improvisation (Borgo 2006).

5.3.2 The Metatone Log Protocol

Over our earliest rehearsals with Ensemble Metatone and the *MetaTravels* app, we developed a protocol for capturing touch-screen information from each performer's iPad that mirrors Apple iOS's touch-event handling framework. The information is sent to a central server using the OSC data format. As we developed more features for our apps and our (Metatone Classifier) server software this protocol was extended to document the performers' gestural and ensemble states and app-to-app interactions sent between iPads. A complete listing of our OSC messaging scheme is given in Table 5.1. When our server receives one of these OSC messages, it assigns a timestamp and records it to a text file for later analysis. Each line of the text file is written in CSV (comma separated values) format. Although the different aspects of the performance are recorded using different numbers of parameters, these can be trivially separated or reorganised by filtering through the unique OSC address of each type of message.

Our iPad apps send messages to the server in response to three of the four touch-events in iOS, `touchesBegan`, `touchesMoved`, and `touchesEnded`. Both the beginning and movements of touches are recorded using a `/touch` message recording the iPad's app-level unique device ID. The velocity of `touchesMoved` messages is recorded while `touchesBegan` messages are distinguished by having a velocity of zero. A `/touch/ended` message is used to record `touchesEnded` events. `touchesCancelled` messages are ignored.

Each of our iPad apps contains a small number of button and switch UI elements that are used in the performances to activate looping functions and algorithmically-generated backing sounds, and to change the timbre and pitch of sounds available through the touch interface. The performers' interactions with these elements are recorded using /switch messages which record the iPad device ID, the name of the UI element and its new state. During performances, our iPad apps send messages to the other apps performing while connected on the same local network. These messages are also copied to the server software using the /app OSC address.

As will be described in later sections, Metatone Classifier has the capacity to identify the performers' touch gestures in real-time during performances. The server tracks these gestures to identify the state of the whole ensemble and, in particular, identify moments of peak gestural change where the group may have moved onto a new musical section. While this information is recorded for later analysis, it is also returned to the performers' apps, and the apps use it to update their interfaces and present new performance possibilities to the performers (Martin et al. 2015). Our protocol for performance logging includes three OSC messages from the server to the iPad apps. Gesture classifications are returned to the iPads each second with OSC /gesture messages; whenever a new musical section is detected, the server sends an /event/new_idea message to all connected iPads. Various measures of the ensemble state are returned to the iPads each second using the OSC address, /state.

The scheme for logging touch-interactions (see Table 5.1) was chosen to study the process of improvising with iPad instruments and not necessarily for replaying performances. Other aspects of the touch-screen state, such as unique identifiers for each touch point, are not tracked, nor are the exact pitches available on screen for each player. Multi-tracked audio recordings of performance are deemed to be sufficient record of the particular sounds created during the performance while the touch protocols store the details of performers' interaction with the instruments – something the audio recording cannot achieve. While our protocols were created for research purposes, the CSV storage format allows us to easily transform these logs into alternative representations of performances. The next section will describe these new outputs, and how they not only aid in understanding the improvised performances, but serve as representative artefacts along with audio and video recordings.

5.4 Transcoding Performance Protocols

Our system of iPad apps and server software records all touch events, UI interactions, and app-to-app communications that occur during improvised performances in CSV format. These recordings are mutable new-media objects and, as suggested by Manovich, by transcoding these objects "the logic of a computer can be expected to significantly influence the traditional cultural logic of media" (Manovich 2002).

In this section we will describe ways in which our performance protocols can be transcoded into new representations of the improvisations, both in real-time, during a performance, and afterwards. We will explain how gestural classifications of each performer's touches leads to graphical "scores" and animated visualisations provide new perspectives on the ensemble interaction. These representations not only form important archival documents of performance but feed into the ongoing artistic practice of touch-screen improvisation.

5.4.1 Gesture Classification and Gestural Scores

Each second during performances, our server software analyses the previous five seconds of touch-data from each connected iPad and identifies the performers' current touch gesture. Our system calculates feature vectors of descriptive statistics for each player from these five-second windows of recorded touch interactions. The feature vectors are classified using a Random Forest Classifier (Breiman 2001) from the Python `scikit-learn` library (Pedregosa et al. 2011) that is trained with examples of nine touch gestures recorded by our app designer using a formal data collection procedure (Martin et al. 2015).

The nine gesture classes are based on those discovered through qualitative analysis of Ensemble Metatone's earliest series of rehearsals (Martin 2014). The vocabulary focusses on three fundamental touch-gesture groups: tapping, swiping, and swirling, and it includes several variations of each group. Unlike other systems for gesture recognition (Wobbrock et al. 2007) which are designed to interpret sequences of movements with a beginning and ending as a command in a computing interface,[3] our classification system aims to segment a continuous stream of free-form gestures. For this reason, our vocabulary seeks to identify "tapping", which could continue indefinitely, rather than "tap" which is completed after one touch interaction. In this way, our touch-screen gestural vocabulary resembles some of the snow gestures of *Syntax of Snow* (Burtner 2011) which also are open ended with respect to the number or length of interactions. Applying this gestural classification scheme to touch-screen performances results in a new representation of the performance, that is, a time series of gesture classes at one-second intervals for each performer in the ensemble. Although this time series does not contain the details of each performer's interactions, it can still serve as a kind of musical score for performances, albeit a non-traditional one.

When a graphical plot is created of such a time series, the score starts to bear resemblance to the time-space graphical scores of contemporary classical music. In the gesture-score plots of Fig. 5.5, each performer's gestures are represented by a different line. These gesture-scores reveal much about the structure of improvisations that is difficult to appreciate from temporal representations like audio and

[3]This includes Apple's built in `UIGestureRecognizer` class (Apple 2015).

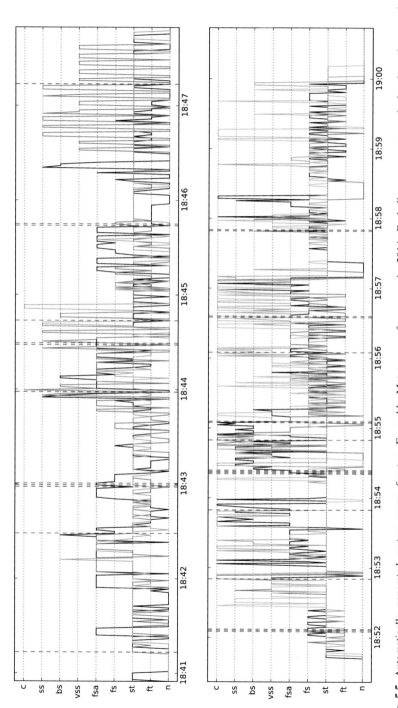

Fig. 5.5 Automatically generated gesture-scores for two Ensemble Metatone performances in 2014. Each line represents a single players' gestural classifications sampled once per second. The *dashed vertical lines* represent moments when a new-idea message was triggered by the Metatone Classifier server. The left score was a trio improvisation by Ensemble Metatone on 2014-08-14 and the right score is of a quartet improvisation on 2015-05-07 by a group of research participants. See Table 5.2 for definitions of the gestures given at each level of the y-axes

Table 5.2 The nine gesture classes that our server software, Metatone Classifier, can identify in touch screen performances. This vocabulary resembles the gestural language of percussion performance, rather than typical command gestures used in HCI

#	Code	Description	Group
0	N	Nothing	0
1	FT	Fast tapping	1
2	ST	Slow tapping	1
3	FS	Fast swiping	2
4	FSA	Accelerating fast swiping	2
5	VSS	Very slow swirling	3
6	BS	Big swirling	3
7	SS	Small swirling	3
8	C	Combination of swirls and taps	4

video recordings. In Fig. 5.5, it is clear when all performers are focussed on the same broad gesture groups as their lines are on close levels of the plot. When one performer breaks out for a solo idea, their line moves up or down, or might move to the "nothing" level if they have stopped playing. Sometimes the performers split into sub-ensembles, exploring separate groups of gestures. Perhaps most interesting are the broadest structural elements where all members of the ensemble change gestures together over a short period of time. Such moments of increased change seem to segment the improvisations into large sections. In a composed piece, these might be called movements, but in an improvised setting, they appear to be related to "new idea" moments where the ensemble spontaneously transitions into a different sound or musical behaviour. While such behaviour in improvisation has been previously described by Pressing (1988), Stenström (2009), Bailey (1993), and others, it has not previously been observed in an automatically-generated gestural transcription.

Since these gestural scores are so helpful in understanding, at a glance, the overall flow of improvised touch-screen performances, they serve as more useful archival documents of performances than, for example, still photographs of the stage setup. Rather than simply recording the location and setting of the performers, gesture-scores store a high-level view of the performers' gestures throughout a whole performance. In fact, it would be possible to use gesture-scores as the reference material for new musical performances. An ensemble of touch-screen musicians could simply read a gesture-score, as they would a graphical score, and play through the sequence of gestures. Alternatively, a computerised score display with a synchronised cursor could be used to assist the performers or even be integrated into the touch-screen interface as in the Decibel ScorePlayer (Hope and Vickery 2015). While such performances would probably not retain the sonic characteristics of the source improvisation, they would include similar musical interactions between the members of the ensemble and identical moments of structural change. By selectively recording and regenerating multiple versions of a transcribed gesture score, a touch-screen ensemble could curate a repertoire of works from improvised source material. This process has precedent in contemporary classical music, the composer Stuart S. Smith recalls allowing "muscle memory to create the initial gesture while letting my mind/ear polish the gesture, refining cliches out of the picture" (Smith and Goldstein 1998).

5.4.2 Identifying Special Events

Some aspects of musical structure in touch-screen improvisations are visually apparent in graphical gesture-scores, but it is also possible to automatically discriminate between different styles of touch-screen performance and identify transitions between multiple sections. To analyse such features, the performance of all performers in an ensemble must be considered at once, and our time series of gestural classifications are an ideal format for exploring these ensemble interactions. The method used in our Metatone Classifier software is that of transition matrix analysis (Swift et al. 2014), where performers' changes between gestures are summarised in matrices allowing simultaneous analysis of the whole ensemble over varying windows of time, or over a whole performance. In Metatone Classifier, transition matrices of gesture groups are calculated over 15 s windows each second during a performance, a value determined through a process of trial and error. Once a transition matrix has been produced, several measures can be applied to them with little computational cost, an important factor in a real-time application.

Out of several experimental tests on transition matrices, our *flux* measure (Martin et al. 2015) has proven to be extremely promising. Flux is a measure of the rate of gestural change calculated by dividing the number of transitions from one gesture to another by the self-transitions where a gesture is followed by itself. The flux of a transition matrix has a maximum of one, when no gesture follows itself, and a minimum of zero, when each member of the ensemble stays on the same gesture for the whole window of calculation. When applied to a window of calculation that slides over a whole performance, peaks in flux tend to match moments where the ensemble shifts to a new section. In Metatone Classifier, we have implemented a strategy that tracks sudden increases in flux to identify these new ideas.

When our software identifies one of these events during a performance, an OSC message is sent to each of the connected iPad apps. We have experimented with a number of responses in the app interfaces for these messages (Martin et al. 2015). The apps might display a series of new notes to reward the performers, or progress through a composition of soundscapes to encourage further exploration.

As with all of our app-server interactions, new-idea messages are logged to our performance protocols and have been useful in later analysis of improvised performances. These messages are shown in Fig. 5.5 as dashed vertical lines. Since calculations over several seconds may identify the same increase in flux, new-idea messages are often grouped together closely although our apps are designed to ignore messages that arrive more frequently than once every 10 s.

5.4.3 Visualisations

To understand the structure of the improvised performances we have developed a method for translating touch and gesture protocols into animated visual

representations of the performance that can accompany the audio and video recordings in the documentation of each performance. Two animations are typically produced for each research-focussed performance using the Processing (Reas and Fry 2006) programming language. The first is an animated version of the gesture-scores discussed in Sect. 5.4.1, with an integrated playhead that indicates the current position in the performance.

The second animation visualises the logs of performers' touches over each performance. Our program reads a captured log file and renders an animation of all four players' touches overlaid in the space of one iPad screen with the different players distinguished by colour. Each touch point is represented by a circle that fades away after about a second allowing different types of swirl, swipe, and tap gestures to be distinguished at a glance. The software also draws a date and time-stamp in each frame as well as text notification of app and switch messages. This touch animation presents an entirely new view of the performance which was not visible to the performers or audience on the day. As all the touch movements are layered in one performance area it is immediately clear when performers mimic each other, when they form sections, or when they experiment with a new musical idea. From the researcher's point of view, the animation also gives a "performer's perspective" on touch interaction, allowing us to connect patterns of touches with musical gestures that the performers discuss after rehearsals.

While the two visualisations can be viewed separately, they are most useful when synchronised with the audio and video recordings of performances and displayed together. Figure 5.6 shows stills from hybrid visualisations of three different performances. Each shows an alternative arrangement of visualisations from our performance protocols and multiple camera-angles of video. Such videos have been used within our research group to study the performances of Ensemble Metatone and other groups that have performed with our iPad apps. While the video component of these hybrid visualisations allows us to recall the context of the concert and to observe the stage interactions and communications of the performers, the visualised touches and gestures have proven to be much more useful from a research standpoint. With the gesture-score we can see performance interactions across time, and with the touch visualisation we can see across the performers' touch spaces. In this way, the hybrid visualisation becomes a kind of "Seeing Space" (Victor 2014) for improvised touch performances where multiple dimensions of the performance can be examined simultaneously. This new and useful representation of performances is only possible because of the performance-logging protocol that we have designed.

It is possible that the visualisations described here could also be used in a live performance context where they could be projected onto a large screen for the audience to view or even superimposed on the performers' iPad touch screens. A prototype touch visualisation has been developed from our software and has been used as a backdrop projection in some performances, but the implications and affordances of this addition to the performance have not yet been fully explored.

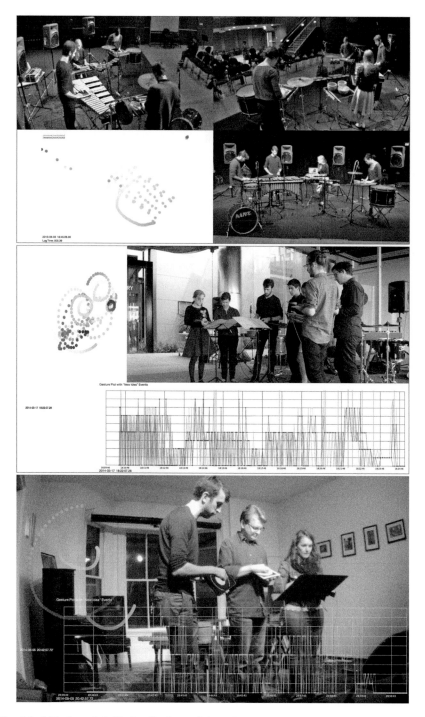

Fig. 5.6 Stills from hybrid visualisations of three Ensemble Metatone performances showing video, touch animations, and gesture-scores. From top to bottom, MetaLonsdale in Canberra, August 2013, Study in Bowls in Canberra, March 2014, and Touch and Tone in Boston, May 2014

5.5 Conclusions

In this chapter, we have presented our protocol for logging free-improvised touch-screen musical performances which has been implemented in our Metatone Classifier software and used to record more than 100 performances by Ensemble Metatone and other groups. Our protocol records all touch interactions during each performance as well as network interactions between the performers' apps and the server software. Our protocol is a much more appropriate record of our performances than conventional systems, such as MIDI, because each touch-interaction maps directly to sound, and because network interactions are key to our ensemble improvisations. Our archive of performance protocols encodes aspects of the improvisations that are not accessible in traditional recordings and that align with theoretical models of free-improvised music. The performance logs in our archive are also new-media objects satisfying Manovich's principles for new media and can be transcoded into multiple alternative representations of the performance. Such transcoding can lead to increased understanding of touch-screen improvisation and to the creation of derivative artworks. The logs themselves, as well as derivative objects, could allow improvised musical interactions to be included in spaces for curating, cataloguing, and exhibiting digital art and interaction.

In this chapter we have also presented visualisation techniques for transforming logs into gestural time series, graphical gesture-scores, and animations that afford the viewer a new performer-centric perspective on the touch improvisations. Animated visualisations have been crucial in understanding the nature of touch-screen improvisation. These have allowed the touches of all performers to be viewed simultaneously and have clearly shown the vocabulary of gestures that the ensemble explores throughout a performance. The time series of gestures have allowed us to perform statistical investigations on the performances to uncover methods for automatically segmenting performances by identifying moments of gestural change. Gesture-scores created by plotting these time series give an overview of a whole improvised performance reminiscent of graphical scores. These images allow multiple improvised performances to be directly compared at a glance and could even be used as the stimulus for future performances.

We emphasise that our protocol and our visualisation techniques have not just been used to archive touch-screen performances but also to develop an ongoing artistic practice. This has included new Metatone apps that react to gestural classifications and new-idea messages sent by the Metatone Classifier server in real-time during performances, live visualisations of touch-screen movements, and even compositions based on our vocabulary of touch-screen gestures. Such techniques could assist the broader musical community to curate and understand the long-term development of musical interactions both improvised and composed. While our touch-screen protocols allow us to archive, preserve and curate free-improvised performances, they also suggest new forms of exploratory iPad performances of the future.

References

Apple Inc. (2015) Event handling guide for iOS. Apple Developer Documentation (published online). https://developer.apple.com/library/

Bailey D (1993) Improvisation: its nature and practice in music. Da Capo, Cambridge

Blades J (1992) Percussion instruments and their history. The Bold Strummer Ltd., Westport

Borgo D (2006) Sync or swarm: musical improvisation and the complex dynamics of group creativity. In: Futatsugi K, Jouannaud JP, Meseguer J (eds) Algebra, meaning, and computation. Lecture notes in computer science, vol 4060. Springer, Berlin/Heidelberg, pp 1–24. doi:10.1007/11780274_1

Breiman L (2001) Random forests. Mach Learn 45(1):5–32. doi:10.1023/A:1010933404324

Burtner M (2011) Syntax of snow for bells and amplified snow. Published digitally by the author. http://matthewburtner.com/syntax-of-snow-2/

Cahn WL (2005) Creative music making. Routledge, New York

Cook G (1997) Teaching percussion. Schirmer Books, New York

Davies S (1991) The ontology of musical works and the authenticity of their performances. Noûs 25(1):21–41. doi:10.2307/2216091

Davies S (2005) Themes in the philosophy of music. Oxford University Press, Oxford

Evens A (2005) Sound ideas: music, machines, and experience. Theory out of bounds, vol 27. University of Minnesota Press, Minneapolis

Feldman M (1965) The king of Denmark for solo percussionist. Edition Peters, Glendale

Fette I, Melnikov A (2011) The WebSocket protocol. RFC 6455 (Proposed Standard). doi:10.17487/RFC6455

Fowler CB (1967) The museum of music: a history of mechanical instruments. Music Educ J 54(2):45–49. doi:10.2307/3391092

Freed A, Schmeder A (2009) Features and future of open sound control version 1.1 for NIME. In: Proceedings of the international conference on new interfaces for musical expression. Carnegie Mellon University, Pittsburgh, pp 116–120. http://www.nime.org/proceedings/2009/nime2009_116.pdf

Hope C, Vickery L (2015) The Decibel scoreplayer – a digital tool for reading graphic notation. In: International conference on technologies for music notation and representation (TENOR 2015). IRCAM, Paris

Kaltenbrunner M, Bovermann T, Bencina R, Costanza E (2005) TUIO – a protocol for table based tangible user interfaces. In: Proceedings of the 6th international workshop on gesture in human-computer interaction and simulation. Springer, Ile de Berder

Kania A (2006) Making tracks: the ontology of rock music. J Aesthet Art Crit 64(4):401–414. doi:10.1111/j.1540-594X.2006.00219.x

Kapur A (2005) A history of robotic musical instruments. In: Proceedings of the international computer music conference. International Computer Music Association, San Francisco. http://hdl.handle.net/2027/spo.bbp2372.2005.162

Lazzaro J, Wawrzynek J (2004) An RTP payload format for MIDI. In: 117th Audio engineering society convention. Audio Engineering Society, New York

MacDonald C (2009) Scoring the work: documenting practice and performance in variable media art. Leonardo 42(1):59–63. doi:10.1162/leon.2009.42.1.59

Manovich L (2002) The language of new media. MIT Press, Cambridge

Martin C (2012) Creating mobile computer music for percussionists: Snow Music. In: Hitchcock M, Taylor J (eds) Interactive: Australasian computer music conference 2012 conference proceedings. Australasian Computer Music Association, The Basin

Martin C (2014) Making improvised music for iPad and percussion with Ensemble Metatone. In: Proceedings of the Australasian computer music conference '14. Australasian Computer Music Association, Fitzroy. http://acma.asn.au/media/2014/01/ACMC-2014r1.pdf

Martin C, Gardner H (2015) That syncing feeling: networked strategies for enabling ensemble creativity in iPad musicians. In: CreateWorld 2015: A Digital Arts Conference. Griffith University, Brisbane

Martin C, Gardner H, Swift B (2014a) Exploring percussive gesture on iPads with Ensemble Metatone. In: Proceedings of the SIGCHI conference on human factors in computing systems (CHI '14). ACM, New York, pp 1025–1028. doi:10.1145/2556288.2557226

Martin C, Gardner H, Swift B (2014b) MetaTravels and MetaLonsdale: iPad apps for percussive improvisation. In: CHI '14 extended abstracts on human factors in computing systems (CHI EA '14). ACM, New York, pp 547–550. doi:10.1145/2559206.2574805

Martin C, Gardner H, Swift B (2015) Tracking ensemble performance on touch-screens with gesture classification and transition matrices. In: Berdahl E, Allison J (eds) Proceedings of the international conference on new interfaces for musical expression. Louisiana State University, Baton Rouge, pp 359–364. http://www.nime.org/proceedings/2015/nime2015_242.pdf

Martin C, Hopgood C, Griffiths J, Lam Y (2014) Ensemble Metatone. Digital Audio Album available on Bandcamp. https://charlesmartin.bandcamp.com/album/ensemble-metatone/

Mazzola G, Cherlin PB (2009) Flow, gesture, and spaces in free jazz. Computational music science. Springer, Berlin

Mey TD (1987) Musique de tables for three percussionists. Percussion Music Europe, Tienen

MIDI Manufacturers Association (1996) The complete MIDI 1.0 detailed specification. MIDI Manufacturers Association, Los Angeles

Nunn T (1998) Wisdom of the impulse: on the nature of musical free improvisation. Self-published

Pedregosa F, Varoquaux G, Gramfort A, Michel V, Thirion B, Grisel O, Blondel M, Prettenhofer P, Weiss R, Dubourg V, Vanderplas J, Passos A, Cournapeau D, Brucher M, Perrot M, Duchesnay E (2011) Scikit-learn: machine learning in Python. J Mach Learn Res 12:2825–2830

Pressing J (1988) Improvisation: methods and models. In: Sloboda J (ed) Generative processes in music. Oxford University Press, Oxford

Reas C, Fry B (2006) Processing: programming for the media arts. AI Soc 20(4):526–538. doi:10.1007/s00146-006-0050-9

Rinehart R (2007) The media art notation system: documenting and preserving digital/media art. Leonardo 40(2):181–187. doi:10.1162/leon.2007.40.2.181

Schick S (2006) The Percussionist's art: same bed, different dreams. University of Rochester Press, Rochester

Schmeder A, Freed A, Wessel D (2010) Best practices for open sound control. In: Proceedings of the Linux audio conference, vol 10. http://lac.linuxaudio.org/2010/papers/37.pdf

Smith SS, Goldstein T (1998) Inner-views. Perspect New Music 36(2):187–199. doi:10.2307/833528

Stenström H (2009) Free ensemble improvisation. ArtMonitor, vol 13. Konstnärliga fakultetskansliet, University of Gothenburg, Gothenburg. http://hdl.handle.net/2077/20293

Swift B, Sorensen A, Martin M, Gardner HJ (2014) Coding livecoding. In: Proceedings of the SIGCHI conference on human factors in computing systems (CHI '14). ACM, New York, pp 1021–1024. doi:10.1145/2556288.2557049

Victor B (2014) Seeing spaces. Available on the author's website. http://worrydream.com/SeeingSpaces/

Waisvisz M (1985) THE HANDS, a set of remote MIDI-controllers. In: Proceedings of the international computer music conference (ICMC '85). International Computer Music Association, San Francisco, pp 313–318. http://hdl.handle.net/2027/spo.bbp2372.1985.049

Wobbrock JO, Wilson AD, Li Y (2007) Gestures without libraries, toolkits or training: a $1 recognizer for user interface prototypes. In: Proceedings of the 20th annual ACM symposium on user interface software and technology (UIST '07). ACM, New York, pp 159–168. doi:10.1145/1294211.1294238

Xenakis I (1975) Psappha for solo multi-percussionist. Universal Music Publishing – Durand Salabert Eschig, Paris

Chapter 6
A Free-Form Medium for Curating the Digital

Andrew M. Webb, Andruid Kerne, Rhema Linder, Nic Lupfer, Yin Qu,
Kade Keith, Matthew Carrasco, and Yvonne Chen

Abstract We present a free-form medium of curation for digital arts catalogues, which connects an infinite zoomable canvas, sketching, and spatial arrangement of rich catalogue elements. We draw on an architectural theory that integrally joins the properties of building materials, construction techniques, and sites to develop a tectonic theory of media of digital curation. The theory addresses media of curation on two levels: the materials of *elements* that can be collected and the medium of assemblage, which prescribes how those elements can be joined together in a spatial matrix. The elements of prior digital arts catalogues are joined together in linear lists or grids. These assemblages do not scale well, making them agonizing to wade through when collections are large. Assemblage in our new, free-form medium supports curating across multiple scales, easing demands on visual attention, while opening conceptual horizons. We created an artifact, *The Digital Curated*, as an example of a digital arts catalogue represented in our new medium.

6.1 Introduction

A mission of digital arts is to challenge and transform people's senses of technology's potential, addressing what is possible, what is in/appropriate, what is intimate, and what is scary. Yet, while boundaries have been blurred and hybrids assembled, the form of the arts catalogue has hardly advanced. We develop a tectonic theory of curation, rooted in materials and how they can be joined to create a meaningful sense of place. We use the tectonic theory as the basis for a new medium of curation that applies digital arts and sciences methodologies to the form of the arts catalogue. The medium embodies *free-form thinking*, which involves improvisation, divergence, and emergent associations (Linder et al. 2015). The free-form medium

A.M. Webb (✉) • A. Kerne • R. Linder • N. Lupfer • Y. Qu • K. Keith • M. Carrasco
Texas A&M University, College Station, TX, USA
e-mail: andrew@ecologylab.net; andruid@ecologylab.net; rhema@ecologylab.net;
nic@ecologylab.net; yin@ecologylab.net; kade@ecologylab.net; matthew@ecologylab.net

Y. Chen
University of Washington, Seattle, WA, USA
e-mail: evechen@uw.edu

© Springer International Publishing Switzerland 2016
D. England et al. (eds.), *Curating the Digital*, Springer Series
on Cultural Computing, DOI 10.1007/978-3-319-28722-5_6

Fig. 6.1 Static rendering of the overview of an inherently dynamic medium. This work, entitled *The Digital Curated* (Webb et al. 2014), presents a digital arts catalogue. The assemblage expresses the curator's ideas about the relationships among elements and a synthesis of the whole collection

is referential, visual and semantic, scalable and expressive. Contextual semantics, textual exegesis, rich imagery, video, and sketching are integrated in a holistic medium for authoring and exhibiting free-form curations.

We present *The Digital Curated* (Webb et al. 2014), a digital arts catalogue exemplar of our free-form medium of curation (see Fig. 6.1). *The Digital Curated* joins clippings of artworks with curatorial writings and sketches in a free-form assemblage designed to attract engagement and provoke divergent interpretations. Multiple scales of detail develop narrative across levels of a holistic spatial ensemble as the user zooms in and out. Text and sketching articulate themes. In contrast with prior digital arts catalogues (e.g., see Fig. 6.2), the new medium takes advantage of the capabilities of digital computing, interaction, and display to bind heterogeneous visual and semantic elements into a meaningful and poetic whole.

Fig. 6.2 The Museum of Modern Art has one of the better digital catalogues. Yet, clicking on the Medium: Installation link from an artwork by Bill Viola brings us here, to 48 of 319 results (Museum of Modern Art 2014). It looks pretty, but form is trumping function. We can see neither the scope of the collection, nor its associationality. Further, the page lacks a label for Installation. As a result, the user could forget what this collection represents, as I myself did, while preparing the present research

6.2 Media of Digital Curation: A Tectonic Theory

> The tectonic potential of the whole would seem to derive from the eurythmy of its parts and the articulation of its joints…The word for space … means a place cleared or freed for settlement and lodging…
>
> —Kenneth Frampton, *Studies in Tectonic Culture*

Tectonics, as an architectural theory, integrally addresses the properties of building materials and sites. According to Frampton, *tectonics*, the art of joining, is derived

from *tekton*, signifying carpenter or builder (Frampton et al. 1995). He says that in Sappho, the tekton assumes the role of the poet. A tectonic system binds all parts of a building into a single whole. The parts are assembled to encompass a spatial matrix.

In formulating a tectonic theory of media of digital curation, we thus consider the 'material' (Miller 2004) elements that a curator gathers, and the means through which platform enables the whole of a curation to be assembled. On the web, the medium of the individual material *element*s of a curation varies, based on the situated context of the platform of a hosting website. The user experience is realized both through the material of these elements, and through how the platform enables them to be joined together.

We draw from Giaccardi and Karana's materials experience framework for HCI (Giaccardi and Karana 2015). The framework suggests that materials are experienced through sensory, interpretive, affective and performative aspects. In forming a tectonic theory of media of digital curation, the *sensory* involves the representation of elements of curation—with text, metadata, graphics, and multi-media—and the modalities they can be interacted with—such as mouse, keyboard, touch, pen, tangible, and full body. The manner of interaction, such as point and click or gesture, is also sensory. The *interpretive* involves how people understand curations—based on representation, interaction, and content—and our processes of ascribing meaning. The *affective* involves human emotional response—from art museum collections to cats (Linder et al. 2015) to #blacklivesmatter social media (King 2015)—through situated interpretation of the sensory. The *performative* involves the activities people engage in with elements and assemblages of curation, which in turn are affected by sensory, interpretive, and affective aspects of their materiality and tectonics.

The tectonics of elements of web curation differ in personal (Linder et al. 2014) and institutional contexts. In personal digital curation, the *material of elements*, depending on the platform, potentially encompasses images, bookmarks, videos, clippings, and other web content formats. On Pinterest, these material parts are manifested as pins, on Facebook, they become posts, and on Twitter, tweets. The material of the pin, for example, is always an image, chosen from a web page by the user, with underlying text, which by default is the title of the web page, and which the user may modify. A tweet, on the other hand, is text first, which may be augmented with an image, video, or link. In the digital arts catalogues of museums, such as MoMA or the Tate, the material of elements is a templated web page, which typically incorporates images and descriptive semantics.

Like the material of elements, the *media of assemblage*—how content elements are arranged and exhibited as a whole—vary in the ways that affordances of web platforms enable arrangement and organization of elements. Meaningful and connected user experiences result when the eurythmy of how elements can be joined together enables constructing what Harrison and Dourish call *places*, which frame interactive behavior (Harrison and Dourish 1996). Media of assemblage for popular web curation platforms, such as a Pinterest board or a Facebook feed,

constitute *places* that have been designed to provide for settlement and lodging through meaningful and social experiences of exhibits. On Pinterest, as users curate pins, the medium of assemblage that they flow into is the board. The board is a two dimensional representation of the first in first out feeds in which Facebook posts and Twitter tweets likewise flow. These mechanisms are effective for showing people the latest content. However, they provide limited support for making deeper associations.

In prior digital arts catalogues, works for a particular artist or genre are similarly assembled in a list or grid (see example, Fig. 6.2). Facets, such as medium and genre, may be specified. As collections grow large, the user is left to fend with a seemingly interminable sequence of items, across linked web pages. These are agonizing to wade through and hardly usable. The grid of thumbnails barely ameliorates the problem. The grid doesn't scale well, particularly since unless semantic information for each entry is simultaneously displayed, the presentation, while perhaps pretty, is rendered uninformative.

In short, instead of taking advantage of digital media's potential for joining graphic and interactive techniques to bind parts into a new form of whole, major museums presently represent themselves on the web in a manner resembling disadvantaged print art catalogues. The material of elements is similar to what you see in print, but with lower resolution. The medium of assemblage is even worse. Catalogues as print books afford thumbing through. Thumbing through a printed catalog typically constitutes a rich, high fidelity, sensory experience because the elements are nicely printed photographs, and the grain of the paper is tactile. In contrast, digital lists and grids can be experienced as long and arbitrary edifices, in which order, selection, and presentation read as machinic. New media of curation have the potential to make digital arts catalogue experiences better resemble the curation spaces of physical museums.

6.3 Information Composition

We consider precursors to the present free-form medium of curation. In spatial hypertext, elements were flexibly organized by users in 2D space, using features such as size and weight (Marshall et al. 1994; Nakakoji et al. 2000). The elements were typically plain text scraps, which don't support re-finding or visceral engagement.

Information composition is a joining medium, which extended spatial hypertext by emphasizing the visual and sensory (Kerne et al. 2008). Composition is an artistic, performative method. Composition means to assemble elements to form a coherent whole. Information composition added emphasis on images, overlap, and translucence to spatial hypertext's flexible 2D medium of assemblage. From the start, information composition constituted a medium of curation, in that elements typically included source URLs and so afforded re-finding. The medium

of information composition was found to improve navigation while browsing a collection of web pages, as compared to linear text (Kerne et al. 2005). Composition was subsequently found to improve creativity during open-ended tasks through a field study of students (Kerne et al. 2008) and a laboratory study (Kerne et al. 2014), and to contribute to phenomena of situated creative learning and distributed creative cognition (Kerne and Koh 2007).

6.4 Multi-scale Information Composition of Rich Clippings

The present research extends prior work on information composition through the incorporation of sketching and a zoomable interface to create the new curation medium of mutli-scale information composition. By multi-scale, we mean spatially organizing elements across a range of sizes, in order to improve the readability of large datasets. The result is reminiscent of Powers of Ten (Eames and Eames 1977) and Google Maps, but here the space and data create an information geography corresponding to an abstract, rather than physical space. The zoomable user interface literally adds dimension to the sensory aspect of the medium of assemblage.

We illustrate principles of multi-scale information composition as a new, free-form medium (Interface Ecology Lab 2014) for art curation through an example, *The Digital Curated* (Webb et al. 2014) (see Fig. 6.1). In this exemplar, we curate media from museums, exhibitions, and scholarly literature, joining concepts, forms, and content that underlife this chapter, itself, to form an integrated whole. We use our tectonic theory of curation to examine the medium of multi-scale information composition on two levels, the material of elements and the medium of assemblage.

6.4.1 Material of Elements of Curation: Rich Clippings

The materials of the composition's elements of curation include rich clippings, writings, and sketches. A *rich clipping* is web content (image, text, or video), which a user chooses, clipped from a web page. The clipping automatically becomes enriched with the joining of contextual semantics, including the URL and title of the source document. Rich clippings may contain additional web semantics, such as a paper's journal title, authors, references, and citations. Composition of rich clippings was found to support reflection and interpretation during open-ended ideation tasks (Webb et al. 2013). Writings are used as expository labels and annotations in *The Digital Curated* to call out themes, such as 'aesthetics', 'abstract', 'kinesthetic', 'embodied', 'digital', 'analog', 'rhythm', 'found object', and 'assemblage' (see Fig. 6.3). For example, in the area delimited by the labels 'embodied', 'kinesthetic',

Fig. 6.3 Annotations label themes in the Digital Curated, such as 'embodied', 'kinesthetic', 'abstract', and 'rhythm'

and 'touch', we encounter a spatial matrix of rich clippings representing works by Schiphorst (2009), Rokeby (Jones and Muller 1983), and Candy and Edmonds (2002). The assemblage of clippings joins gestures, everyday users, dancers, sculptures, wearables, and projections. Embedded YouTube videos can be played, paused, and scrubbed directly from within the curation.

Activating a rich clipping presents its semantics in an exploratory browsing interface (Qu et al. 2014) (see Fig. 6.4). For an ACM article, e.g., soft(n) (Schiphorst 2009), we explore the reference list, and in turn, discover an article on second and third wave HCI methodology (Bødker 2006). Through the semantic browsing interface we read the article's abstract, again without leaving the context of the curation. We read that this work involves topics of multiplicity, context, boundaries, experience and participation, particularly as they arise as technology spreads throughout everyday cultural contexts. Thus, through the experience of this curation

Fig. 6.4 Semantics for soft(n) (Schiphorst 2009) rich clipping are displayed in-context. Nested fields such as references and citations, which incorporate semantics for other scholarly articles, can be expanded, iteratively, to discover connected works. Clicking the title for these related articles enables the user to browse the actual articles, in a new browser tab

as a place of lodging, we discover an interesting conceptual juxtaposition between nested, discoverable semantics, and themes articulated by the visual and conceptual assemblage of the exhibit's whole.

6.4.2 Medium of Assemblage: Multi-scale Information Composition

Cultural theorists, Deleuze and Guattari, describe the assemblage of cultures and societies as a *rhizome*, a meshwork of interconnected heterogeneous elements without a clear beginning or end (Deleuze and Guattari 1987). The relationships among elements are as important as the elements themselves. A rhizome is a map conveying relationships rather than a tracing, which accurately reproduces elements at the expense of the whole. We argue that our free-form medium of digital arts catalogue constitutes a map, not a tracing, and so functions rhizomatically. With an infinite and zoomable canvas, curators can continually evolve digital arts catalogues in this new medium. Curators express relationships between artworks by joining them together through use of scale, spatial juxtaposition of elements, and sketching. The eurythmy of the catalogue's parts, constructed as a multi-scale information composition of rich clippings, affords interpretation and provides space. Thus, multi-scale information composition, as a medium of assemblage, with sensory, interpretive, and affective aspects, has the potential to transform the digital arts catalogue into a functioning virtual exhibition. Further research can also enable

visitors to annotate these free-form assemblages for themselves, engage socially in their midst, and thus create a sense of place in the digital arts catalogue/exhibition.

6.5 IdeaMâché

The medium of multi-scale information composition is currently supported through the web application, IdeaMâché [free to use at http://ideamache.ecologylab.net]. IdeaMâché is a web application that supports free-form curation on an infinite and zoomable exhibition space with design capabilities for writing, sketching, and graphical transformation. Sketching adds free-form lines to the composition of image and text rich clippings. It can be thought of as a graphical form of annotation. Zoomable user interface techniques enable assembling information on and across levels. This, in turn, enables conceptually and cognitively scaling the assemblage of a curation. Incorporating curation tools into the cloud makes data available anywhere, freeing the user from working on particular computers. Through IdeaMâché's web browser extension, which processes drag and drop events, all of the content a user browses directly affords incorporation into the curation environment, which also resides in the browser. Contextual semantics are automatically extracted from source web pages (Qu et al. 2014). We examine three specific aspects of free-form curation, multi-scale, juxaposition and arrangement, and sketching.

6.5.1 Multi-scale

In *The Digital Curated*, we see that over 50 elements have been joined together. In a linear or grid representation, this collection would overwhelm cognition, and so be rendered almost meaningless. In the information composition, we see the clippings are organized into a tectonic system of four or five clusters; the sizes and positions of elements cluster are arranged in accord with associated labels. Thus, the curation as composition is articulated at multiple scales, incorporating techniques originated by Perlin and Fox (1993).

At the initial, top level scale, we encounter a gestalt reading of the whole, but can see little detail in individual rich clippings. To focus, we use pinch or mouse scroll wheel to zoom in and examine a subset of the composition, the 'analog-installation-kinesthetic-digital' region. The focus of the zoom action is easy to control, because it is centered around the point of interaction. Constituent elements get bigger. With semantic information from Foundation Langlois, a series of rich clippings representing works by Paul Sermon, Steina and Woody Vasulka, and Bill Viola, lead to a transition, through the 'analog' label across to 'digital' installations with David Rokeby's Very Nervous System (Jones and Muller 1983) (see Fig. 6.5) and

Fig. 6.5 Zoomed in view of the 'installation' theme. Use of scale creates a visual transition between themes of 'analog' and 'digital'

then to the 'kinesthetic-embodied' cluster, described above. The transition through history that this represents is expressed spatially not just by position, but further, by a rotation of near 30 degrees. This juxtaposes the two clusters in orientation, while connecting them in space.

6.5.2 Juxtaposition and Arrangement

Through spatial areas and rotation, elements of curation are joined together to articulate themes. Annotations are joined through spatial proximity and rotation consistent with related rich clippings. For example, 'rhythm' is positioned closely between a clipping from an article by Latulipe et al. (2010) and one of a painting by Jackson Pollock (see Fig. 6.6). This presentation strategy constitutes a tectonic system of curatorial association. On a more macro level, we can trace from 'embodied' to 'kinesthetic' to 'rhythm', then, through a forking path (Borges 1964), to 'interaction' in one direction, and 'found object' and 'assemblage' in another. 'Kinesthetic', 'embodied', and 'touch' are rotated similarly, promoting readings in which they bind together.

6.5.3 Sketching

Sketching is a means for visual annotation. Glyphs can be sketched to bind elements, promoting synthesis and emergence. In a playful pastiche style, a figure recalling the Matisse dancers has been sketched through the 'embodied-kinesthetic-rhythm' region. Again, its rotation aligns with associated annotations and rich clippings, promoting integral readings. To organize the elements of curation in

Fig. 6.6 The theme of 'rhythm' juxtaposes work by Latulipe et al. (2010) with that of Jackson Pollack. A connection is formed from 'rhythm' to Marcel Duchamp's Fountain through arrangement of elements with nineteenth century guitars from the Met

the area labeled 'aesthetics-abstract-minimalist-informative art', a grid has been sketched, employing a style recalling Mondrian. This echoes a rich clippings from an article on informative art, which also looks Mondrian-esque. From a clipping of Duchamp's *Fountain*, we see wavy sketched lines that suggest water splashing back, up and out of the readymade urinal, toward 'rhythm' and 'interaction', into clippings of a guitar and harpo-lyre from the Metropolitan Museum of Art, and a Pollock at the Guggenheim. How rude!

6.6 Discussion

Curation is an interpretive, structure-generating process that takes a heterogeneous collection of artworks and yields, as De Landa would describe, a joining of specific hierarchies and meshworks (De Landa 1997).

Hierarchies homogenize subsets of the heterogeneous collection into groups of similar importance and relation, providing a top-down, linearized representation. Hierarchies are formed through sedimentary processes, in which similar elements are sorted and grouped together over time, forming layers of detail. The medium of multi-scale information composition supports hierarchies, enabling curators to sort and assemble artworks into meaningful groups through both spatial proximity and scale. From a holistic view, the most general level of detail is shown, but through zooming in, more specific levels of details become revealed.

Meshworks are non-linear, rhizomatic structures, in which elements become bound through strong mutual interactions (De Landa 1997). Emergent properties, not present in any single element, arise through the meshing of heterogeneous elements. The free-form medium of multi-scale information composition is a meshwork, supporting the emergence of new ideas. Through overlap and juxtaposition, curators are able to mix and connect artworks in imaginative ways, exploring and discovering new understandings, interpretations, and approaches for exhibiting artworks. The sensory form of rich clippings, as material, with visual representation of artworks and details-on-demand, supports tectonic free-form assemblage into interconnected hierarchical and meshwork structures.

Information composition, as a sensory medium for authoring and exhibiting conjoint meshworks and hierarchies, becomes a convivial tool (Illich 1973), supporting free-form thinking for curator and audience. The curator can explore a space of possibilities, break away from common structures, and represent new experiences and performances with art. Audiences form their own interpretations. Stimulated by the curator's composition, but not forced into a specific path, audience members engage in their own performances, moving freely, not only up and down hierarchical structures, but across and between through meshwork connections. Each participants has their own affective experience.

The *Art of Assemblage* was the title of an exhibition at The Museum of Modern Art, in New York, in 1961, featuring works e.g. by Apolinaire, Gide, Picasso, Schwitters, Ernst, and, the originator of readymade, Marcel Duchamp (Seitz et al. 1961). Assemblage is a form for joining meshworks and hierarchies in innovative combinations. *The Digital Curated* develops a new tectonic exhibition catalogue medium, connecting form and content. Assemblage is invoked on the material not of chair caning and painting, using paste, but of clippings and contextual semantics, using position, scale, rotation and sketching.

Through the composition of rich clippings, the assemblage of this free-form medium of curation is rhizomatic. The multi-scale representation enables elements to be reproduced accurately, with great detail, enabling micro conceptual and visual assemblage, and yet combined pointillistically, at macro scales.

MoMA curator, William Seitz, wrote of assemblage as involving ordinary objects, placement, juxtaposition in, "...not only a technical procedure, ...but also a complex of attitudes and ideas" (Seitz et al. 1961). He associates with assemblage, harmony of contrary and similar elements, explanation in Gestalt psychology, an abstract aesthetic of multiple confrontation, and the syntax for a sharp break with previous modes of aesthetic coherence. Assemblage becomes an abstract method for binding elements in rhizomatic tectonics of curation.

6.7 Conclusion

Multi-scale information composition is a free-form medium for curation, which provides a tectonic representational strategy for digital arts catalogues. Eurythmic joining of elements to form a connected whole becomes a means of binding diverse artistic forms and creating new ones. The assemblage of art works, as material, to form a whole in the virtual space of the digital catalogue corresponds to how contemporary curators such as Harald Szeemann, working in physical space, become artists, using works by other artists as material, in exhibitions such as Documenta (O'Neill 2012). Multi-scale information composition enables the curator to function as tekton, in the role of poet, supporting the continuing evolution of the curator as artist.

Free-form curation is a tectonic method for the flexible joining of elements in hierarchies and meshworks. Compared to lists and grids, multi-scale information composition better conveys conceptual and sensory aspects of curated elements as material. Composition better captures the ineffable interplay between elements of an exhibition. Its rhizomatic form supports interpretation. We constructed *The Digital Curated* as an exemplar, to demonstrate how multi-scale information composition can function as a tectonic medium for the digital arts catalogue. We look forward to the potential of multi-scale information composition as a medium that engages people in new digital arts exhibition experiences.

References

Bødker S (2006) When second wave hci meets third wave challenges. In: NordiCHI. ACM, New York

Borges JL (1964) The garden of forking paths. In: Labyrinths: selected stories and other writings, vol 186. New Directions Publishing, New York

Candy L, Edmonds EA (2002) Explorations in art and technology. Springer, New York

De Landa M (1997) A thousand years of nonlinear history. Zone Books, New York

Deleuze G, Guattari F (1987) A thousand plateaus: capitalism and schizophrenia. University of Minnesota Press, Minneapolis

Eames C, Eames R (1977) Powers of ten [motion picture]. IBM, United States

Frampton K, Cava J et al (1995) Studies in tectonic culture: the poetics of construction in nineteenth and twentieth century architecture. Cambridge University Press

Giaccardi E, Karana E (2015) Foundations of materials experience: an approach for hci. In: Proceedings of the 33rd annual ACM conference on human factors in computing systems, Seoul. ACM, pp 2447–2456

Harrison S, Dourish P (1996) Re-place-ing space: the roles of place and space in collaborative systems. In: Proceedings of the 1996 ACM conference on computer supported cooperative work, Boston. ACM, pp 67–76

Illich I (1973) Tools for conviviality. World perspectives. Harper & Row. http://books.google.com/books?id=n2lEAAAAYAAJ

Interface Ecology Lab (2014) IdeaMÂCHÉ. http://ideamache.ecologylab.net/

Jones C, Muller L (2010) David Rokeby, Very Nervous System (1983-) Documentary Collection. http://www.fondation-langlois.org/html/e/page.php?NumPage=2186

Kerne A, Koh E (2007) Representing collections as compositions to support distributed creative cognition and situated creative learning. New Rev Hypermedia Multimed 13(2):135–162

Kerne A, Koh E, Smith SM, Webb A, Dworaczyk B (2008) Combinformation: mixed-initiative composition of image and text surrogates promotes information discovery. ACM Trans Inf Syst 27(1). doi:10.1145/1416950.1416955. http://doi.acm.org/10.1145/1416950.1416955

Kerne A, Smith SM, Choi H, Graeber R, Caruso D (2005) Evaluating navigational surrogate formats with divergent browsing tasks. In: Proceedings of CHI extended abstracts, Portland. ACM

Kerne A, Webb AM, Smith SM, Linder R, Lupfer N, Qu Y, Moeller J, Damaraju S (2014) Using metrics of curation to evaluate Information-based Ideation. ACM Trans Comput Hum Interact 21(3):14:1–14:48

King JC (2015) Our demand is simple: stop killing us. New York Times

Latulipe C, Wilson D, Huskey S, Word M, Carroll A, Carroll E, Gonzalez B, Singh V, Wirth M, Lottridge D (2010) Exploring the design space in technology-augmented dance. In: CHI EA. ACM. doi:10.1145/1753846.1753904. http://doi.acm.org/10.1145/1753846.1753904

Linder R, Snodgrass C, Kerne A (2014) Everyday ideation: all of my ideas are on pinterest. In: Proceedings of the CHI, Toronto, pp 2411–2420. http://dl.acm.org/citation.cfm?id=2557273

Linder R, Lupfer N, Kerne A, Webb AM, Hill C, Qu Y, Keith K, Carrasco M, Kellogg E (2015) Beyond slideware: how a free-form presentation medium stimulates free-form thinking in the classroom. In: Proceedings of the 2015 ACM SIGCHI conference on creativity and cognition, C&C '15. ACM, New York, pp 285–294. doi:10.1145/2757226.2757251. http://doi.acm.org/10.1145/2757226.2757251

Marshall CC, Shipman III FM, Coombs JH (1994) Viki: spatial hypertext supporting emergent structure. In: Proceedings of the 1994 ACM European conference on hypermedia technology, ECHT'94. ACM, New York, pp 13–23. doi:10.1145/192757.192759. http://doi.acm.org/10.1145/192757.192759

Miller PD (2004) Rhythm science. MIT, Cambridge

Museum of Modern Art (2014) The collection (medium:installation art). http://www.moma.org/collection/works?classifications=20&locale=en

Nakakoji K, Yamamoto Y, Takada S, Reeves BN (2000) Two-dimensional spatial positioning as a means for reflection in design. In: Proceedings of ACM DIS, pp 145–154. doi:http://doi.acm.org/10.1145/347642.347697. http://doi.acm.org/10.1145/347642.347697

O'Neill P (2012) The culture of curating and the curating of culture(s). MIT, Cambridge

Perlin K, Fox D (1993) Pad: an alternative approach to the computer interface. In: Proceedings of SIGGRAPH. doi:10.1145/166117.166125. http://doi.acm.org/10.1145/166117.166125

Qu Y, Kerne A, Lupfer N, Linder R, Jain A (2014) Metadata type system: integrate presentation, data models and extraction to enable exploratory browsing interfaces. In: Proceedings of the 2014 ACM SIGCHI symposium on engineering interactive computing systems, EICS '14. ACM, New York, pp 107–116. doi:10.1145/2607023.2607030

Schiphorst T (2009) Soft(n): toward a somaesthetics of touch. In: CHI EA. ACM. doi:10.1145/1520340.1520345. http://doi.acm.org/10.1145/1520340.1520345

Seitz WC, of Modern Art (New York), M, of Contemporary Arts (Tex.), DM, Museum of Modern Art SF (1961) The Art of Assemblage. Museum of Modern Art New York

Webb A, Linder R, Kerne A (2014) The digital curated. http://ideamache.ecologylab.net/v/lj3V2VT0eR/

Webb A, Linder R, Kerne A, Lupfer N, Qu Y, Poffenberger B, Revia C (2013) Promoting reflection and interpretation in education: curating rich bookmarks as information composition. In: Proceedings of C&C, Atlanta

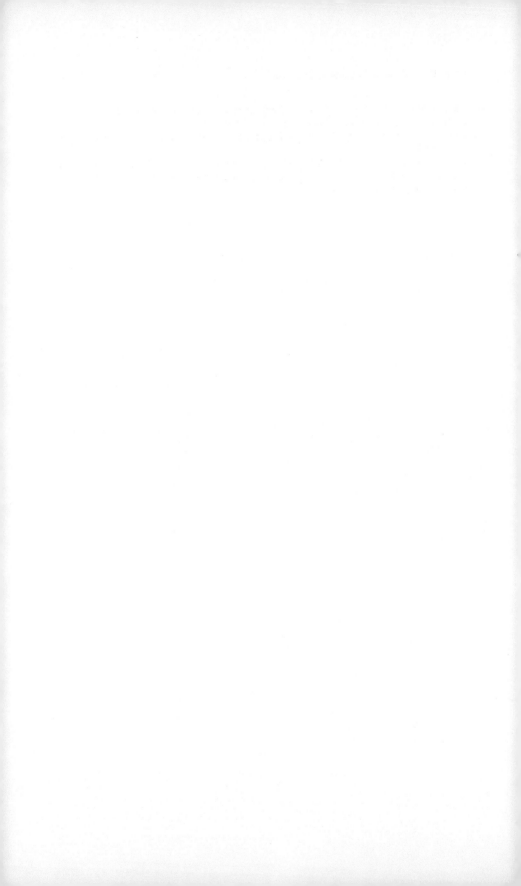

Chapter 7
ICT&ART Connect: Connecting ICT & Art Communities Project Outcomes

Camille Baker

Abstract This chapter broadly addresses the activities and revelations resulting from the author's coordination of the European Commission funded project, FET-Art from September 2013 to June 2014 as they pertain to the CHI 2014 workshop April 2014 on **Curating the Digital: Spaces for Art and Interaction** theme of "fostering collaborations between artists and technologists via Catalog". This chapter covers some of the findings and outcomes of the EU funded FET-Art project, which included performances, exhibitions, and artist-technologist matchmaking events, which led to collaborative residencies around Europe during an intensive 9-month period. These outcomes, and the author's experience in coordinating the artistic dimension of this project, were to contribute to the workshop discussion on the issues of Art-Tech collaboration for the CHI workshop. The chapter reviews the rationale and aims of the FET-Art project, its activities, the approach used to bring the artists and technologists communities together from around Europe, efforts to develop updated methods to facilitate art-tech collaborations and study them, as well as some of the outcomes of those selected and initiated during the project.

7.1 Historical Context

Art and technology collaboration is not a new phenomena, and within the last 20 years many arts organisations, and even earlier tech companies in the US and elsewhere, invited artists and technologists to work together to create a unique technology or approach, spurring innovation in both domains. Music, dance and other performance practices have been incorporating technological approaches and tools for many years, dating far back to the European Musiqe Concréte and Elektronische Musik in the 1940s, and the residency of Edgar Varese at Philips Labs in Eindhoven, the Netherlands, which led to the world famous *Poeme Electronique*. Interactions between technology and artists can also be traced to the 1950s, when such works as the 'Oscillon 40' made by Ben Laposky, who " . . . used *an*

C. Baker (✉)
School of Communication Design, University for the Creative Arts, Epsom, UK
e-mail: cbaker10@ucreative.ac.uk

© Springer International Publishing Switzerland 2016
D. England et al. (eds.), *Curating the Digital*, Springer Series
on Cultural Computing, DOI 10.1007/978-3-319-28722-5_7

oscilloscope to manipulate electronic waves that appeared on the small fluorescent screen ... displaying the wave shape of an electric signal ... constantly moving and undulating on the display ... " (Victoria & Albert museum website 2013). In the 1960s, electronic instruments began to be used to create music, for example as described in "White Heat Cold Logic: British Computer Art 1960–1980" (Brown et al. 2009).

Since then, artists have often been included in corporate R&D departments to help foster more aesthetic or cutting edge approaches to technological development, such as the artist-in-residencies with IBM with William Latham in 1990 as their artist in residence and Sony Computer Science Laboratory with Atau Tanaka as artist-in-residence (2001–2007).

7.2 Art-Tech Collaboration

Art responds to the social currents of the time, whether it is increasing mobility and globalisation, environmental issues and the search for sustainable practices, or the influence of the smartphones and devices, and tablet computing. Today the interface between technologists and artists is constantly increasing in size, scope and sophistication, and attracting practitioners from a variety of disciplines and backgrounds. The use of digital technology, new media and digital networking in artistic practice, as well as the accessibility of online knowledge creates enormous opportunities for new forms of art to emerge and for technological innovation. It also enables interaction with the public, increasingly blurring the boundaries between creators and audiences, giving rise to a significant potential for learning and engagement with the public.

The artistic landscape has been exponentially shifting around us, with Artificial Reality and Oculus Rift performances and smartphone movie editing capabilities, and other amazing developments every day. The arts have further inspired evolution of technology, forming, informing and reforming it through novel interaction and interfaces by instilling fresh and innovative design, style and imagination – as can be seen at the annual International Symposium of Electronic Art (ISEA) Exhibition, Transmediale, and Ars Electronica each year. Artists are now often included in big corporate R&D departments to act as a catalyst, to foster aesthetic, critical and unique approaches to technological innovation and development (i.e. artist in residencies mentioned above). Recent examples of this can be see at CERN and The Centre for Computational Neuroscience and Robotics, with open calls for artists by companies like Nokia and Google providing them 'free' R&D. However, tech & ICT projects seeking to collaborate with artists have not yet been widespread or have received a sufficiently high profile as they could.

There is increasingly a plethora of tools and technologies in use, or in experimental stages of development, that enhance and facilitate the creative processes for artists, either working alone or in interaction/collaboration with other developments and discourses. The tech revolution truly opened up access to a wealth of opportunities for art, driven by the emergence of inexpensive electronics, systems

and interfaces, and new devices with exciting capabilities. Technology is now an integral part of an artwork, performance, or exhibition, with artists exploring novel uses for emerging technologies, and developing ever more thrilling ways to engage with audiences.

One example is the Bristol organisation Watershed and its Pervasive Media Studio (http://www.watershed.co.uk/pmstudio/) initiatives, which supports and funds digital artists and performers, creative companies, and students to make new explorations, digital media art, and community engagement projects using pervasive devices and tools (RFID tags, QR codes, GPS or other location-based tools) to find unique methods to engage the public in digital art, performance and media.[1]

Open-source technologies development and collaboration and their accessibility have enabled more people to engage in and learn programming and electronics, to get involved in technological progress, making their own software applications and electronic devices. These communities produce and develop software tools and hardware, which have spread exponentially since Linux first became available, especially with the Creative Commons copyright (copyleft) and other such licensing methods taking more prominence (i.e. FLOSS etc.). Projects such as nuigroup (nuigroup.com) and OpenNI (openni.org) provide access to cutting edge HCI techniques, while Arduino (arduino.cc) and Processing (processing.org) allow easy creation of software and hardware, targeted towards both creative practice and education. "Maker" communities and spaces have cropped up in every neighbourhood around the world (or at least in the developed world) where engineers, programmers, artists and crafters get together, pool their resources and support each other to make new unusual projects – outside of traditional corporate and academic research environments (such as the London HackSpace, or the worldwide Dorkbot or Maker Faire communities).

Musicians, artists, software developers and technologists have been making their own open-source tools and applications for their projects and performances for many years now. Digital art and technology festivals have been sponsoring 'hack' events for a few years, for artists and technologists to meet and develop ideas, skills and projects with only their laptops or DIY electronics kits, building something together by the end of the day. These 'maker' 'crafting' or art/technology collaborations have increased innovation and enhanced and encouraged creativity, and more recently some have been supported and funded to spur more slow and traditional/ corporate approaches, thus many start-ups abound (as can be witnessed in recent years in East London, Liverpool, and elsewhere).

Organisations, events, and initiatives across Europe and worldwide have been more actively focusing on bringing the technological and Art worlds together, such iMAL, Institute for the Unstable Media — V2 in Amsterdam, Ars Electronica, ISEA, all exploring the intersection between informatics and aesthetic practice. Now there are new initiatives in universities and schools to promote more collaboration between art, science and technology, such as STEAM (Science, Technology,

[1] See also their Pervasive Media Cookbook at http://pervasivemediacookbook.com.

Engineering, Art and Mathematics) in the US and in the EU now STARTS (Science, Technology and Arts), which has potential to further develop synergies across the domains.

7.3 Fet-Art Eu Project/ICT & Art Connect

In response to the above developments, the first "ICT & ART Connect" event took place in Brussels in April 2012 under the aegis of DG CONNECT, European Commission, and co-organised by the Future and Emerging Technologies Unit, Brunel University and University College London issued a series of recommendations, including the following ones:

> *We need to study what problems art and ICT can solve together . . . Does there first have to be a convergence process between art, ICT, brain science, and psychology, whereby each discipline better understands the process and language of the other? . . . Do we need to understand better the intradisciplinary benefits of art and ICT collaborations, before going on to understand the inter- and transdisciplinary ones? . . . The element of the aesthetic in the ICT innovation process may also need more study.* (Foden 2012)

The outcomes reported from this workshop and recommendations for future directions were that the EC should take, in terms of Art and ICT (information communications technology) co-creation, included:

1. *A plea to the EU and Europe to think harder about art and ICT as complementary ways of thinking; whereby both computational and creative thinking include making models and metaphors of the world/experience that involve choosing between a range of narrative options.*
2. *To recognise that Art is generally accepted as a good vehicle for public engagement with an understanding of science and technology, and that Art often provides a holistic view of the social conflicts of science's embodiment in technology. Art helps to convert knowledge into meaning.*
3. *To understand that Artists don't like environments in which they are an afterthought, getting a pat on the back for making technology or science look pretty,; and technologists don't appreciate being brought into creative projects just as technicians. So we must think about how the revelation processes of Art making can be integrated into scientific/policy methodologies; and what the right conditions are for true co-innovation.*
4. *Together, Art & ICT can help the wider public to engage in the ethical issues around policy; and through ICT-enabled communication channels, involving participatory democracy around different artistic interpretations of choice, the public can participate and affect decision-making. But first collective tools for community management, sustainable management and broad exposure across Art & ICT need to be established.* (Foden 2012)

Other policy recommendations were:

- Explore other forms of engagement between art and ICT other than for dissemination purposes only;
- Establish areas of research in ICT where stronger involvement of artists could be synergetic. Three candidates: Creativity, Social innovation, Global Systems science.

- Develop a rationale and operational steps to include artists more prominently in these areas.
- Plan an annual series of workshops in the spirit of ICT & ART CONNECT;
- Consider an organisational structure to facilitate interaction of artists within ICT projects ('in-project artists');
- Explore other forms of CONNECT engagement with art than for dissemination purposes only (for instance co-creation, public engagement with ICT) (Foden 2012).

This event and its outcomes confirmed for the EC, that a great potential to become more involved in fostering the on-going dialogue between technology and art practitioners. It highlighted that is was of import to efficiently and urgently support this dialogue, ahead of the big changes in the way that the EU funds research projects, through the newly implemented Horizon 2020 funding mandate. This dialogue could then contribute to the development of future emerging technologies topics, and how new emerging research areas are identified for funding, being developed by the European Commission.

Thus, to follow this landmark event of 2012, the 1-year EU funded project called FET-Art[2] starting in mid-2013, stemming from the ICT & ART CONNECT event, was intended as a catalyst to connect European technology and artistic communities, and foster productive dialogue, engagement, and collaborative to demonstrate the synergies and how each can contribute to 'a new Europe'. The core objectives were to consult with the art and technology communities in the European Union, identify associated challenges and impacts of art and technology collaboration: on tech innovation, artistic development, education and society in general, and to develop new research avenues and directives as a result of the project (which was left open and undefined).

It was acknowledged that there were already a great number of organisations and individuals in Europe and worldwide successfully addressing these topics and bringing the two cultures together to create new works. Initiatives and studies across various EU countries demonstrated that art and technology collaboration and initiates were moving up the agenda of future research and innovation. The FET-Art project, and its many pan-European activities, aimed to act as a spark to overcome fragmentation, to attempt to merge the two communities to create a critical mass of professionals connecting art[3] and technology activities, in order to push these initiatives to the next level.

In this context, the FET-Art partners from 3 UK countries (UK, Netherlands and France) developed the FET-ART project, to build on recommendations listed from the first 2012 event.

[2]More on the project can be found on its website here http://www.ict-art-connect.eu.

[3]"Art" for this project was broadly defined to include all modern and traditional art and performances practices, including fine art, video, dance and music, well as new media such as digital art and bio-art.

7.4 Activities of Fet-Art/Ict & Art Connect

The FET-Art project was comprised of a balanced partnership of committed organisations offering expertise in technology and art domains, important connections with technology and art practitioners in Europe and worldwide were made, many at the intersection of technology and art, with longstanding experience. This partnership is composed of Sigma Orionis (coordinator), Brunel University, Stichting Waag Society, Stromatolite and BCC. It would not be possible without the hard work and collaboration of all the partners, who include The Black Cube Collective – emerging artist support organisation in Edinburgh; Sigma Orionis – Project Management in Nantes; Stichting Waag Society – internationally well-respected institute for art, science and technology in Amsterdam; Stromatolite and London-based design innovation company responsible for the well-known MusicTechFest and Brunel University, well-known for its Engineering history and namesake Isambard Kingdom Brunel, as well as other academic performance and technology pioneers such as Stelarc and Johannes Birringer (Fig. 7.1).

The FET-Art project has, in its short life, brought together art and technology communities across Europe in order to foster productive dialogue on art-technology co-creation and collaborative work. The project had an all-inclusive approach to collaboration, crossing the full breadth of the fields of art and technology; from traditional and visual arts, to digital media, music, sound and design; and equally across all technology and science practices.

Fig. 7.1 ICT 2013 – FET-Art/ICT & Art Connect promotional stand

The aims were inspired from the April 2012 event to:

1. Move technology and art intersection/interaction from the broad frame of Digital Humanities, or the domain of Creative Industries, toward more specific and direct impact beyond business and society;
2. Encourage technology/ICT specialists to work with artists, on an equal basis, on EU and other funded project initiatives – to show the ICT community the value artists will bring to their activities;
3. Help organisations and companies to consider new organisational structures to facilitate interaction of artists with ICT projects ('in-project artists') and to develop operational schemes to include artists in funded projects.

The main project events took place in Nantes, France, Brussels, London (twice), Edinburgh, Amsterdam and Barcelona over a 9-month period. Each event was organised differently, some included Hackathons or fast project prototyping, to ignite partnerships, while others focused on demonstrating current successful art/tech projects, while discussing the issues and problems of art/tech collaboration more deeply. The activities of each event were interpreted differently by each partner, and included:

1. Consultation with experts, as well as art and technology practitioners themselves, on past art-tech collaborations and issues;
2. Matchmaking activities to bring art and technology practitioners together to create new, more informed collaboration proposals for our residency activities;
3. Selected collaboration pairings as case studies, to try out a new project ideas, to study, analyse, and report back to the EU; three to four per partner of 1 day (hackathon-style) to 3 month residencies each (Fig. 7.2).

Fig. 7.2 ICT 2013 – FET-Art/ICT & Art Connect promotional stand

7.5 Consultation Process and Outcomes

The goal of the consultation aspect of the activities was to highlight the under-discussed topic of collaboration experiences and interactions between artists and technology professionals (good and bad), either with those within their profession or across disciplines, to glean recommendations for future collaboration process approaches.

One of the main aims of the events, branded as *ICT & Art Connect*, were to both seek and document consultation with experts and with the arts and ICT technology practitioners themselves on the issues and process of collaboration. Experts consulted have included some of our partner members, such as Waag Society, with many years of such residency and co-creation facilitation in the Netherlands. However, an active effort has been made to find outside, objective experts from other European and international institutions and organisations, who have experts within them who have witnessed, researched and/or otherwise facilitated and nurtured numerous art and technology collaborations. Some of those that were invited to speak and to get involved in our events and residency proposal selection include:

- **Lindy Candy**, co-founder of the Creativity and Cognition conference, and leader of the relevant art/technology collaboration research project from the late 1990s to early 2000s in England called COSTART.
- **Christiane Paul**, long-time new media curator in both Europe and the US, Director of the Media Studies Graduate Programs and Associate Professor of Media Studies at The New School, NY.
- **Ruth Catlow** and **Marc Garrett** – Furtherfield – a non profit arts organisation, founded in 1997 and sustained by the work of a community of artists, technologists- academics- thinkers and doers.
- **Ghislaine Boddington** – director of Body>Data>Space – a London based org dedicated to Performing Arts and TECHNOLOGY creation, research and collaboration for over 15 years.
- **Honor Harger** – A curator from New Zealand who has a particular interest in science and technology. She joined Lighthouse in March 2010 as Director, and became Artistic Director on 1 February 2013 (Fig. 7.3).[4]

The advice and input from some of these experts on collaborative process and facilitation between artists and technologist was invaluable and shaped the project's residency analysis framework, but also we fed the overall policy recommendations back to the European Commission. The main threads from the experts were: collaborators needed to be clear about the goals of the shared project and what type of collaborator they wanted to work with, to agree in advance to the starting points, conditions, materials, approaches and context of the projects, to trust each other,

[4]More experts can be found on the website http://ict-art-connect.eu.

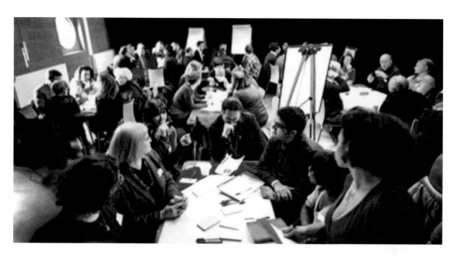

Fig. 7.3 FET-Art/ICT & Art Connect London event January 2014, at the Watermans Art Centre

respect each other's skills, create separate roles and work to fulfill them, teach and learn from each other, and to communicate regularly.

From the UK consultation events, with art and tech participants discussing previous cross-collaboration experiences, the some concerns seemed to come up again and again:

- Communication is very important – often this is a lack of clear communication and goals;
- Trust is critical to collaboration;
- Ego can often get in the way between collaborators and each should come with a more open mind about what can happen in the project rather than preconceived ideas;
- Collaborators need to be equals on all levels and there need to be common motivators for the project;
- Translation is required across disciplines as the same words can mean different things in each discipline;
- People need to "learn" how to collaborate;
- There are differences in expectations of timing/flexibility between collaborators, etc.

Some recommendations from consultation participants on future funding for art and technology/ICT collaborations to the European Commission (primarily from the January 2013 consultation session in London), included:

- **More diversified funding (across disciplines)** – primarily since much funding in Europe has been cut in arts especially in the UK, the new Creative Europe funding puts much of its emphasis on the creative industries and larger endeavours, rather than individual artist development, and much research funding is focused on science, engineering, manufacturing and technology, not creative projects;

- **Sustainable, centralised platforms for distribution of open source tools** – so that artists and technologist know where to go to find tools to work together with in collaboration;
- **Involvement of artists in projects of any discipline as a rule** – meaning having more emphasis and mechanisms to bring artists into a range of research and other big collaborative projects as creative catalysts, no matter what the subject or problem being solved;
- **A matchmaking database of interdisciplinary collaborators** – there are a multitude or databases, especially for EU funded projects, but there are not easy to find and often duplicate each other; this point was to make one central and well designed and promoted matchmaking tool to bring collaborators together for interdisciplinary activities;
- **Distributed collaborative spaces around Europe** to be visited and used by artists and technologists from Europe, with access to technologies (these spaces could be newly created ones or existing ones in universities and labs and be obliged to share them);
- **More transparency about or new standards for evaluating proposals** (more access to decision makers/making) – this was based on the fact that all funding agencies in Europe seem to use different standards and evaluating methods, which makes it hard for artists and innovators or any sort to know what the criteria is or how they are being evaluated, as well as very cumbersome and lengthy application processes.

The aim of the consultations was to feed into the collaborative residencies in phase 2 to help direct and guide them in a more productive way and a model, based on expert advice, for all future collaborative interactions and approaches. However, with such a short time frame imposed by the EC project coordinator, much of these recommendations went directly into policy recommendations for the EC future funding initiatives.

The lessons learned against the goals and the initial recommendations for the project were that such a project needs much more time to plan and thoroughly develop methodologies and processes to create collaborative encounters and engagement over the long term – our goals were ambitious and made good impact but need longer development. We were able to initiate very exciting activities but were not given enough time or resources to support those activities to full fruition. We also did not have enough time allocated to the mentoring process and our efforts were really just an ignition to a much longer, ongoing process needed to continue the art-tech connection. The initial recommendations from the first workshop still stand.

7.6 Matchmaking Process Selection

The matchmaking activities usually took place separately from and/or after the consultation and other activities (such as the performance activities of the London events). This approach was intended to enable participants to discuss views with

Fig. 7.4 FET-Art/ICT & Art Connect Barcelona, February 2014

each and socialise together first, so as to "pre-match" or connect with possible collaborators to suss each other out prior to potentially partnering with them (Fig. 7.4).

During the actual matchmaking activity (based on the speed-networking model of corporate networking events) the goal was to give each person a sampling of the people, expertise and projects available to possibly partner on. After all have met each other they are asked to find the people whose ideas they liked the most and would like to work with and start to discuss the project idea a bit further. All were then guided through the proposal requirements and told of the deadline and sent away to try to develop a proposal together for the next deadline. In the first round, we only had a few proposals, but as the project aims and vision spread and more events took place to bring people together to meet, each round has received more proposals. Unfortunately, since the project was only 9-months, the momentum began, but only three deadlines were possible to administer.

7.7 Residency Methods and Monitoring

The second phase of the project included taking the proposals from the art and technology pairings from the matchmaking activities and from the project's online matchmaking tool and selecting collaborators for the residencies. A residency was defined as a period of collaborative work bringing together an ICT scientist/technologist and an artist over a period of time (between 1 and 4 weeks). 'Pop Up Pairings' were developed as a way to define certain special events that some

partners wanted to use as their residency opportunities and took the form of short, intense, collaborative partnerships lasting up to 24 h or 'hackathons'. There was a separate application process for these through the specific events.

An external independent expert panel reviewed and elected the best proposals, and then each consortium partner took three to four of the projects from all three selection rounds onto the residency stage. Each partner hosted and facilitated the selected parings for between 1 day and 3 months (depending on whether it was a hackathon or a longer residency), and funded the pair to work together intensely over the chosen timeframe, either at one of the project partner locations or within the work space of one of the collaborators. Each host partner provided mentoring support for all residencies, in order to provide expert guidance in the facilitation of the collaborative working process. The assigned mentor from each host partner addressed any and all concerns or needs by collaborators, and a weekly meeting between the mentor and the pair was advised and provided to aid in monitoring, but also to discuss progress and any issues or concerns.

A pairing consisted of two or more collaborative participants, with at least one taking the role of technology specialist partner and at least one taking the role of artist partner. It was recognised that in some cases the boundaries may already be blurred in terms of roles and disciplinary boundaries, so participants are asked to self-define their role and to provide evidence of their ability to fulfill their chosen role. Residencies were arranged on a case-by-case basis to support the needs, working practices, and time schedules/commitments of those involved. Artists' studios or working space provided by one of the consortium members, if available, and the residency may be focused on that space (Fig. 7.5).

Fig. 7.5 FET-Art/ICT & Art Connect Hackathon NEM 2013 Nantes

During each residency, participants were asked to complete two surveys, one prior to the start of the residency 'pairing' and one after the completion of the residency. These were designed to capture participants' hopes and fears about the collaboration at the start, and garner their reflection on the process, and then capture their perception of the outcomes at the end. Background data about the participants' is also captured, as well as the nature of their working environment, and the outcomes and their future plans (if any). Both interviews and surveys are intended to capture different aspects of the collaboration: interviews are for the host mentor to objectively understand the collaboration process and for research and documentation purposes, and in-person interviews determine the personality types and suitability for the pairing, on a personal level. The survey is intended to capture the subjective perspective of the tasks and content of the pairing and residency.

Each of these pairings was considered a case study to understand the different styles, processes and methods of collaborating between artists and technologists, and the framework for analysis will be based on the expert advice and research from our experts, such as Lindy Candy, Ghislaine Boddington and Ruth Catlow, toward further research by other 'sister' projects to follow on from after the end of this project. The results of each pairing were analysed in terms of the overall collaborative processes, communication, and overall interaction, which were then fed back to the EU via policy recommendations for future funding initiatives (Fig. 7.6).

At the end of the project, there was an exhibition and performances of the case study collaborations and a presentation in European Parliament of the

Fig. 7.6 Selected FET-ART Residencies – 19 in total see at http://www.ict-art-connect.eu/residencies/

recommendations made by the project from the consultation, matchmaking and case study collaborative projects. Each of the residencies became part of the final showcase at the Fo.Am artist centre in Brussels, and the members of each presented in European Parliament the same weekend at the end of May 2014. Most continued their collaborations and went onto show or get further funding for their work elsewhere.

The final outcomes, in terms of impact from the FET-Art project on the EC funding remains to be seen, however it is clear from this project and the follow-up ICT&Art Connect Study project that, while it is important not to instrumentalise artists for the sole purpose of catalysing technology innovation for business and industry alone, this role already exists and some artists readily take it on. These artists should however continue to be supported for their part and quest to make their influence felt and in some ways paving the way for other artists to access such support, but digital artists who wish to make art for it's own sake should equally be supported and rewarded for their role in reflecting back social issues and concerns, as well creating meaning and beauty in the world through their artworks.

A follow up tender for a research study was funded, called ICT-Art Connect Study, started in April 2014 to December 2014, with a separate consortium (this author was an advisory board member for that project) intended to map and provide success stories of art and technology collaboration activities around Europe, and their impacts on innovation and business in Europe.[5] However, additional research needs to be directed toward creating new guidelines and training on the art-technology collaboration process, methods and facilitation. This research could guide and feed into future European Commission research and innovation projects and research funding policies and other European Arts and Technology funding bodies. The ultimate goal would then be the blurring of disciplinary boundaries or merging them for a more productive, exciting collaborative future. Such an initiative called STARTS appears to have started in June 2015, but at the point of this writing it is very early days for this initiative.

7.8 ACM CHI Workshop: Curating the Digital

In relation to the art/artists <-> curating <-> interaction design triad of the ACM CHI workshop, the FET-Art project highlighted for the author the following issues:

1. The on-going challenge of fostering successful collaborations between artists and technologists – and in the case of the workshop – via the Catalog;

[5]The final report for this follow up study can be found here http://www.ictartconnect.eu/files/ ICTARTCONECT.study%20brochure.pdf; or more on that study can be found on their website here http://www.ictartconnect.eu/.

2. How curating digital artworks in this context is not always only about how to present great art, or innovative technological solutions, but also to find participants who truly and equally embrace collaboration and the collaborative process, by empowering and engaging both artists and technologists for further success;

3. Many times technologists come to the table to work with artists who are themselves already also artists or have a deep interest in art practice. Thus, reaching the wider technology industrial, academic, and hobbyist communities is much harder for such cross-disciplinary collaborations, and reaching a broader group is more likely in the CHI context, however to reaching the wider public to share the value of technological art, in terms of influencing technological innovation and to the wider public – is a much harder task, not to mention demonstrating the value of tech art in and of itself;

4. The resulting FET-Art case study projects and the study of their collaborative processes was not about just creating new artworks, but had a larger agenda: to inform the FET (future emerging technologies) division of the DG-CONNECT branch of the EC funding agency of the importance of creating calls that include the artistic community, and of the value their contributions to make technological development and social change, which that development has contributed to. This may add value to the CHI workshop outcomes, in terms of how to reach the higher level decision makers, when it comes to funding and fostering future art-tech collaborative work within and outside the CHI community, as well as the upcoming Art.CHI, the catalogue that was discussed and planned out and future workshops and exhibitions at CHI and elsewhere.

5. The CHI: Curating the Digital workshop itself focused on three areas of presentation: print, innovative digital approaches on site, as well as an online catalogue. These presentation formats are intriguing and perhaps critical to engage the HCI community who attend CHI, but the larger issues of 'form over content' still need addressing – focus for future live and online CHI digital artworks and galleries should attempt to make sure works shown demonstrate three key areas of quality: conceptual, artistic and technological and not only focus on works that might have flashy 'interface or interaction design' that might excite HCI audiences, but actually contributes meaningfully to the digital arts field, and might also embrace collaboration across disciplines, contributing equally to digital art and to industry participants. Technological/digital artworks need to also be curated in such a way as to demonstrate to CHI attendees and HCI experts the fundamental role that these types of works play in not only making novel interactivity or coding and hardware design, but in critically challenging viewers/ interactors to think about how technology is developing, its role in society and how it impacts our lives – for good or ill – as well as to demonstrate innovative and beautiful interfaces and solutions to user experience problems, to used in business, education, culture and society.

Bibliography

Ahmed SU, Camerano C, Fortuna L, Frasca M, Jaccheri L (2009) Information technology and art: concepts and state of the practice, Handbook of multimedia for digital entertainment and arts, pp 567–592. Available online at http://prosjekt.idi.ntnu.no/sart/publications/BChapter2_ IT&Art.pdf. Accessed 10 Jan 2013

Boddington G (2014) Art & ICT – presentation at ICT & Art Connect East event, February 2014, Ravensbourne University. Available online at http://www.ict-art-connect.eu/about/resources/ ict-art-connect-london-eastcentral/. Accessed 17 Mar 2014

Candy L (2014) Collaborative creativity: learning from art and technology experience and research, presentation at ICT & Art Connect West event, Jan 2014, Watermans Art Centre, Brentford (Greater London). Available online at http://www.ict-art-connect.eu/about/resources/ict-art-connect-west-london/. Accessed 17 Mar 2014

Candy L, Edmonds E (2002a) Modeling co-creativity in art and technology. In: Proceedings of the 4th conference on creativity & cognition, pp 134–141, ACM. Available online at http://dl.acm.org/ft_gateway.cfm?id=581731&type=pdf&CFID=168552758&CFTOKEN= 86563620. Accessed 5 Apr 2012. See also Candy's other research here http://research. it.uts.edu.au/creative/eae/candy/LCandyPubsMar08.htm and conferences here http://www. creativityandcognition.com/research/themes/

Candy L, Edmonds E (2002b) "Explorations in Creativity and Cognition" Chap. 5, practice. In: Explorations in art and technology, XVI, Springer-Verlag, Berlin, pp 69–83. Available online at http://www.springer.com/978-1-85233-545-8. Accessed 5 Apr 2012

Candy L, Zhang Y (2007) A communicative behaviour analysis of art-technology collaboration. In: A communicative behaviour analysis of art-technology collaboration: human interface, Part II, HCII 2007, LNCS 4558, Springer-Verlag, Berlin, pp 212–221

Catlow R (2014) Don't just do it yourself do it with others – presentation at ICT & Art Connect East event, Feb 2014, Ravensbourne University. Available online at http://www.ict-art-connect. eu/about/resources/ict-art-connect-london-eastcentral/. Accessed 17 Mar 2014

Kidd P (2013) ICT-ART CONNECT in the horizon 2020 ICT programme: preliminary reflections on realising the potential, final report on the roundtable discussion held at the European Parliament, Brussels, 11 Nov 2013. Available online at http://ictart.artshare.pt/ICT-ART_ CONNECT_EP_Rountable_Discussion_Report_Final.pdf. Accessed 25 Feb 2014

Kresin F, Reitenbach M, Rennen E, van Dijk D, Wildevuur S (eds.) (2011) Users as designers: a hands-on approach to creative research, Waag Society. Available online at http://Waag.org/ sites/Waag/files/public/Publicaties/Users_as_Designers.pdf. Accessed 10 Jan 2013

Leggett M (2006) Interdisciplinary collaboration and practice-based research. In: Converg: Int J Res New Media Technol. 12: 263 Available online at http://con.sagepub.com/content/12/3/ 263. Accessed 5 Apr 2012

Miller AI (2000) Insights of a genius. Imagery and creativity in science and art. The MIT Press, London

Perello J, Murray-Rust D, Nowak A, Bishop SR (2012) Linking science and arts: Intimate science, shared spaces and living experiment. Eur Phys J Spec Top 214:597–634

Shanken EA (2002) Art in the information age: technology and conceptual art. Leonardo 35(4). The MIT Press, Cambridge, MA, pp 433–438 http://artexetra.files.wordpress.com/2009/02/ shankenartinfoage.pdf. Retrieved 10 Jan 2013

Turney J (2006) Engaging science: thoughts, deeds, analysis and actions. Wellcome Trust, London. Available online at: http://www.wellcome.ac.uk/stellent/groups/corporatesite/@msh_ publishing_group/documents/web_document/wtx033010.pdf. Accessed 10 Jan 2013

Wilson S (2010) Art + science now: how scientific research and technological innovation are becoming key to 21st-century aesthetics. Thames & Hudson, London

References

Brown P et al (2009) White heat cold logic: British computer Art 1960–1980 (Leonardo Book Series) Available online at: http://mitpress.mit.edu/books/white-heat-cold-logic. Accessed Apr 2013

Candy L, Edmonds E (2003) Collaborative expertise for creative technology design. In: Proceedings of the 5th conference on creativity & cognition, Australia. Available online at http://research.it.uts.edu.au/creative/COSTART/pdfFiles/Expert03.pdf. Accessed 5 Apr 2012

Foden G (2012) ICT and art connect: engaging dialogues in art and information technologies. DG INFSO, European Commission, Brussels. Available online at http://www.euclidnetwork.eu/files/artandictreport.pdf. Accessed 10 Jan 2013

Victoria & Albert museum website. Available online at: http://www.vam.ac.uk/content/articles/a/computer-art-history/. Accessed Apr 2013

Chapter 8
Interactivity and User Engagement in Art Presentation Interfaces

Jeni Maleshkova, Matthew Purver, Tim Weyrich, and Peter W. McOwan

Abstract In spite of the rapid technological development in the field of digital image processing and communication, the dominant way of presenting works of visual art virtually is still based on more traditional methods. These are commonly related to the 'white cube' exhibition space, which is a popular way of displaying art in museums. Most of the attempts to introduce modern technologies in the digital presentation of visual art are based on the approach of recreating the conventional real environment using realistically rendered two- or three-dimensional computer models. Such forms of presentation fail to take full advantage of the new opportunities, offered by modern digital technologies. In this chapter, we examine through quantitative studies how interactivity in virtual environments can contribute towards visual art presentation. More precisely, we investigate how four interactivity modes through which images of visual art are presented, relate to the different phases of user engagement. The results from our studies indicate that more interactivity in an interactive application contributes towards higher user engagement with the presented content and the application itself.

8.1 Introduction

Recent technological developments have drastically changed the way in which media can be created and presented. Sounds, videos and even 3D animations can be recorded and projected in a multitude of ways, creating almost limitless options for combining and mixing individual media sources in order to produce complex installations. Similarly, the decreasing size of media hardware components enables the almost ubiquitous creation and presentation of music, images and videos. All

J. Maleshkova (✉) • M. Purver • P.W. McOwan
Cognitive Science Research Group, Electronic Engineering and Computer Science,
Queen Mary University of London, London, UK
e-mail: j.maleshkova@qmul.ac.uk; m.purver@qmul.ac.uk; p.mcowan@qmul.ac.uk

T. Weyrich
Virtual Environments and Computer Graphics Research Group, Department of Computer
Science, University College London, London, UK
e-mail: t.weyrich@ucl.ac.uk

© Springer International Publishing Switzerland 2016
D. England et al. (eds.), *Curating the Digital*, Springer Series
on Cultural Computing, DOI 10.1007/978-3-319-28722-5_8

107

these possibilities, in combination with the World Wide Web as a communication platform, present limitless possibilities for the display of artworks and media installations, enabling not only the outreach to a large audience but also providing the basis for interactive engagement with the user.

Only until recently, the traditional view for art and media presentation was guided by commonly accepted and fixed stereotypes. The artists of the twentieth century were used to having white spaces as an exhibition surrounding and this environment was taken as a given, without offering many options for changing or adjusting it in accordance with the presented artwork. Similarly, modern art museums are designed and conceptualised in such way that the inner space offered very few options for adjustments and tailoring to the particular artist's need. The exhibition space was usually taken as a given and then filled with artwork following mainly practical guidelines. Recent developments, especially in the context of visual arts presentation, break drastically with this tradition, enforcing the acceptance of the belief that an exhibition space should be designed for multiple and diverse purposes and it should not be narrowed down to any specific kind of art. Furthermore, it becomes even more evident that there is no specific rule for art presentation. This trend is supported by recent technology developments, which provides the tools and flexibility needed to design and realise multimedia exhibitions.

As a result, the innovation potential in the context of media presentation and exhibition spaces design is very high. In addition, increasingly more visitors like to experience interactive features in an exhibition (Haywood and Cairns 2006). The viewer of interactive exhibitions is no longer invited to only stand and observe, but to participate in the art exploration or even creation. In terms of liveness and performance, Sheridan (2006) distinguish between 'witting' and 'unwitting' spectators. 'Witting' audience members are understood as those who interpret the performers actions as a performance, while 'unwitting' bystanders are the people who may observe the performers' actions but do not interpret them as a performance.

Despite the increased need new technologies for presentation of visual artworks in interactive virtual environments are facing a number of limitations. Moreover, it is still quite unclear to what extent user engagement is influenced by the type of interaction provided by a digital technology application. Our assumption is that more interaction will result in increased user engagement throughout its different phases. This hypothesis has been tested in the studies described below.

8.2 Interactivity and User Engagement in the Context of Virtual Presentation of Visual Artworks

It is not our intent that the virtual space looks and feels like the real world, which the majority of the current applications are aiming to achieve, but rather provide an escape from reality, offering the option to view things differently through an interactive and engaging way of viewing art. Therefore, we want to offer a different

experience from that the user has in a common exhibition space. Additionally, we want to provide a framework that helps to evaluate to what extent the user is engaged during the interaction with an artwork presented through different interactivity modes. As basis for our experimental work we will discuss first the theoretical foundations around it. We will define the term interactivity broadly and then specifically in the context of art applications. Further, we define user engagement and its different phases in the context of interactive art and applications.

8.2.1 Interactivity in Human-Computer Interaction

In the research area of Human-Computer Interaction (HCI), interactivity does not have only one coherent description but has been a subject of interest to many researchers for the past 20 years. One of the first to specify interactivity is Sheizaf Rafaeli. He defines it as "an expression of the extent that in a given series of communication exchanges, any third (or later) transmission (or message) is related to the degree to which previous exchanges referred to even earlier transmissions" (Rafaeli 1988). Interactivity is usually understood as the user's physical input towards a machine, e.g. moving a PC mouse and gaining a response from the computer (Murray 1997). Sims (1997) defines interactivity on an operational level as the function of input that is required by the user while responding with the computer and the nature of the system's response to the input action. Steuer goes a step further by taking in consideration the time factor of the system's response to the user's input. He describes interactivity as the degree to which users of a medium can influence the form or content of the mediated environments in real time (Steuer 1992). Though, there is no description provided to the kind of response the system should give in order to have meaningful interaction. Another definition describes interactivity as the ability to respond to changing conditions, when the changes in conditions are determined by the user's input (Ryan 2001). Ryan also claims that an interactive system can be only appreciated fully after the user has made a significant emotional and intellectual investment. Joiner (1998) distinguishes between a game, which represents an interactive digital environment, and a less interactive system like a video recording device. He believes that a more interactive system adapts better to the actions of the user. The term interactive experience has been defined as the process of actively involving the participant in a physical, intellectual, emotional and even social manner (Adams and Moussouri 2002). Rokeby (1998) sees interaction also as an active form of engagement. According to Hall (2004), conversation as well as communication are based on the premise to have a common language; in other words – in order for the human to successfully interact with the machine or a system there should be an input and a feedback understood by both parties. Therefore, without feedback there is no interaction. That way feedback is a core part of a system's design. Hall's understanding overlaps with the well-established Norman's interactive system design guidelines, including providing feedback as well as making things visible, making clear how actions are

to be carried out, have clear affordances, give a natural mapping, and have clear constraints for object manipulation (Norman 1988).

In a broader context we can define the interaction by describing the *interaction model* (structure, hierarchy, data format etc.) and the *interaction tasks* (e.g. travel, select, manipulate etc.) Each of these tasks can be completed by using different interface devices and various interaction techniques (press button, perform gesture, pronounce voice command etc.).

8.2.2 Types of Interactivity

In the literature focusing on interaction in HCI, researchers have been dealing with the taxonomy of the topic. Rhodes and Azbell (1985) and later Sims (1997) identify three levels of interactivity: reactive, coactive and proactive. Here under reactive level is understood that the user has little control over the system, where in the next coactive level there is some level of control for sequence, place and style of the system. In the highest level, the proactive one, the user gains control over the system's structure and content. Jonassen (1988) on the other hand, distinguishes between five levels of interactivity focusing on the user's involvement with the application. These levels include modality of the user's response, the nature of the task, the level of processing, the type of program and the level of intelligence in design. In the context of narratives and computer games, Ryan (2001) differentiates between internal vs. external and exploratory vs. ontological interaction. The users are playing in first person mode or identify themselves as an avatar in the internal interactivity type. In the external interactivity the player has the role of a 'god' in the virtual world, where he can manipulate and change the environment. The other pair of interactivity refers to the free ability of the user to navigate around the virtual world, while in the exploratory form of interaction there are no changes on the plot of the game from the user's interaction, in contrast to the ontological mode where the player's decisions determine the change of the narrative. Kaur (1998) classifies three models of interactivity in virtual environments: task-based (describing purposeful behaviour in planning and carrying out specific action as part of the user's task), explore/navigate (describing opportunistic and less goal-directed user's behaviour) and system initiative (describing reactive behaviour to system events, and to the system taking control from the user).

The three general types of interactivity can be analysed in greater detail by creating classification schemes for each of them. An approach for the tasks of the *manipulative* interactivity is proposed by Bowman and Hodges (1999). It consists of two steps: first – a task analysis is performed and using hierarchic decomposition the task considered is subdivided into subtasks, which can be represented in several levels; and second – for each of the subtasks at the lowest level the corresponding possible techniques for accomplishing this task are specified. Since our manipulative task is designed as a fairly simple one (see Sect. 8.3), the two steps

are not prominent. However, future more complex tasks can benefit from Bowman's framework in order for them to be developed in a way that is meaningful for both the user and the designer.

Applying the same procedure, corresponding classification schemes can be created for the *explorative* and *contributive* interactivity. Using the example of explorative interactivity the tasks of navigation, visual information browsing and measurement can be identified. Each task on this level can be decomposed into subtasks: for example the task of navigation can be divided into the subcategories 'travel' (movement in the space) and 'way finding' (this is the cognitive component of navigation where decision about the current location in space, the desired target and the approach how to move to the target have to be determined). By analogy a similar classification scheme for the tasks and subtasks of *contributive* interactivity can be created.

Finally, Pares and Pares (2001) and subsequently Roussou (2006) distinguish between three general types of interactivity: *explorative* – referring to the ability of the user to navigate freely in the virtual environment, *manipulative* – addressing the ability of the user to manipulate objects within the virtual environment and *contributive* – stating the ability of the user to alter the environment itself, either in form or functionality. Many classification schemes, e.g. Bowman et al. (2001), Bowman (2005), introduce a fourth type of interactivity: *system control*, used to change the system state or the mode of interaction. Usually, this type of interaction can be accomplished by applying techniques from the other three interaction types (e.g. by executing tasks of the manipulative interactivity to chose and invoke the required command to the system). System control interactivity plays a secondary role in our studies; this research will therefore focus on Pares and Pares' definition of interactivity as well as adopt the understanding of the three interaction levels: *explorative*, *manipulative* and *contributive*. We have adapted Pares and Pares (2001) understanding of interactivity and their three types of modality *explore*, *manipulate* and *contribute*.

8.2.3 Interactive Art Systems

Cornock and Edmonds's (1973) gave one of the earliest classifications of interactive art, providing four categories:

1. The static system – it refers to any unchanging work of art and includes most traditional art works. The individual is simply a spectator, who just observes with no interaction or influence on the artwork.
2. The dynamic-passive system – it changes in response to time or external environmental factors. The individual has no influence on the system and is defined as a spectator.
3. The dynamic-interactive system – it alters in response to the individual. It is now the individual who can influence the system and is referred to as a participant. A feedback loop is established.

4. The dynamic-interactive system (varying) – it is a special case of a system where 'an artist modifies the system or process in a way not allowed for in its original definition.'

This classification of interactive art systems provides a framework that is well suited for describing the co-relation between the user and the application. We go a step further by looking into the interactivity modes and their contribution towards user engagement. The next section gives an overview of the taxonomy of user engagement in the context of interactive applications.

8.2.4 User Engagement

There are a few other areas of research relevant to our work, where user engagement has been studied. The most explored area is the one of market research and user behaviour. Engagement has been also analysed in computer game design and linked closely to immersion and being in the state of flow (Csikszentmihalyi 1990). The most relevant to our work area, where user engagement has been looked at, is the area of interactive art installations, performance and audience engagement. Here, the two most significant works done are by Bilda et al. (2008) and Latulipe et al. (2011). Latulipe et al. state that engagement is related to attention and interest, and although it is often associated with positive valence, it is possible that the audience can be interested with negative valence as well. The definition of engagement is closely impacting the technology used for measuring it. Latulipe et al. are distinguishing between measuring engagement explicitly: with post-performance surveys, focus groups and audience interviews; and implicitly: with common physiological measures that can be used to measure implicit engagement biometrically, such as GSR, heart rate, blood pressure and respiration.

Another substantial research in the area of user engagement with technology, in more general terms, is done by O'Brien and Toms (2008). They refer to engagement as positive characteristics that are synonymous with quality of user experience in interaction and gameplay.

In the literature about engagement from the 1990s, (Chapman 1997; Chapman et al. 1999) defines user engagement as "something that draws us in; that attracts and holds our attention". Laurel (1993) emphasizes playfulness and sensory integration in engagement, which she also refers to as a first-person experience. Quesenbery (2003) proposed that engagement is a dimension of usability, and is influenced by users' first impression of an application and the enjoyment they derive from using it. Multiple studies of engagement have described it according to different characteristics, such as media presentation, perceived user control, choice, challenge, feedback, and variety (Jacques et al. 1995; Said 2004; Webster and Ho 1997; Chapman 1997; Chapman et al. 1999).

Bilda et al. (2006) define three primary features in an interactive artwork towards user engagement. The first one is *attractors*; these are features which encourage

the user to initially notice the system. They have so called attraction power. Bollo and Dal Pozzolo (2005) describe attractors thus: 'in a busy public place there are many distractions, so the attractor acts as a showstopper and aims to grab peoples first attention'. The attractor is an important feature of the interactive art system that is inclined to cause the passing audience to pay attention to the work and at least approach it. This is obviously a crucial factor in enabling an interactive experience to even have a chance of happening.

The second stage towards user engagement Bilda et al. (2006) call *sustainers*, which are attributes that keep the audience engaged during an initial encounter. These have holding power and create museum hot spots, in Bollo and Dal Pozzolo's (2005) terms. Sustainers refer to short-term engagement.

On the other hand, *relaters* are aspects of the interactive art system that help a continuing relationship to grow so that the audience returns to the work on future occasions. Relaters address features in the interactive art system, which contribute towards long-term user engagement.

The key to understanding interactive experience and engagement according to Edmonds et al. (2006) is to learn about people's intentions in performing certain actions and how they make sense of their experience and outcomes of their actions. Audiences have various intentions and motives for acting in a certain way, although their interaction behaviour often looks similar (Edmonds et al. 2006).

A participant's intention (in performing an action) can be identified from two different perspectives. First, the participant's specific purpose (fun, pleasure, curiosity, accomplishment etc.) in performing the action. Second, the outcome or goal the participant has, where they expect an action, which will result in a specific response or outcome by the system. Whilst the first perspective is related to personal experience, the second perspective is more about the participant's expectations of the system. In most areas of HCI and computation, whether an action is successful or unsuccessful depends on whether the intended result is achieved: for example, clicking on the play button will be a successful action if it plays the video. However, for understanding the experiences with an artwork, whether an action is deemed to be successful or not may not be an appropriate measure of success (Bilda et al. 2008).

We will adopt the understanding that engagement consists of several engagement phases and is closely linked to the initial user interest and the ability to keep that interest in short and long terms of interaction.

8.3 Presentation of Visual Art Through Four Different Interactivity Modes Towards User Engagement

Our previous investigations (Maleshkova et al. 2013; Maleshkova and Purver 2014) indicate that more interactivity in an application aids towards a more enjoyable experience, which contributes towards increased user engagement. We can also note that navigation and the task definition in an application can contribute significantly or hinder the intuitive interaction with the application as a whole. Further, we have

tested an interactive application presenting visual art in a real-world scenario at the Victoria and Albert Museum in London. We have rated user engagement by looking at the categories: body posture of the participants, hand movement and face expression. Our findings indicate that measuring user engagement is a non-trivial task, which needs careful consideration. In pursuit of reliable conclusions we designed a study where we are investigating how users relate and behave with an interactive application. In the study presented below, we go a step further and examine what type of interactivity more specifically aids towards user engagement. As described, we have adopted Pares and Pares (2001) understanding of interactivity and their three types: *explore, manipulate* and *contribute*. In addition to these modes we have included the passive user task *observe*, where the user does not perform any type of interactivity but looking at the system. Six paintings of famous artists are presented through those four interactivity modes. The design description of the interactivity modes is given below:

- *Observe* – video looping the images of the six paintings in 5 s slots.
- *Explore* – presentation of the six paintings in a virtual galley context with enabled simple navigation through first-person controller (Fig. 8.1).
- *Manipulate* – presentation of the six paintings in a virtual gallery, where one (or more) paintings can be manipulated by dragging out elements of the paining. To make this task universal, it can be argued that all paintings can be reduced to few simple key shapes, which can be manipulated in the way as shown below on Fig. 8.2.
- *Contribute* – presentation of the six paintings in a virtual galley, where the user can choose a colour and change the background and the surrounding of the paintings (Fig. 8.3).

The interactivity tasks developed are as follows:

- *Observe*: Look at the following paintings;
- *Explore*: Navigate through the virtual gallery using the mouse and the arrow buttons;
- *Manipulate*: Extrude elements of the painting by pressing 'play' and using the mouse cursor to drag-out elements of the painting. You can navigate with the arrow buttons and the mouse.
- *Contribute*: Add to the environment of the paintings by changing the colour of the walls by using the pallets on the left. You can navigate with the arrow buttons and the mouse.

All tasks are designed as open-ended ones. The user chooses when to quit or go to the next task.

8.3.1 Field Study

In the experiment conducted in this study and described below, the following three interactivity modes were compared and tested: *observation* (no interaction),

Fig. 8.1 Presentation of the paintings in the *explore* mode

Fig. 8.2 Display of the paintings in the *manipulative* mode

explorative interaction (enabled navigation) and *manipulative* interaction (game-like task). Thirty-six visitors took part in this field study. The content presented in all three interactivity modes is the same: a virtual gallery displaying six paintings of well-known artists.

The experiment setup is presented in Fig. 8.4. All participants in the experiment are visitors to a real-world social event. They have been attracted by the experiment

Fig. 8.3 Display of the paintings in the *contributive* mode

Fig. 8.4 Experiment setup comparing the interactivity modes: *observe*, *explore* and *manipulate*

setup and asked to execute the corresponding tasks, so that as consequence they can be considered as representatives of the general public. Each interactivity mode is implemented and exposed to the participants on a separate system as a small computer game using a common game engine. In interactivity mode *observe* the task is only to watch the paintings, while in interactivity mode *explore* the user has to walk around the virtual scene and discover the exposed paintings.

Each participant's behaviour is videotaped and analysed. Using the recorded time code, the duration of the period that each participant has spent working in particular interactivity mode (Mode1-Observe, Mode2-Explore, Mode3-Manipulate)

is calculated and stored and used as dependent variable in the statistical analysis performed afterwards. When coming to the experiment setup each participant has to make a decision about which system to approach first. This choice is left to the participant and is not controlled during the experiment, assuming that the selection of the first and the consecutive systems to work with is done in random manner. On the other hand, the system that is first approached can be considered as an *attractor*, those having the biggest attraction power and grabbing people's first attention (Bilda et al. 2008). Even though the variable *attracted-by* (presented in nominal scale with three levels: System1 – Observe, System2 – Explore, System3 – Manipulate) is not manipulated on purpose during the experiment, it can be considered to have the role of secondary independent variable rather than those of a control variable and its influence on the dependent variable can be analysed applying statistical methods.

8.3.2 Statistical Analysis

The primary independent variable is the interactivity mode (presented in nominal scale with three levels: Mode1- Observe, Mode2 – Explore, Mode3 – Manipulate), while the observed dependent variable is the time a user spends working in each interactivity mode, which is used as indication of the user's short term engagement defined by Bilda et al. (2008) and Edmonds (2006) as *sustainers*. The dependent variable *time* is presented in a ratio scale. The following two hypotheses are considered and tested:

H_0 = all means of the populations of the dependent variable *time*, registered by the three different levels of the independent variable *interactivity_mode* (Mode1-Observe, Mode2-Explore, Mode3-Manipulate) are equal. This would denote that the interactivity mode does not cause any statistically significant difference in the time spent working in a particular interactivity mode that would indicate no difference in the *sustainers*.

H_1 = the alternative hypothesis – the opposite of H_0, meaning that there is a statistically significant difference between the time spent working in each interactivity mode, that indicates difference in the *sustainers*.

The influence of the primary factor *interactivity_mode* can be checked applying the one-way ANOVA (ANAlysis Of VAriances) method (Lind et al. 2014). The statistical analysis is performed using the *R* software for statistical computing (Navarro 2013) and the graphical user interface known as the R-commander (Fox 2005). The results from the one-way ANOVA are presented in Table 8.1 and shown as graphics in Fig. 8.5. The error bars at each mean value denote the standard error (SE) of the mean.

This result shows that the null hypothesis (H_0) can be rejected (p-value = 0.003, denoting that a Type I error rate of 0.3 % is acceptable for the rejection of H_0). This means that the hypothesis H_1 is retained: there is a statistically significant

Table 8.1 One-way ANOVA results

	Degree of freedom	Sum of squares	Mean square	F value	Pr(>F) p-value	Sign
Interactivity_mode	2	30,945	15,472	6.401	0.00302	*
Residuals	60	145,023	2417			

Significance: '*' 0.01

Fig. 8.5 Graphs of the means of the primary factor interactivity_mode computed by the One-way ANOVA method. The results show that the means have different values with relatively small standard error what indicates difference between time spent working in each interactivity mode leading to difference in the sustainers

difference between the time spent working in each interactivity mode, which indicates a difference in the *sustainers*. The plot of means confirms the conclusion of the ANOVA test, namely that the three samples originate from populations with different means having relatively small standard error. It is important to mention that when the null hypothesis (H_0) is rejected by the one-way ANOVA test, we receive only the information that the three means are not equal without any indication which group differs to which other one. In order to analyse the later issue paired t-tests with each combination of any two levels for the factor *interactivity_mode* have been performed, e.g. three t-tests for the combinations: Mode1-Observe vs. Mode2-Explore, Mode1-Observe vs. Mode3-Manipulate and Mode2-Explore vs. Mode3-Manipulate. All three t-tests produce results indicating rejection of the null hypothesis (H_0), leading to the conclusion that all three means differ from

each other. However, the result from the paired t-test: Mode1-Observe vs. Mode2-Explore has to be considered carefully because the p-value is very close to the significance level of 5 % (p = 0.0485) and it is quite likely to have Type I error, e.g. the null hypothesis for this particular case to be retained.

We can also investigate the assumption that the *sustainers* represented and measured in the experiment described above through the variable *time*, are depended not only on the interactivity mode, but are also related to the type of the application, which has attracted the user. Following this hypothesis we can analyse the behaviour of the dependent variable *time* in terms of both factors *interactivity_mode* and *attracted_by* simultaneously, applying the two-way ANOVA test. Most packages for statistical analysis require having equal number of observations in each group. This condition is not fulfilled for the data registered during this experiment (leading to the so called unbalanced design) and can be hardly satisfied because the participants are not forced to test compulsory every of the three systems implementing each of the three different interactivity modes under consideration. In contrast the R package implements a method for calculating two-way ANOVA statistics also for unbalanced design (Type II tests). The results are presented on Table 8.2 and shown as graphics on Fig. 8.6. These results can be considered as confirmation that the factor *interactivity_mode* has a statistically significant effect on the time spent working with each system, indicating a difference in the *sustainers*, while the factor *attracted_by* does not show a considerable effect on *sustainers*.

8.3.3 Summary and Future Work

From the experimental study presented, we can draw the conclusion that there is a statistically significant difference between the time spent interacting with the system in manipulative mode, in comparison to the two other types of interactivity tested (observe and explore). This leads us to say that potentially when the user is given the choice between several interactivity modes, they would prefer a game-task approach of interaction and presentation of visual art content. The findings from this study may be applied in the design process of interactive art installations

Table 8.2 Two-way ANOVA results

	Sum of squares	Degree of freedom	F value	Pr(>F) p-value	Sign
Attracted_by	659	2	0.1286	0.879599	
Interactivity_mode	26,335	2	5.1409	0.009042	*
Attracted_by: interactivity_mode	6051	4	0.5906	0.670854	
Residuals	138,313	54			

Significance: '*' 0.01

Plot of Means

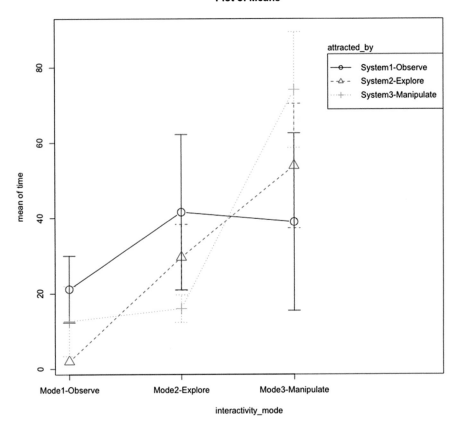

Fig. 8.6 Graphs of the means considering both factors interactivity_mode and attracted_by simultaneously, computed by the Two-way ANOVA method. The results confirm the conclusion that the factor interactivity_mode has a statistically significant effect on the time spent working in each interactivity mode, indicating a difference in the sustainers, while the factor attracted_by does not show a considerable effect on sustainers

and virtual presentations of visual content. We acknowledge that 'time spent' does not necessarily always relate to an increased user engagement, thus some other reasons can prolong the experience with the application, e.g. not being able to figure out how to start or complete the interactivity task. Our findings relate to the specific application we have developed. However, it can be assumed that this research provides the possibilities for an application generalization to other virtual environment applications. We discuss this potential in future work.

We would like to draw from the study presented here and examine a further type of interactivity, *contributive*, in comparison to the other modes, which was beyond the tasks of the current study. A further step in our research is to

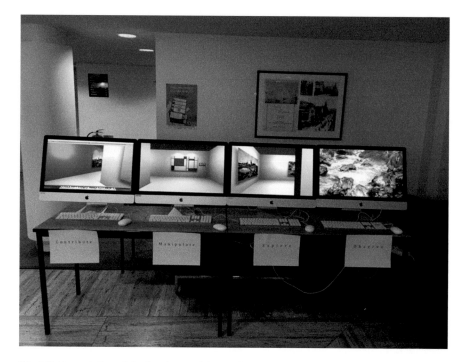

Fig. 8.7 Presentation of the four interactivity modes

investigate the relationship between the different types of interactivity implemented in an application and the level of successful communication of the visual content (Fig. 8.7).

8.4 Conclusions

This research aims to explore the influence of different types of interactivity on user engagement and communication related to presentation of visual artworks. In general: the more interactivity in an application, the more engaging and attractive the application appears to the user. We can also note that navigation and the task definition in an application can contribute significantly or hinder the intuitive interaction with the application as a whole. When the user is given the choice between several interactivity modes, our investigations have shown that they prefer to spend more time when a game-like task approach of interaction and presentation of visual art content is applied, which could be interpreted as indication of increased engagement. The findings from this study can be applied in the design process of interactive art installations creating guidelines for development of interactive applications for presentation of visual artworks.

References

Adams M, Moussouri T (2002) "The interactive experience: linking research & practice". Web publication of keynote address at the Interactive Learning in Museums of Art & Design: an International Conference. Victoria & Albert Museum, London, http://media.vam.ac.uk/media/documents/legacy_documents/file_upload/5748_file.pdf

Bilda Z, Costello B, Amitani S (2006) Collaborative analysis framework for evaluating interactive art experience. CoDesign 2(4):238–255

Bilda Z, Edmonds E, Candy L (2008) Designing for creative engagement. Des Stud 29(6):525–540

Bollo A, Dal Pozzolo L (2005) Analysis of visitor behaviour inside the Museum: an empirical study. Proceedings of the 8th International Conference on Arts and Cultural Management

Bowman DA (2005) 3D User interfaces. Theory and practice. Addison-Wesley Professional

Bowman DA, Hodges L (1999) Formalizing the design, evaluation, and application of interaction techniques for immersive virtual environments. J Vis Lang Comput 10(1):37–53

Bowman DA, Johnson D, Hodges L (2001) Testbed evaluation of immersive virtual environments. Presence: Teleop Virt Environ 10:75–95

Chapman P (1997) Models of engagement: intrinsically motivated interaction with multimedia learning software. Unpublished master's thesis. University of Waterloo, Waterloo

Chapman P, Selvarajah S, Webster J (1999) Engagement in multimedia training systems. In Proceedings of the 32nd Hawaii International Conference on System Sciences pp. 1084. Washington, DC: IEEE

Cornock S, Edmonds E (1973) The creative process where the artist is amplified or superseded by the computer. Leonardo 6(1):11–16

Edmonds EA, Muller L, Connell M (2006) On creative engagement. Vis Commun 5(3):307–322

Edmonds, E.A., Muller, L. and Connell, M. (2006) On Creative Engagement. Visual Communication, 5(3). 307–322.

Fox J (2005) The R Commander: a basic-statistics graphical user interface to R. Journal of Statistical Software, vol 14, Issue 9

Hall S (2004) Telling old stories new ways: using technology to create interactive learning experiences. Technical report. Smithsonian Center for Education and Museum Studies, Washington, DC

Haywood N, Cairns P (2006) Engagement with an interactive Museum exhibit. People and computers XIX – the bigger picture. Proceedings of HCI 2005. Springer-Verlag London Limited, pp 113–129

Jacques R, Preece J, Carey T (1995) Engagement as a design concept for multimedia. Can J Educ Commun 24(1):49–59

Joiner R (1998) Gender, task scenarios and children's computer-based problem solving. Educ Psychol 18(3):327–340

Jonassen DH (1988) Instructional designs for microcomputer courseware. Lawrence Erlbaum, Hillsdale

Kaur K (1998) Designing virtual environments for usability

Latulipe C, Carroll E, Lottridge D (2011) Love, hate, arousal and engagement: exploring audience responses to performing arts, Proceeding CHI '11 Proceedings of the SIGCHI Conference on Human Factors in Computing Systems, pp. 1845–1854

Laurel B (1993) Computers as theatre, vol 2. Addison-Wesley, Reading, pp 214–219, Conference on Multimedia

Lind DA, Marchal WG, Wathen SA (2014) Statistical techniques in business and economics. McGraw-Hill, New York

Maleshkova J, Purver M ((2014) Beyond the white cube: presentation of visual art in interactive 3D environments. In: Electronic Visualisation and the Arts (EVA): proceedings of EVA London 2014. BCS Learning, Swindon

Maleshkova J, Purver M, Grau O, Pansiot J (2013) Presentation and communication of artworks in an interactive virtual environment. Poster, in ACM SIGGRAPH Asia, Hong Kong

Murray J (1997) Hamlet on the holodeck: the future of narrative in cyberspace. The Free Press, New York

Navarro D (2013) Learning statistics with R., http://ua.edu.au/ccs/teaching/lsr

Norman D (1988) The design of everyday things. Basic Books, New York

O'Brien H, Toms E (2008) What is user engagement? A conceptual framework for defining user engagement with technology. J Am Soc Inf Sci Technol 59(6):938–955

Pares N, Pares R (2001) Interaction-driven virtual reality application design. A particular case: El Ball del Fanalet or lightpools. Presence: Teleop Virt Environ 10(2):236–245

Quesenbery W (2003) Dimensions of usability: defining the conversation, driving the process. In: Proceedings of the UPA 2003 conference, 23–27 June

Rafaeli S (1988) Interactivity: from new media to communication, Sage annual review of communication research: advancing communication science, vol 16. Sage, Beverly Hills, pp 110–134

Rhodes D, Azbell J (1985) Designing interactive video instruction professionally. Train Dev J 39(12):31–33

Rokeby D (1998) The construction of experience: interface as content. In: Dodsworth C (ed) Digital illusion: entertaining the future with high technology. ACM Press, New York, pp 27–47

Roussou M (2006) Interactivity and learning: examining primary school children's activity within virtual environments. PhD Thesis, pp 1–282

Ryan ML (2001) Beyond myth and metaphor – the case of narrative in digital media, published. In: Game studies – the international journal of computer game research, vol 1, Issue 1, July 2001; presented as a paper at the Computer Games & Digital Textualities conference in Copenhagen, Denmark

Said N (2004) An engaging multimedia design model. In Proceedings of the 2004, Conference on Interaction Design and Children. ACM, New York, pp 169–172

Sheridan JG (2006) Digital live art: mediating wittingness in playful arenas, PhD thesis, Lancaster University, UK

Sims R (1997) Interactivity: a forgotten art? Comput Hum Behav 13(2):157–180

Steuer J (1992) Defining virtual reality: dimension determining telepresence. J Commun 42(4):73–93

Webster J, Ho H (1997) Audience engagement in multimedia presentations. Database Adv Inf Syst 28(2):63–77

Chapter 9
Investigating Design and Evaluation Guidelines for Interactive Presentation of Visual Art

Jeni Maleshkova, Matthew Purver, Tim Weyrich, and Peter W. McOwan

Abstract Many of current applications for digital art presentation are built by creating a virtual environment, which aims to mimic the look and feel of a common real world exhibition space. Such attempts to imitate existing spaces are more or less unsuccessful and do not support the imagination of the user, nor do they provide an opportunity for a different experience from that in the real-world. Furthermore, presentation environment affects the art perception. Specifically designed exhibition spaces and interactive elements can aid and enhance the viewer's experience. The design, form and colour of the artwork's environment can influence the impact that it has on the viewer, especially in digital art presentation. A major role in how paintings are perceived in a virtual environment is played by not only the exhibited surrounding but also the interaction enabled within the application. What type of interaction contributes towards user engagement with the content presented and the application itself? How does interactivity aid digital art display and what types of interactivity are better suited for presentation of visual content? What types of paintings are most suitable to be presented in a virtual exhibition space? These are some of the questions raised and discussed in this chapter. Through two qualitative studies, we investigate how four different interactivity modes can aid towards user engagement and its different phases. Design guidelines for the virtual exhibition space are gathered as well as a list of suggested improvements for the interactivity tasks in the different modes. Moreover, the experts that took part in both focus group studies agreed with our proposed extended framework on user engagement with its different phases and the suggested metrics for their evaluation.

J. Maleshkova (✉) • M. Purver • P.W. McOwan
Cognitive Science Research Group, Electronic Engineering and Computer Science,
Queen Mary University of London, London, UK
e-mail: j.maleshkova@qmul.ac.uk; m.purver@qmul.ac.uk; p.mcowan@qmul.ac.uk

T. Weyrich
Virtual Environments and Computer Graphics Research Group, Department of Computer
Science, University College London, London, UK
e-mail: t.weyrich@ucl.ac.uk

© Springer International Publishing Switzerland 2016
D. England et al. (eds.), *Curating the Digital*, Springer Series
on Cultural Computing, DOI 10.1007/978-3-319-28722-5_9

9.1 Introduction

The presentation of art to a broad audience began with the Parisian salons in the late baroque period. In these salons paintings were displayed on the whole wall without any concept of placement and just following the rule – large paintings on the top, small ones on the bottom. Later on in the nineteenth century artworks were usually presented only on eye level. Since the twentieth century the ideal room for exhibiting visual art is believed to not overwhelm the artwork and it should be as simple as possible (O'Doherty 1986). There are no exact rules how a painting or a sculpture should be presented, although curators usually stick to certain well-established display patterns. Furthermore, it is very common for the artist himself to take over a few of the curatorial tasks in the process of creating an exhibition.

Still, the use of new technologies in the field of art presentation gives artist and curators numerous exciting opportunities. "New media art presents the opportunity for a complete rethink of curatorial practice, from how art is legitimated and how museum departments are founded to how curators engage with the production of artwork and how they set about the many tasks within the process of showing that art to an audience" (Graham and Cook 2010).

As a result, the innovation potential in the context of media presentation and exhibition spaces design is very high. Whereas the presentation environment can manipulate the impact that an artwork has on the viewer, a custom-designed space and interactive elements can increase the viewer's experience. In the context of employing new technologies for art display, Virtual Reality and the possibilities it offers can be very beneficial. Furthermore, these can be mirrored in the form of 3D interactive features for the Web, which can be used for presentation of art as well.

In this context, we are aiming to contribute towards escaping from the common space for art presentation by creating a virtual application that benefits from the used technology and augments the presented artwork by offering an interactive and enhanced audience experience. Our intent is to offer a different experience from that the user has in a common exhibition space. Additionally, we analyse not only how visual art is best displayed in virtual exhibition spaces but also how the user perceives and interacts with the selected and presented paintings. For the purpose of our investigations an interactive online application was developed where users can view the same visual information presented through four different interactivity modes. We aim to stimulate the viewer to step out of the role of passive spectator, to become an active participant and engage with the presented visual content as well as with the interactivity mode.

9.2 Types of Interactivity Tested Towards User Engagement

In the chapter "Interactive presentations of visual artworks – a quantitative investigation towards user engagement" we have presented in detail the background and definition to interactivity and user engagement along with the differentiation of its

phases. Thus, the mentioned chapter provides an extended theoretical foundation to this chapter. However, a summary of the theoretical background used is given below.

9.2.1 Interactivity

In short, our understanding of interactivity draws on the three general types identified by Pares and Pares (2001) and subsequently Roussou (2006). These are: *explorative* – referring to the ability of the user to navigate freely in the virtual environment, *manipulative* – addressing the ability of the user to manipulate objects within the virtual environment and *contributive* – stating the ability of the user to alter the environment itself, either in form or functionality. Since the norm of presenting visual content online or in virtual environments is through still images, we have also introduced the *observe* mode, where there is no active interaction but to view the presented visual content.

9.2.2 User Engagement

In terms of user engagement and its prominent phases, we draw from Bilda et al. (2006) separation of *attractors, sustainers* and *relaters*. The attractors have the so- called 'attraction power' (Bollo Dal Pozzolo 2005), these are features of the interactive system that encourage the user to notice the application in the first place. The *sustainers* represent the second stage of the interaction process. There are attributes that hold the user throughout engaged in the process and have the ability to maintain the short-term engagement process flowing. The last phase are the so called *relaters*, which are the factors of the interactive art system that aid towards long-term user engagement, where the relationship with the system grows even after the immediate interaction and the audience returns to the work on future occasions.

Another substantial research in the area of user engagement with technology is done by O'Brien et al. (2008). They refer to engagement as positive characteristics that are synonymous with quality of user experience in interaction and gameplay. Additionally, they distinguish between point of engagement, engagement, dis-engagement and eventually sometimes re-engagement.

9.2.3 The Interactive Application

The chapter "Interactive presentations of visual artworks – a quantitative investigation towards user engagement" presents and analyses a quantitative field study, whereas here we focus on the qualitative investigation of the four different types of interactivity towards user engagement. In the previous study we gave the option to the visitors to choose to interact with one of the modes that were presented

Fig. 9.1 Display of the four interactivity modes (*observe, explore, manipulate, contribute*) on a desktop screen where the user can choose and run through the four interactivity modes sequentially

on different machines. In this lab-based study, we give the participants the same option, but on one machine. The application tested provides the same interactivity mode options as in the previous study (*observe, explore, manipulate, contribute*). However, this time all modes are given on one screen at the same time, with the option to choose one interactivity mode first and then come back to the main page and continue interacting with the other modes (Fig. 9.1). It is important for the design of the experiment and the forthcoming measurements to mention that all interactivity tasks are implemented as open-ended tasks, in which the user can determine themselves when the interaction comes to an end. The tasks for the interactivity mode are stated as follows:

Observe: Look at the following paintings;
Explore: Navigate through the virtual gallery using the mouse and the arrow buttons;
Manipulate: Extrude elements of the painting by pressing 'play' and using the mouse cursor to drag-out elements of the painting. You can navigate with the arrow buttons and the mouse.
Contribute: Add to the environment of the paintings by changing the colour of the walls by using the pallets on the left. You can navigate with the arrow buttons and the mouse.

The interaction enabled in the four modes is described below.

9.2.4 The Observe Mode

In the observe mode (Fig. 9.2) the user can view the six paintings as simple still images. As most common digital art presentations, in this case there is no active interaction with the visual content but just to observe and perceive the images.

Fig. 9.2 In the *observe* mode the user can view the paintings as still images without any interaction

Fig. 9.3 In the *explore* mode the user can navigate trough a virtual gallery using first-person controller, popular from game engines

9.2.5 Explore Mode

In the explore mode the six paintings are presented in a virtual environment, where a first-person controller navigation is enabled. The user can move left, right, forwards and backwards using the arrow keys on the keyboard, rotate in 360° or tilt up or down using the hand mouse (Fig. 9.3).

Fig. 9.4 In the *manipulate* mode the user can manipulate elements of the painting by extruding them forwards

9.2.6 Manipulate Mode

The enabled interaction in the manipulative mode, is slightly more advanced than in the explore mode. The user can navigate the same way as in the explore mode, with the additional option to manipulate elements of a painting by extruding parts of it forwards (Fig. 9.4).

9.2.7 Contribute Mode

The contribute mode goes a step further by allowing the user to add to the surrounding of the paintings by altering the colours of the wall in the exhibition space (Fig. 9.5).

9.3 Proposed Extended Framework for Evaluation of User Engagement

In addition to Bilda et al. (2008) and O'Brien and Toms (2008) phases of user engagement and based on the observations from our previous studies (Maleshkova and Purver 2014), we propose two additional steps – '*Figure Out*' and '*Breaking*

Fig. 9.5 In the *contribute* mode the user can contribute towards the presentation environment by changing the colours of the walls

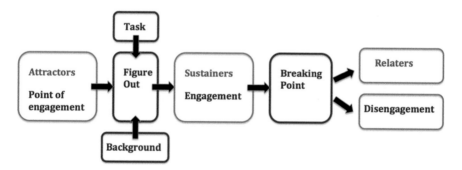

Fig. 9.6 Diagram of the extended user engagement framework displaying Bilda et al. attributes (*text marked in dark green*) and O'Brien engagement phases (*marked in purple*). We propose two more phases – 'figure-out' and 'breaking point' (*text marked in read*)

Point' (Fig. 9.6), which serve as intermediate binding blocks, linking the phases introduced by researchers in previous publications. Under '*Figure-out*' we understand the phase in the engagement process with an interactive application, when the user has already understood the tools for interaction and knows how to proceed with the task. On the other hand, the '*Breaking Point*' refers to the stage of engagement when the user is facing the decision to continue interacting with another mode or quit the whole process (Fig. 9.6).

The user's *background* is considered as a factor affecting the '*Figure-out*' phase. Under *background* we understand the user's personal traits such as interest in art,

technology skill sets and motivation. The *background* factor can also be seen as a reason for the initial attraction (attractors/point of engagement) with the system.

9.4 The Qualitative Study

For this qualitative investigation two focus groups were put together, involving experts from the field of digital art, art curation and digital technology. Using the application that incorporates the four interactivity modes, the experts were consulted in the evaluation metrics of the different types of interactivity towards the phases of user engagement. In addition, we were seeking the experts' opinion about the proposed extended framework for evaluating user engagement. Furthermore, expert feedback was gathered on what type of visual art would be more suitable to be displayed through an interactive application.

9.4.1 Study Outline

Both focus group studies had the same organisation and were divided into three parts. In the first part, the experts were asked questions about art presentation and interactivity. In the second part of the study, the participants interacted with the application described in Sect. 9.2, after which they completed a short survey about the presented visual content. The third part of the study was in the form of a discussion, through which feedback was gathered on the proposed evaluation framework and its metrics (Fig. 9.6). Additionally, the participants are asked to elaborate on their over all experience with the application and the different interactivity modes. Both focus groups were audio and video recorded.

Part I of the Study

The first part of the study gathers qualitative data about the experts' understanding about digital art presentation through interactive applications as well as their definition about engagement and evaluation measurement suggestions. The questions asked were:

1. *What is your most recent experience with an art gallery?*
2. *What are the best ways to present visual art digitally?*
3. *Considering user experience with web gallery applications, how would you define engagement?*
4. *Continuing on in the context of virtual galleries on the web, are there activities that you find most engaging?*

5. *In the context of web based digital galleries, what elements do you find least engaging?*
6. *How do you evaluate the engagement of a web based digital gallery?*

Part II of the Study

In the second part of the study a short presentation by the researcher was given, describing the proposed extended framework for measuring user engagement (Fig. 9.6). After the presentation, the experts were asked to interact with the tested application individually. Depending on their preference and expertise, the experts completed a short multiple-choice survey by choosing overall 5 paintings out of 20 (choosing five times 1 painting out of 4). The five paintings were picked according to their suitability to be presented through an interactive application.

Part III of the Study

The last part of the study was in the form of a group discussion where the experts were asked questions about the evaluation framework and the presented content.
Questions about evaluating user engagement:

1. *During the work with the application have you recognised the described engagement phases?*
2. *Which phase was more dominant?*
3. *Do you agree with the proposed evaluation metrics for each engagement phase?*
4. *How else would you measure the engagement phases?*
5. *Can you propose changes in the task descriptions, which would better represent the various interactivity modes?*

Questions about the presentation of visual content:

1. *Why did you choose these five paintings?*
2. *Which painting style and composition type is most suitable for interactive digital presentation?*
3. *Which paining style would not be suitable for interactive digital presentation and why?*
4. *Do you think these paintings have similar first attraction power?*

Concluding Question:

5. *Would you like to add something related to the extended framework that has not been addressed?*

The expected outcomes from this study are to determine the content that is going to be presented, but more importantly to gather expert feedback on the proposed user engagement evaluation metrics.

Fig. 9.7 Participants in the first focus group study

9.4.2 Outcomes from the First Focus Group Study

The experts that took part in the study were (Fig. 9.7):

- Irini Papadimitriou, Digital Programmes Manager, V&A and Head of New Media Arts Development Watermans
- Carl Smith, Senior Research Fellow (Creativity and Learning Technologies) at the London Metropolitan University
- Francesca Guerrera, Researcher at Ravensbourne: Learning Technologies Research Center (LTRC)

Part I of the First Focus Group Study

The main outcomes from the discussion can be summarised as follows:

Trends

There is a trend within big museums to upgrade their exhibitions and make them more interactive (on- and offline). Especially in large-scale museums, guided tours that highlight the well-known artefacts from a collection, give the visitor a much better understanding of the whole exhibition. In order not to overwhelm the user, an approach of 'less is more' should be followed in the curation process. Further, it is important to provide an exhibition space, which guides the visitors without constraining them.

Presentation Space

In virtual worlds such as *Second Life*, the design of the space and the laws of interaction most often mirror what we are used to from the real world, without taking the full advantages of the virtual medium and its possibilities. Avatars look and behave like we are used to from the real world; virtual buildings mirror the standards and the architecture from reality as well. The virtual media offer many more options that are not possible to be done in the real world, so there should not be a constraint in the presentation to what we know from the real world. Overall, the virtual world should not recreate the real one.

Content vs. Context

Ideally, the space should aid towards the understanding of the context and the history behind the artefacts. The exhibition space should set the context and contribute towards a better understanding of the history behind the presented artefacts. Overall, it is not so much about the content any more but about the context, and the user experience provided. Thus, in the future the focus should be targeted more towards the engineering of the context and being able to augment the user's perception. Then the user's own perception will become the content. There is a lot of already existing content. Thus, the future aim of designers and curators should be on creating a valuable perception with the content, rather than on developing more and more new artefacts. Museums nowadays are aiming, especially with the help of technology, to bring the content to the user in an approachable and interesting manner. However, most digital representations of visual art are in the form of simple images. It is evident that there is a lack of prominent good online examples of interactive digital art presentations.

Part II of the First Focus Group Study

In this part of the study, the experts were asked to individually interact with the desktop application (Fig. 9.8). Although the various interactivity modes were displayed at different positions on the screen (Fig. 9.1) each time the desktop application was loaded, all three experts chose to interact with the *observe* mode first. Their behaviour was explained later in the discussion with the fact that the *observe* mode was understood as the most basic mode of interaction and was considered the one mode that does not requires any pre-skills or knowledge, as assumed it would have been necessary for the other interactivity modes. Also, the *observe* mode was seen as a way that prepares the user and gives them some kind of knowledge before the further interaction in the other modes.

The *manipulate* mode was highlighted as a novel way of interacting, while the *explore* mode, enabling a simple walk-through, was considered as very common and not particularly interesting. The interactive feature of zooming-in closely and having a different view of the artwork was appreciated and pointed out as a positive

Fig. 9.8 Participants in the first focus group testing the desktop application featuring all four interactivity modes

Fig. 9.9 Discussing the proposed extended evaluation framework in the first focus group study

option. The changing of the wall colours in the *contribute* mode was accepted as an intriguing feature. However, it was indicated that it would have been better to enable the additional option to change the actual colours of the paintings, too. The modes *observe*, *explore*, *manipulate* and *contribute*, were accepted in this order as intuitive increased interactivity.

Part III of the First Focus Group Study

The last part of the study was in the form of a group discussion where the experts were asked questions concerning the evaluation framework and the presented content (Fig. 9.9).

The experts were able to recognize the different stages of engagement: *attract*, *sustain*, *relate*, as well as the proposed additional ones – *'find-out'* and *'breaking point'* of engagement. The *'breaking point'* was considered as the point where the experts felt that there was nothing else to do in the interactivity mode. One of the experts *'figure-out'* was referred to as the phase where the user finds out what kind of interactivity is possible to be done and what is the expected user behaviour. Also, the *'figure-out'* and the *'breaking point'* are closely related to one another, since if the *'figure-out'* phase is not accomplished or does not happen as such, then it is immediately followed up by the *'breaking point'* phase. For example, when one of the experts was not able to find where the 'play' button was in the manipulative mode, they stopped the interaction with the whole mode.

9.4.3 Outcomes from the Second Focus Group Study

In the second group study two digital artists took part (Fig. 9.10).

- Julie Freeman, an artist whose work spans visual, audio and digital art forms and explores the relationship between science, nature and how humans interact with it.
- Fabio Lattanzi Antinori, an artist working across a range of media including sculpture, print and interactive installations, whose work examines the language of power and control of corporate systems and its effect on the belief systems of the individual.

Fig. 9.10 Participants in the second focus group study

Part I of the Second Focus Group Study

In the first part of the study the different methods of physical and virtual art presentation were discussed in general. The main outcomes are given below:

Presentation Space

For better perception, video-based artworks are usually displayed in dark rooms with no natural light. Some kind of an eye-catching art piece is commonly displayed at the entrance of an exhibition space to gather the visitors' initial attention. Good examples of interactive artworks were considered those which make the user forget about the 'real world' and have very short learning curve for the user to understand the purpose and the interaction tool of the artwork. The user should not feel the need to get used to the system in order to interact with it fully. The digital 3D representation of space is usually hard to believe and can disturb the actual viewing of the art presented in it.

Physical vs. Digital Art Presentation

The use of digital headsets as an art medium tool or for the presentation of art digitally can be very immersive. However, many virtual reality examples using headsets like the *Oculus Rift* focus much more on the technology itself than the presented content.

Going into a physical art exhibition space and looking at an artwork online are two very different experiences. There are a lot of contextual and social attributes that go along with visiting a gallery. The experience of going to a physical art gallery is accompanied by smells, sounds, other visitors, and also things like having a cup of tea, going to the gift shop, meeting with a friend etc. When the art is presented on a screen through a gallery website, it becomes more like a research process. In a way, it is a more formal experience since the user is not 'just wandering around' as they might do in the physical space, but they are usually on the specific website for a reason.

User Engagement

For a physical art gallery the first level of engagement with the presented content can be from the digital presentation of an art piece for advertising purposes. The expectations for the real show are build on few digital (or print) images. While there are usually no big expectations of encountering an artwork online. Probably most people would not say that they have 'seen' an artwork if they only viewed it online, even if was a digital piece. Engaging features for interactive online viewing of an artwork are considered zooming-in on a super high-resolution image, which is

beyond what the nacked human eye can see, or being able to have a digital scrapbook where different images are saved. Online tools that are not possible in the physical gallery are considered more engaging. The information that is provided online about an artist is well presented when it is given with reference and hyperlinking to other artists that are similar or influential to each other, or there is a historical background provided. Intelligent searching is one of the strong benefits that web has over the physical presentation of art. Digital art presentation online is very well suited for making connections between different art pieces. Least engaging features for digital art presentation online are those causing distraction from the actual content, such as long text, flickering headlines, irrelevant images, flash videos etc.

User Engagement Measures

Measuring user engagement for an online application could be done through counting the time users spend at a specific page, provided that there is some type activity. Number of clicks can also be an indication for higher or lower user engagement. However it has to be taken into consideration, that users have different viewing habits – some might be very slow and precise, while others go through the whole content very fast and concentrate more on one or two art pieces. The number of images and texts posted about the presented content on social media can also be used to measure user engagement.

Part II of the Second Focus Group Study

In the second part of the study the digital artists were asked to interact with the application described in Sect. 2. This part of the study is shown in Fig. 9.11. While in the first focus group all participants chose the *observe* mode first because it was perceived as the most basic one, here just one of the experts picked this mode but for the same reason as the rest of the experts in focus group one. The other expert in focus group two, chose the *manipulate* mode because as described it seemed most interesting to them. The order in which the interactivity modes were selected is the following:

Expert 1 – Observe, Explore, Contribute, Manipulate;
Expert 2 – Manipulate, Manipulate, Observe, Explore, Contribute;

The second expert selected the *manipulate* mode twice. This mode was interpreted as the mode that seems to be further away from the physical gallery experience because 'messing around' and manipulating the artworks is an action that is specifically not allowed in official exhibition spaces. The *contribute* mode was picked last by the same expert because they felt that some pre-knowledge of the application and the interaction has to be gathered first in order to be able to 'contribute' towards something. While, Expert 1 picked the different interactivity modes as they were following what they thought to be the natural progression of

Fig. 9.11 Participants in the second focus group testing the desktop application featuring all four interactivity modes

the interactivity level. Later in the discussion both experts agreed that the order *observe, explore, manipulate, contribute* follows a hierarchy in the interactivity, the modes get slightly more complex and the effort that the user needs to put in grows.

Another aspect of the different interactivity modes that was pointed out was the fact that it was sometimes difficult to place the camera view of the first-person controller directly at the paintings. This seems to be a habit from the real-world gallery where the visitor usually stands right in front of an artwork while viewing it. Especially in the case of the *explore* mode, the user had to 'fiddle' around with the navigation in order to place the viewpoint exactly at one painting.

Part III of the Second Focus Group Study

The last part of the study was in the form of a group discussion (Fig. 9.12) focusing on the proposed evaluation framework (Fig. 9.6). Each suggested phase of the user engagement process was considered:

Attractors

On the main page of the application (Fig. 9.1), featuring all four interactivity modes, two attributes representing each mode were playing a role in grabbing initial user attention and having the so called 'attraction power'. These elements are the thumbnail representing each interactivity mode and the text description of the mode. If the mode was explained in the least amount of words possible, the experts

Fig. 9.12 Discussing the proposed extended evaluation framework in the second focus group study

considered it as an attention grabbing feature. Words like 'press' or 'go' encourage the user to start the interaction, while long text phrases are usually ignored or not fully read. The visual attractor, the thumbnail, is commonly chosen by the user's own aesthetical preferences and is harder to be generally defined.

Figure Out

Usually, the 'figuring out' process is successful when the user's actions are matched to the user's expectations, whereas the expectations were created by the way the content was presented – positioning of the image, positioning and the art of the explanation, etc. The 'figuring out' comes from 'within' the user, meaning that every one 'figures it out' depending on their capabilities, background and expectations.

Sustainers

The power of sustainers, or the attributes that keep the short-term engagement, depend on the level of interest that the user has from the very beginning. Thus, if the user is not interested, they might 'skim on the surface' of the application, rather than going deeper into content details, or they might end up not using all of the features provided.

Another attribute related to sustainers is the user's competency. Depending on the personal skillsets, people might spend more or less time interacting. Also, in certain situations users are interacting with a specific goal in mind, as to find a particular image, which could affect their behaviour and interaction.

The 'figuring out' phase and short-term engagement phases with sustainers as attributes, can sometimes be hard to distinguish. Since it is not always clear if the users interact because they are confused and try to understand the means of interaction, or because they are very interested and engaged in the interactivity process.

Breaking Point

For each interactivity mode the following situations were defined as 'breaking points':

Observe – the realisation that nothing is changing with time and there is no interaction;
Explore – when all paintings were seen;
Manipulative – when there were no more options to play with;
Contribute – when some colours were changed and it was understood that the task is repetitive. There was no desire to change all wall colours.

Relaters

The attributes for long-term engagement, the 'relaters', were tested, with a post-interaction task, where the experts had to choose one from four popular websites. All experts in the first focus group selected a site with art content. In the second focus group, one expert chose the art content site, whereas the other chose the news-related one. Overall, the majority of the participants (in both groups) did pick the website with the art content, which can indicate that their interaction with the tested system influenced not only their short-term engagement but also their long-term behaviour. However, we need to acknowledge the fact that the experts who took part in both studies have higher art interest than the general public, so their behaviour cannot be considered representative for the majority of users. Forthcoming quantitative studies can give us this information.

9.4.4 Summary Outcomes from the Qualitative Study

The expected outcomes from this study were to determine the content that is going to be presented, but more importantly to gather expert feedback on the proposed user engagement evaluation metrics. The study has started with general discussion and afterwards the evaluation metrics were considered and analysed in detail. In the second part of the study the experts were asked to interact with the application using the four interactivity modes. The third part of the study was focused on discussing the proposed extended evaluation framework. The overall results of the study can

be considered as confirming the proposed extended user engagement framework as shown in Fig. 9.1. The different phases of the engagement framework can be clearly distinguished and as a whole represent a complete model of the process. This layout can be further used for development of guidelines and metrics for evaluation of user engagement in the context of interactive applications for presentation of visual artworks.

9.5 New Design of the Application

The outcomes from both focus groups were used as input for an improved design of the exhibition space. The content presented has been changed according to the feedback of the experts.

9.5.1 Displayed Content

Based on the discussions from both focus groups, the following paintings are presented in the new interactive application (see Table 9.1).

9.5.2 Exhibition Space

The design of the new gallery has the shape of a regular hexagon instead of a cube in order for all paintings to be equally presented (Fig. 9.13). The user starts

Table 9.1 Details of the six paintings that are going to be presented trough the new application

Artist	Name	Medium	Date
Braque, Georges	The studio (vase before a window)	Oil mixed with sand on canvas	1939
Chirico, Giorgio de	Ariadne	Oil and graphite on canvas	1913
Gris, Juan	Violin with playing cards on a table	Oil on canvas	1913
Matisse, Henri	Snow flowers	Watercolour and gouache on cut and pasted papers	1951
Miró, Joan	Potato	Oil on canvas	1928
Picasso, Pablo	Man with a hat and a violin	Cut and pasted newspaper, and charcoal, on two joined sheets of paper	1912

Fig. 9.13 Bird view of the new exhibition space. The initial position of the user is in the middle of the space (Represented with the first person controller's icon) blocking the camera view of the paintings

Fig. 9.14 Initial view of the exhibition space, showing the panels (*left image*), which are removed after 10 s revealing the paintings (*right image*)

in the middle of the space, where the paintings are not initially revealed. Six panels (Fig. 9.14 – left) hide the images for 10 s, after which they slide down and reveal the paintings not disturbing the subsequent interaction (Fig. 9.14 – right). In this way the user starts the navigation without facing any particular painting. Additionally, the camera view rotates at each new load of the interactivity mode at 0°, 30°, 60°, 120°, 180°, 240°, providing a new view-point to the user even if there is no movement while the paintings are still covered. The regular shape of the exhibition environment allows more paintings to be viewed at once and enables much easier navigation in the space.

Fig. 9.15 *Manipulate* mode, enabling the user to extrude forwards parts of each paining

9.5.3 Interactivity Modes

Additionally, there are changes made in the design of the interactivity modes. Displaying the new content, the interaction in *observe* and *explore* modes remains the same. In the *manipulate* mode there are five elements in each presented painting, which can be extracted from the image (Fig. 9.15). In the *contribute* mode the wall has been divided into five parts, of which the colours can be altered (Fig. 9.16).

9.6 Future Work

Our future work will focus on objectively measuring the different phases of user engagement using the new design of the interactive application. In each mode we will count the number of different user behaviour events. Such events are *BecameVisibleObject* (when the presented painting is visible in the scene), *EnterObject* (when the painting is hovered over with the mouse), ClickObject (when the painting is clicked on). A sample of such a log file displaying those events is given on Table 9.2.

Further, we are using the API face tracking software (Soyel and McOwan 2013), in order to gather additional objective data on the user's behaviour while interacting (Fig. 9.17). From this data we will be able to tell where the user is looking, distinguishing between three head positions (looking down, straight forward at the

Fig. 9.16 *Contribute* mode, allowing the user to change five different elements of each wall

Table 9.2 A sample log file of the counted events in the virtual exhibition space

```
BecameVisibleObjectID:10298,4,103.63---------- EnterObjectID:10298,1,0.00----------
BecameVisibleObjectID:10290,1,0.00---------- EnterObjectID:10290,6,103.17----------
BecameVisibleObjectID:10292,5,99.07----------
BecameVisibleObjectID:10284,2,94.87---------- EnterObjectID:10284,1,0.00----------
BecameVisibleObjectID:10294,3,16.56---------- ClickObjectID:10284,1,0.00----------
EnterObjectID:10294,3,3.49---------- EnterObjectID:10292,2,0.68----------
ClickObjectID:10294,1,0.00---------- BecameVisibleObjectID:10282,1,0.00----------
EnterObjectID:10282,2,2.06---------- ClickObjectID:10282,1,0.00----------
```

screen or elsewhere). After the log file (Table 9.2) and the data from the face tracking are time synchronized, we will look for different patterns of behaviour indicating and characteristic of each phase of user engagement.

9.7 Conclusion

Our findings provide some concrete design recommendations; for example, that more interactivity results in more *sustainer* power, and that the 'Figure-out' phase is very important to ensure continued interaction. Additionally, the tests showed that the framework suggested in this research provides a suitable basis for developing an evaluation framework for user engagement. Other factors such as user collaboration

Fig. 9.17 Face tracking API software, differentiating between the user looking down, straight forward or elsewhere

and social behaviour can be incorporated in the research and investigated in depth, taking into account the exchange of information between the users themselves acting as participants as well as with other social groups.

References

Bilda Z, Edmonds E, Candy L (2008) Designing for creative engagement. Des Stud 29(6):525–540

Bollo A, Dal Pozzolo L (2005) Analysis of visitor behaviour inside the museum: an empirical study. In: Proceedings of the 8th international conference on arts and cultural management

Graham B, Cook S (2010) Rethinking curating. Art after new media. The MIT Presss, Cambridge, p 283

Maleshkova J, Purver M (2014) Beyond the white cube: presentation of visual art in interactive 3D environments. In: Electronic Visualisation and the Arts (EVA). London

O'Brien H, Toms E (2008) What is user engagement? A conceptual framework for defining user engagement with technology. J Am Soc Inf Sci Technol 59(6):938–955. doi:10.1002/asi.20801

O'Doherty B (1986) Inside the white cube: the ideology of the gallery space. University of California Press, Berkeley, p 14

Pares N, Pares R (2001) Interaction-driven virtual reality application design. A particular case: El Ball del Fanalet or lightpools. Presence: Teleoperators Virtual Environ 10(2):236–245

Roussou M (2006) Interactivity and learning: examining primary school children's activity within virtual environments. PhD Thesis, pp 1–282

Soyel H, McOwan PW (2013) Towards an affect sensitive interactive companion. Comput Electr Eng 39(4):1312–1319

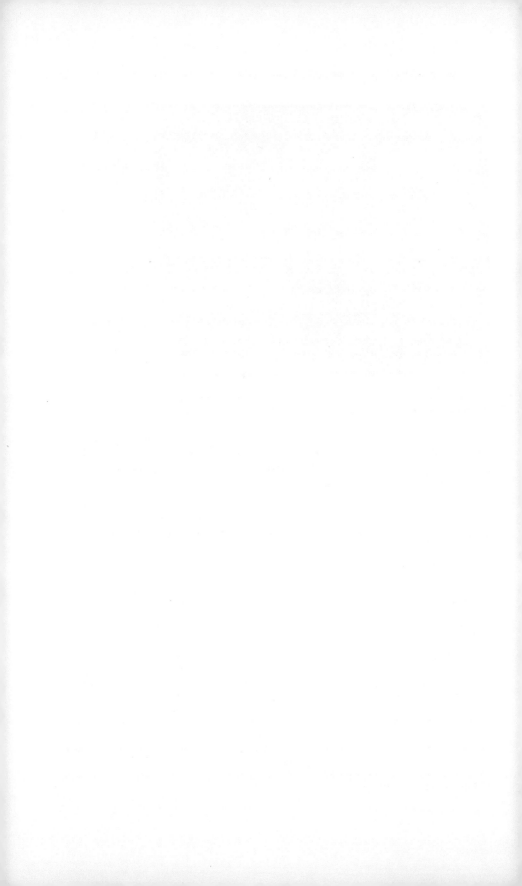

Chapter 10
Virtual Reality, Game Design, and Virtual Art Galleries

S. Guynup

Abstract With the emergence of WebGL as an online 3D standard and Facebook's purchase of the Oculus's head mounted display (HMD) technology comes a renewed interest in the form and function of online 3D virtual worlds, spaces and interfaces. As a starting point for exploring 3D virtual form and function, this chapter offers an overview of virtual art gallery design through videogame scholar Jesper Juul's framework of rules and fictions. Applied to non-game, creative, function-oriented, 3D virtual art galleries, the lens of rules and fictions offers revealing insights on the design choices of this new medium.

10.1 Introduction

Videogames and virtual reality are often tied together, usually in the context of play, storytelling, or simulation. This chapter takes a different approach. This chapter applies the videogame framework of narrative and interactivity, specifically Jesper Juul's revision of the terms as fictions and rules, to non-game 3D virtual spaces. To go beyond theory, a domain of example virtual spaces is needed. Creative, visionary, yet practical in non-game usage, virtual art galleries and their curation of diverse data sets called art is a good domain for exploration. Linked to the reality creating/reality breaking nature of art, galleries and museums often lead innovation in architectural form. From the Crystal Palace to the Guggenheims in New York and Spain, art galleries and museums have pushed the boundaries of form and function. Unbound from physical architectural limitations, 3D virtual galleries also express a broad range of design possibilities. Digital structures, realistic and abstract, small and vast, interfacial and immersive have tumbled off the workstations of game designers, architects, and university professors.

3D virtual art galleries share an interest in creating positive user experiences, but are not conceived as playable videogames. This removal of a videogame

S. Guynup (✉)
Hayfield-Isovista, LCC, Wellsville, NY, USA
e-mail: steve@isovista.org

© Springer International Publishing Switzerland 2016 149
D. England et al. (eds.), *Curating the Digital*, Springer Series
on Cultural Computing, DOI 10.1007/978-3-319-28722-5_10

context seems to intensify and enrich the already complex relationship of rules and fictions. Emerging then appears to be a new 3D virtual design language grounded in videogame theory.

10.1.1 Foundational Theory, Game On

Videogames are often seen as a blend of interactive and narrative elements (Adams 2014; Schell 2014). More importantly for the purposes of this paper is that these separate interactive and narrative elements can (and often do) conflict with one another. Many game design scholars, including; Murray (1997), Frasca (2014), Juul (1999), Eskelinen (2001), King and Krzywinska (2002), Aarseth (2004), Jenkins (2004), and Guynup (2012) have weighed in on the subject. To clarify the nature of this conflict, game scholar Jesper Juul in his 2005 text *Half Real* (Juul 2011), repositioned the term narrative as fiction and took interaction as rules. Broadly then, videogames are seen here as a blend of fictions and rules. For Juul, fiction represents the story-driven and subjective elements in a game, while rules are objective and encode the allowable interactions and outcomes. For example, the castles, swords and starships in videogames are fictions. Their presence and appearance is dictated by the fiction. The interaction, the damage done by the sword or the speed of the starship, is governed by rules.

On the surface, rules and fictions seemingly fit together seamlessly in videogames. Below the surface however, are the efforts of professional game designers who work through potential conflicts to a create unified and playful experience. The crux of the conflict and the game designer's challenge is that fiction and rules can inspire different perceptions and pursue different design goals. Simple examples of conflict include unopenable doors that are drawn on to walls in a video game, or multiple allowable deaths. The drawn door is part of a larger fiction used to shape the players belief in their surroundings. The conflict arises from how the drawn door inspires the players belief of possible interaction, the acts of opening, closing, and passage through. These interactions, however, are not fulfilled by the rules when the door is simply a drawn 2D texture – not a 3D interactive model.

Programming all the rules implied by a fictional environment is difficult if not impossible. Videogames such as World of Warcraft have tremendous interactive options, but digging holes, breaking a chair, talking to an enemy non-player character (NPC), is impossible unless that behavior was encoded for a quest. In this sense, videogames are incomplete worlds, unable to provide all the interaction implied by the fictional surroundings (Juul 2011). Designers work to hide this incompleteness as the game fictions seek to direct the player to what is possible and necessary in the game. Videogames are self contained systems that operate within a logic dictated by the game play (Csikszentmihalyi 1997; Gingold 2003), which also helps to hide this incompleteness.

A second point of potential conflict stems from new and necessary rules that are not supported by the fiction of the world. A good example in videogames is the handling of player death. The multiple deaths and associated death penalties are a set of rules governing task failure. The player accepts these rules despite the physical world knowledge that death is permanent. Replayable death breaks the narrative frame that death is singular and permanent. In games that aspire to suspend the disbelief of the player, this conflict can break the illusion, the immersion of the game world. To address this, many games have altered the narrative framing of death. Often the idea of magic justifies the new rules, and there is resurrection, respawning, and/or spirit walking from a graveyard to your digital corpse. One especially clever narrative twist is in Assassin's Creed, in which player must restart because the person being controlled never died that way.

Outside of these narrative frames are rules designed to shape game play. The videogame Runescape penalizes player death with the loss of carried goods. Counter Strike death means you are out of the Player vs Player (PvP) match entirely and must wait for the next match to start. Issues of incompleteness and new necessary rules extend into non-game virtual worlds, including art galleries. In an art gallery, rules for patron death seems undemanded by the fiction and unneeded by the user. If death is unnecessary, what other fictions and associated rules are unneeded?

In the non-game virtual art gallery, the fiction of unopennable doors drawn onto geometry raises deeper questions. If faux doors are unneeded, what of the fictional windows, plants, track lighting, benches, etc. that are often found in physical art galleries? What application and level of fiction is needed create immersive belief and behavior in the user. Many virtual 3D art galleries are wholly abstract in appearance, so the question is not a simple one. Videogames, through the diversity of their designs and playful handling of fiction and rules, have addressed similar issues and have more insights to share.

10.1.2 Rules and Fictions Within Games, a Complex Relationship

Some videogames, such as Last of Us, Uncharted, and Dragon Age have deeply immersive fictional stories. To suspend the disbelief of the player, realism in rendering and behavior as framed by the storyline becomes critical. Often, fictional stories of elemental magic or superpowers granted by radioactive animal bites are used to justify the rules behind the interactions desired or needed by the player. These fictional stories become part of a cognitive framework through which the player processes the rules behind their newly gained abilities

Other videogames, such as Tetris, are a largely a set of rule based interactions. There is fiction in Tetris (Murray 1997) but its nature is difficult to discern (Juul 2011). In Tetris, task completion is prioritized and positioned within a set of rules

that challenge the skill of the player, while also providing random chances to do well or poorly. This balance of chance and skill raise the aspect of play driven behavior (Sutton-Smith 2009).

Videogame rules even embrace task failure to a degree. Balanced in a channel of Flow, task failure is a key component of game design (Csikszentmihalyi 2014; Schell 2014). Flow is an optimal state, maintains an optimal level of challenge throughout the play experience. Within a Flow Channel, players are neither bored nor overly taxed. Their challenge is optimized to allow for – but not demand – failure. Typically, videogame challenges become greater over time. To aid the player in the face of greater challenges, most videogames increase the usability of a player's abilities as a reward for levelling up (Guynup 2012). Examples of increase usability include faster (or new) travel options, shorter cool downs on abilities, and greater damage dealing.

Curiouser still are games that celebrate incongruences of fictions and rules. Stressing both fiction and rules, many games break from a straightforward real world-like linkage between fictions and rules. This third relationship frame may be the most critical for virtual reality development, as it highlights the true flexibility of linking fictions and rules. One example is the videogame Donkey Kong.

10.1.3 Realism vs Donkey Kong

Donkey Kong, with its barrels to be jumped, power-ups, three lives for Mario, and carpenter – princess – giant ape relationship makes little sense except in the context of videogames. Within videogames, such incoherent transgressions of physical reality are often celebrated (Juul 2011). Other video game examples include *Plants vs Zombies* and *Angry Birds*. The odd fiction of birds attacking pigs on pedestals, or plants fighting zombies on a chess-like board is cognitively acceptable in the lens of videogames. It's currently true that Mario is a plumber, but to better fit the fiction of a barrel filled construction site this was changed. In the virtual, only slender threads of fiction are needed.

For 3D virtual art galleries, videogames like *Donkey Kong* hint at new and novel design possibilities. *Donkey Kong*'s blend of rules and fictions imply greater flexibility in the layout and architecture of virtual worlds than currently seems allowable. This limitation of non-game virtual world design may be in part due to the general prioritizing realism in rendering and/or behavior (Manovich 2001).

Videogames do use the level of realism in graphics and behaviors as measure of cutting edginess. Videogames are, however, not limited to realism as a gauge of their success in creating playful experience. Fiction itself seeks to create a sense of belief, a reality on its own terms, rather than a mimetic copy.

Realism in rules, such as those shaping the mechanics of death or the carrying of gear is often altered in favor of less realistic outcomes. Furthermore, for videogame players, the idea of incompleteness is ingrained and accepted. For videogame players, incompleteness is accepted when the missing rules are not connected

to completing the videogame tasks. Outside the framework of videogames these clashes of rules and fictions remain, but without the moderation of play they become more rigid and brittle. To retain the creative force of *Donkey Kong*, in the design of non-game virtual spaces, a still deeper appraisal of rules and fictions outside of videogames is needed.

10.2 Barrel Jump, Outside of Game Worlds

For virtual worlds and 3D art galleries, tasks are not created for a playable, win/lose outcome. Fictional realism, often in pursuit of heightened immersion and presence sets up a heightened of the conflict rules that may request the limits of physical reality be lifted. Issues that challenged game designers such as incompleteness and new necessary rules outside of fiction remain intact, Without the playful, failure friendly videogame frame, these issues perhaps become more stubborn to comprehend and resolve.

While many professionals advocate copying reality as a starting position. This is problematic – copying reality is not the same as designing reality. Copying a videogame that transgresses the space between rules and fiction may be a better point for our conceptual departure from realistic space. A game perhaps, like Shigeru Miyamoto's *Donkey Kong*.

In this context, *Donkey Kong* is a harbinger of the design process needed to break virtual worlds, spaces, and interfaces from their current constraints. *Donkey Kong* achieves much within the domain of videogames, but applying its use of rules and fictions outside of videogames is a challenge. Outside of videogames, rules and fictions shift.

The overarching goal of a playful experience drops away and unmasks deeper conflicts between rules and fictions. Fiction exists, but there is no hero to save the world. Common software packages like Microsoft Word leverage minor fictions in the icons of its interface. Microsoft Word also cares about the user experience, but there are no 3D dragons to slay, no features granted as rewards for leveling up, and quests are often unwanted journeys to the forums for help. The rules remain, but failure is less accepted and usability is demanded up front. The rules that guide the interaction in Microsoft Word focus on being immediate and accurate. Processes are meant to be quick and done without failure. In Microsoft Word, task failure is not an accepted part of the process. While videogames create rules allowing for failure for the sake of a user's experience, most productive software seek to avoid failure altogether. The avoidance of task failure also raises questions of the need for 3D in Microsoft Word. Many HCI scholars recommend limiting user interaction to what's needed for task completion. Often this means reducing 3D to 2D (Wilson et al. 2010).

To extrude a text editor like Microsoft Word into a 3D virtual workspace seems unnecessary. The media it deals with, the written word, is 2D. The required fictions do necessarily require great realism, though a beachside view or Victorian parlor

might be inspiring. The rules for interaction seem ill suited for an added 3rd dimension for manipulation. Yet, when the question of 3D moves away from a presentation on 2D monitors and shifts to head mounted displays, it becomes plausible to imagine Microsoft Office as a virtual 3D office space. Here again, rules and fictions operate. Visions of an office that looks like a physical world office follow a path of fiction. The rules of this production oriented space may, however, suggest a more Tetris-like outcome. A 3D virtual office is defined more by its actions than its appearance. It is not a fiction, and need not copy reality in the sense a castle or starship, needs to.

The rule heavy, interactive and functional virtual office space is hard to imagine outside of mimetic representation. Successful virtual examples are few and far between. Thankfully, many, many virtual art galleries do exist and successfully explore a range of rules and fictions in their designs. Equally useful is that virtual art galleries prioritize user experience in a way that a 3D version of Microsoft Office would not. To restate and clarify, the virtual art gallery is – if it holds works deemed to be art – an art gallery regardless of its appearance. This stands in contrast to art galleries in video games such as City of Villains. The art galleries in City of Villains are designed to be robbed and are created as fictional backdrops, much like those found in stage set of a Pink Panther movie. The rules in the virtual art gallery also break from videogames. As noted earlier, the new rules do not support patron deaths. The idea of balancing a visitors chances of viewing work (success or failure) along a track of optimal flow also seems unhelpful in the general sense.

In sum, using a lens of rules and fictions to understand virtual spaces appears to have value. The goals pursued by rules and fictions force a change in their application, yet the underpinnings of their relationship and their potential for conflict remains. A virtual art gallery need not employ the fictional mask of a physical gallery to be a freely exploreable structure that presents a curated body of artwork. Without the mask of the physical, our imaginations become overwhelmed by possibilities. Rules alone may be able shape virtual reality, yet this raises new and deep questions as well. Before diving into examples of virtual art galleries a bit more explanation of rules and fictions outside of videogames is needed. The differences cited before in games and hinted at in the discussion of a virtual Microsoft Office is only the tip of a large conceptual iceberg.

10.2.1 Deep Pivot: Fictions and Rules, Signs and Referents

Understanding virtual space, perceiving its design challenges, and looking into its future is difficult. Against this backdrop, there is an oddness in that our physical world with it's sensors and satellites is growing more digital – more virtual every day. The question arises – Why does 3D space inside the computer screen seem the least capable of exploiting its virtual potential? Answers of media newness or limited abilities of interaction or rendering are commonly cited, yet after so many decades of virtual reality creation, they are unappealing. Newness and limitations

provide no answers or insights for designers. The vastness of what may be possible is easily daunting for many. Rules and fictions borrowed from game design is a helpful frame for construction yet, virtual worlds are still something more.

Many theorists have viewed virtual worlds in a post structural lens as a domain of signs. In so doing, literary philosophers like Baudrillard (Baudrillard 1994; Adams 2014) found trouble in the use of images to mask an absence of physical reality. Putting aside the cultural ramifications, the virtual as a domain of signs and of image masks strikes a cord with our use of the term fiction. Conversely aspects of objective rules may connect the domain of physical referents.

To view rules and fictions as a world building framework that touches on concepts of signs and referents requires a look outside of videogames. It requires a look outside of 3D virtual worlds altogether. In his 1985 text *The Power of Movies*, film scholar Noel Carroll (1985) offers a unique pivot point for exploring rules and fictions in the context of the physical world and the domain of signs. Carroll sets up a discussion of plows. One is a farmer's plow – the kind found in a field. The other plow is in a movie – the type found on a theatrical stage. The farmers plow is a product of objective rules, the rule of humans needing food, to grow it, to dig the earth, and to plant seeds. The form of the farmers plow is dictated by the nature of the soil, materials available for construction, and the means (Oxen, Horse, Human, Pig) to pull it across the landscape. Its core form reflects the objective rules that follow its needed functionality. The farmers plow is judged by its speed, efficiency, and durability. For Carroll, the farmer's plow is an invention.

In contrast the plow in a movie is a prop that may never see a working farm. The movie plow is in service to the story not the soil. Its form, primitive or modern, simple or ornate, is determined by the goals of a greater fiction. The movie plow is part of a viewer's journey through the story. The movie plow is a narrative convention in Carroll's thesis. Going further and asserting that the movie plow is like Margritte's pipe – a signifier, the subjective visual representation of the concept of a plow – or sign, is not a stretch. The other part, the farmer's invented plow, is then a referent – a product of objective rules.

Enter then the next iteration the plow within the virtual. In videogames, we see the fiction and conventions. There are film-like prop plows in many videogames – such as the PvP battleground in World of Warcraft's Arathi Basin. In this PvP environment this immobile, non-interactive plow lies in a ruined field and contributes only to fictional farm setting.

Invention-like virtual plows that perhaps dig into fields of data do not seem to exist in 3D form – yet. Leaving the plow analogy behind, a larger question of inventions within a virtual world arise. What form do virtual inventions take? Their existence seems logical, yet wholly undefined. Inventions are creations determined by rules not fictions, yet the rules themselves seem to deny or at least work against the need for 3D form within the virtual.

Between the physical and the filmic, virtual worlds represent a domain that resets the concept of sign, signifier and referent. Invention and convention merge. In a sense, it's a step as profound as the creation of symbolic language itself. Masked in the self-contained (Csikszentmihalyi 2014; Gingold 2003), playful experience

focused domain of videogames, lies the fundamental tools for understanding this emerging design space. Those tools are rules (interactivity) and fiction (story). Videogame-like options for steering virtual design toward rules or fictions remains the same. New challenges and conflicts, however, are exposed. In the paragraph above the movie plow was associated with the viewer's journey while the farmer's plow valued speediness in correctly completing its task. As a designer the question of what is more important – the journey or the destination takes on new meaning.

Journey or destination, task completion or user experience, there are choices to be made and priority to be **granted**. The 1998 movie the Matrix and its White Room do just this. Neo calls out for weapons and racks of weapons appear. He and Trinity then explore rows of weapons making more defined choices. In a physical reality, Neo would have to travel to a weapon depot or military armory, but here in the virtual – the weapons instantly appear via a Google-like keyword search. Unnecessary travel, drive to the armory and the walk from the car to the showroom, is removed. The 1997 virtual space now called *Isovista* explored this dynamic architecture as well. The slideshow-like presentation allows for the fast presentation and searching through of virtual art. The experience of roaming a gallery, however, is lost. The free travel and ability to wander and come upon a work of art from a distance or around a corner is missing. The users of *Isovista* missed this experience, for better or worse the art gallery became a catalog and lost an element of its social interaction among its users. With the issues of presentation, search, and sociability in mind, the virtual art gallery relationship with rules and fictions should be assessed.

10.3 Art Gallery: New Rules, Old Fictions

In this paper, a virtual gallery's critical function is the presentation of curated artwork. Secondary functions address issues of exploration in the context of search and travel, as well as supporting social interaction among the visitors. In service to these three concerns (presentation, exploration, and sociability) are rules that shape the virtual gallery's layout and interaction.

Presentation As an entry point, presentation of artwork can simply mirror practices of physical world galleries. Spaces for installations and sculpture, walls and movable partitions for paintings, prints, and photography. The overall structure echoes a videogame level with a spatial narrative that frames the visitors progression through the exhibitions.

Lost in this physical mirror approach is the opportunity to utilize new rules afforded by virtual space in the organization, searchability, and presentation of the artwork. Even more problematic is that the physical mirror is designed to support only existing genres of physical artwork. This means that the fiction of the space sets a narrative that virtual artwork should mirror physical works. In practice, virtual artwork is diverse and often sweeping in terms of scale. WWII internment camps for Japanese Americans, multilevel expression of William Blake's Crystal Cabinet

poem, and abstract landscapes of images culled from Flicker terms are all existing virtual works that no physical gallery can manage.

Physical galleries also suffer from a lack of presentation space. A great amount of physical artwork is kept in storage and awaits display in accordance to a scheduled show or event. In contrast, virtual spaces are limitless in terms of potential volume of presentation space.

Going further, physical art galleries are singular curated shows. Virtual art galleries can potentially host several curated shows or even allow visitors to create their own show. The visitor created show might mimic Google or Bing search terms being used to bring individual works in for display one at a time or have a room created just for their request.

Exploration Walking through a physical gallery allows the visitor a stable, logical path – a critical path to borrow from game design. Prominent artworks are placed prominently acting like videogame lures. Meanwhile ropelines, moveable walls shape paths and visibility. The curator controls the space and uses it to negotiate time with the visitor. Time in the sense of when and in what order a viewer is likely to see individual works within the show. Ideally, then, every step has value in the creation of a narrative in the body of work. In practice, visitors overlook works, rush to see popular attractions, get lost, and/or wander aimlessly.

Given human nature, it is unlikely to truly resolve these latter concerns with a virtual gallery. The larger issue is that if a virtual gallery that mirrors physical galleries simply scales up, it will become unmanageable. The huge diversity in scale and nature can make even small, curated virtual art shows problematic. To borrow from an earlier section, neither the journey, nor the destination will be rewarding.

Videogame-like teleportation is one likely set of rules needed, and perhaps only to entry positions for engaging works individually or in a curated group. The bigger issue becomes one of how the affordances of virtual space might best be exploited. The original prototype for *Isovista* borrowed a slideshow methodology used for educational presentations and immersive poetry readings. The *Isovista* method succeeded in sharing diverse work, but lost the sense of travel and exploration desired by the participants. *Isovista* early incarnation was seen as more of a catalog than an art gallery. Here the third function of sociability starts to be noticed as a catalog is not currently perceived as a social venue.

Social The use of the virtual as a social space, a shared/networked reality raises the complexity of rules, fictions, and their influence on form and function. This chapter focuses the layout of virtual art galleries in the context of presentation and search, so the issue of social construction is limited.

In terms of gallery layout, the divide between easily searchable art catalog and explorable social space also finds trouble in the videogame norm of using instances, separate spaces enterable through portal-like doorways. In a sense the breaking of artwork from a single structure seems to create the same implied catalog feeling with users. Users are, like the virtual artwork they are viewing, separated from each other.

Tools for supporting social action are an open question. Text chat in MMO's do provide a sense of connectiviness among users, and channels for areas, user groups, and private chats are readily available options. In videogames, VoIP (voice chat) is typically seen as too intrusive for widespread use and is therefore used mainly among users that know each other (a game Guild) or in complex situations requiring close coordination such as PvP or Boss fights. Also supporting social interaction is the fictional body of the user's avatar. Avatars are in a sense a 3D icon that can indicate a human presence, location, and direction of view. It's implied range of interaction is approximately its arm's length. Yet, many worlds also break from the human form in their avatars and some virtual artworks reposition avatars as immersive structures or vast digital agents.

In terms of new virtual abilities, some spaces have explored the ability to leave comments in the space, either as graffiti or as pop-up notes. Other virtual galleries will allow you to share your current viewpoint (your screen) with a friend so that they can see what you see. Some virtual spaces allow for communication to be enhanced with 2D imagery or 3D objects that are dropped into the scene. Given the flexibility of the avatarial form and the modes for communication, the development of virtual space for social interaction holds more questions than answers at the moment.

10.3.1 Art Gallery: The Mirror and Beyond

With issues of presentation, exploration, and social support framed by fictions and rules in mind, virtual art galleries are unique structures. They can visually mirror their physical world counterparts or they can break from realism and still support the goals of gallery design. Breaking from realism, or the mirroring of physical reality leaves many doors open in terms of design outcomes. None of the examples that follow should be seen as final or even definitive. The future remains an open question and these works at best highlight the challenges of what may come.

Many virtual art galleries take a path of realism and of copying physical space. With the idea of realism understood by most individuals, it seems to be an appropriate starting example. The 2015 *EUseum* created by ArchiVision for Europeana does just this. It copies reality and does so with the Oculus Rift HMD. Truly immersive and 3D, the light gray space has the visual fictions of what people interpret as part of an art gallery. A wide open central space, stairs with glass railing, 2D work hung on walls, and a sculpture of a human form in the center. Benches that cannot be sat on, potted plants made of pixels, and track lights that are separate from the actual lighting of the scene are all present. Upon entering the space, it is easy to interpret the narrative as one of an art gallery.

The overall rules for the *EUseum* in large part map to a physical world gallery. One walks through a singular space, able to look in all directions and approach the art. Given that most of the art is 2D paintings, the general rules for placement, loosely centered at eye height still hold. The space itself is rather small, two rooms,

with a balcony in one. The scale and nature of work is not very demanding in terms of gallery design, yet even here issues arise. Incompleteness of physical rules enters when one tries to bend down to see a lower corner of a painting in detail.

Some incompleteness, could be easily addressed such as the ability to sit on a bench. It is also possible for the benches to be removed as avatars never tire of standing. In other words the physical world rules that shaped the benches no longer exists. At present, as unsittable objects they are simply visual props use to flesh out the space, add a sense of detail and depth. If sittablity was added, a case could be made that they could support social interaction among seated visitors. If moved, arranged differently, sittable chairs also can be used to guide users to a location for optimal viewing of the work. Typically this optimal viewing approach is used in classroom, theatres, and related events, but the basic principle still could apply. Lastly, on chairs and benches, it is important to note a western cultural bias for them. In Japan, the Middle East, Africa, India, and even China, cushions on the floor have been the traditional means for being seated. So while the need for virtual benches and chairs remains a question mark, is worth understanding how humans have lived without them for most of our existence.

One more bit of curious incompleteness lies in the purple virtual rope line in front of a painting that cannot be harmed. It's possible to create rules that allow paintings and sculptures to be permanently damaged by visitors. Given that curators want to protect their collections, the allowance of damage seems odd to add in, unless desired by the artist. At best, the true function of the purple rope line is not to protect the work, but to tell a story of work that needs protection – work that belongs in a gallery. In graphic design terms, it literally is an underline for the painting. The secondary function is to fill up the visual space and act as reference for depth and detail, much like the like the benches, plants, and light fixtures.

What becomes curious here and in many other virtual galleries is the use of faux glass cases and other methods used to protect physical world objects. Many art and museums want more interaction and touching of work to engage the visitor. Physical world rules of wear and tear, and insurance policies, make such interaction untenable. The virtual however, can embrace such behavior.

As for the design direction of the *EUseum*, they clearly indicate that copying the physical world is the first step and that more interactive design possibilities are possible. From their page on the Oculus Rift Share website comes:

> A first step would be to recreate existing museums online so that people from all over the world could visit them from exactly where they are. And then each of us could curate collections and put them in an environment of our choosing: how about looking at some of Rembrandt's paintings in one of the workshops he worked in? Or what about a museum in which you could change the entire collection with a press of a button? How about stepping into a painting from Monet and being able to walk around the water-lily pond?

The basic premise they implied by stepping into a painting or workshop is a clickable/enterable link placed on or near the artwork. Upon clicking/entering you would be teleported to a separate room or reality, in videogame terms an instance. This coding already exists and has been applied in a few virtual galleries. The other idea of curating work, creating custom groupings that could be also shareable is also achievable.

What is missing from the *EUseum* approach is twofold. First, there are no examples of artworks created specifically for virtual environments. Second the architecture does not explore the new possibilities for form, structure, and interaction afforded by 3D virtual space. The claim of being a first step is acceptable only in the context that for 25+ years other developers have made similar first steps. Many developers have explored other options in regards to both art works created for virtual environments and architectures that explore new possibilities.

10.3.2 Rules of Presentation: New Virtual Art

There are thousands of virtual artists building 3D works that exist only inside of the computer screen. Some artworks reference 2D paintings as a starting point for development – *Aleph* 1997 by Maurice Clifford, while others are large traversable landscapes, like a US Japanese internment camp – *Beyond Manzanar* 2003 by Tamiko Thiel and Zara Houshmand. There are abstract immersive fields of color that are actually the avatars of musical performers *Memory Plains Returning* 1998 by Adam Nash and works that attack and shoot lasers at digital participants like *Kosovo Unfinished* 1999 by Dr. Steve Guynup. Videogames, software tools, and database driven flows of information become artistic installations, widgets, and interfaces. This is the diversity that confronts 3D virtual art galleries in their core task of presenting artwork.

Showcasing the challenge of presentation is the *Virtual Broad Art Museum* 2012. This multiuser art gallery was created by the Digital Intermedia Arts (IDIA) program at Ball State University. The *Virtual Broad Art Museum* featured virtual artworks by John Fillwalk. The gallery, beautifully mimetic in nature, was unable to hold multiple works by the artist because of each artwork's sweeping scale. Rooms, conceived as and limited to, a fiction of physical world norms could not contain artwork that was created for the huge unbounded domain of virtual space. The virtual artworks often simply went through the walls and into the hallways. This accidental merging of artwork and art space was conceptually engaging and acceptable in the domain of art, yet it seems unlikely to be a good long term design solution, especially as it violates HCI guidelines (Wilson et al. 2010).

After the novelty wears off, a serious issue arises. John Fillwalk had three such sweeping virtual artworks and three separate copies of the gallery, each holding only an individual work, were required. A multi-user virtual art gallery that cannot present multiple works of digital art is highly problematic. The fiction of a physical world gallery conflicted with the sweepingly large virtual artworks, yet, the core issue is one of rules and fiction. Rules for presenting and connecting artworks that exist as sweeping installations, large landscapes, and deep vistas need to be applied. A second very abstract example, also ran foul of the new rules of 3D virtual art gallery design.

In the online *Alternative Fabrique 1999* exhibition, six well known online 3D artists were asked to create works for a beautifully abstract multi-user online 3D

gallery. The structure abstained from fictions implied by realistic representation and used taut lines and clever angled geometry to create a sense of depth and volume in a subtle white and gray design. A seductive narrative was imposed and twisted as realistic images of sensual human lips were placed on the entrance and exits of an enclosed $8 \times 8 \times 16$ m gallery rooms. Users were greeted with audio kisses as they travelled in and out the spaces.

The virtual artists, despite the kisses and general appreciation of the gallery's artfulness took issue with the small size of their allotted rooms. These artists were used to working in infinitely vast digital spaces, used to playing by different rules. Most of the artists actively rebelled against the small mobile home sized spaces. In the service of art, and in the tradition of *Donkey Kong*, they broke the rules imposed on them.

One *Alternative Fabrique 1999* artist, Andy Best, further filled the small room by placing a fiery digital monster in it and demanded the user negotiate passage past it. Squishing along the wall while a large, moderately unruly beast protests, was perhaps Andy's way of sharing his developmental experience with the visitor.

A second artist, Steve Guynup, added a red button to the small room that dissolved away their entire art gallery in favor of a large underwater Zen pool. Users that pushed the red button shared the same space as others in the art gallery and could see and converse with other users, but they saw and travelled in a completely different looking interactive Zen space. This Zen space would flip back to the original gallery when the red button was pushed again. A third artist, Cristiano Bianchi, sets forth a conceptually brilliant head high box with letters on the sides. Visitors would approach the box and put their virtual faces inside. Unknown to the user was the fact that Cristiano had also lessened the user's avatar movement speed upon their face's entry into the box. Slowed down, travel in the small box created the impression of a large space whose volume took time to traverse. Armed with the elegant simplicity of the idea, Cristiano coded the work to add ever more lettered boxes / spaces inside of each other and titled the work Infinite Babel.

The three examples above, along with the work of John Fillwalk, highlight the challenge of holding diverse virtual artworks in a manner that also maintains a usable, searchable, social space. Merging a 2D art catalogue with a 3D art exhibition remains a curious puzzle for HCI and usability scholars. The creative, experimental nature of art itself does allow these galleries to be enjoyable even if not entirely successful from a usability perspective. Art, like game design (Guynup 2012) qualifies task success in service to the overall experience rather than efficiency or even completion.

10.3.3 Gallery Rules: Navigate, Arrange, Search

The technology of Second Life offers a unique and stable community for the development of virtual art and the gallery structures that could hold it. Second Life

sets a fictional of an island with land, sky, and water surrounding it as a means of creating separate, more easily managed environments. In Second Life, artworks can simply be placed on the ground, in an outdoor-fiction of a sculpture garden or in walled off buildings. To break new ground, some artists place their artwork in the sky above or waters surrounding the island. In a sense, the virtual island fiction remains intact, but the new rules that allow for flight without fear of injury through falling open up new possibilities for presentation.

Artfest 4, a small charity art show for example, exists on a small tropical fiction of an island. Artworks are scattered across this small landscape in an almost country fair, island festival manner. Kiosks, booths, and tents that present information, 2D artwork, or small virtual trinkets add to the country fair vibe. With these works being for charitable sale, the fiction of country fair blends with a true and physically real community seeking to support groups like the Red Cross/Red Crescent. The island itself with its mountain, streams, and abundance of digital palm trees seem only slightly adjusted for the virtual art show. Some areas seem to have the ground flattened to better support kiosks and booths. A few palm trees and shrubs may have been moved, but not much. The rules for searching seem to be centered on a happy wandering approach. While this may not be the most efficient design, the ability to simply stumble upon a work off the beach and underwater is a pleasant surprise and enjoyable experience.

A more structured approach to gallery design in Second Life can be seen in Bryn Oh's *2015 Retrospective* show. Built along the coast of an island, Bryn Oh in essence laid out her work on a single timeline based path. Visually, it reads like a conventional hall with a simple path system and rooms built specifically to hold her work along the way. From a design perspective, it may be closer to the idea of a critical path found in videogame levels. Critical paths are a largely singular route through an environment with small side paths that loop back to the critical path. Here the timeline path starts with an introduction to herself and her work. The critical path then kicks in, and we follow Bryn's journey and evolution as early ideas shift into new ideas and later directions. While time is commonly used to group curated art shows in physical spaces, it is the modeling of entire gallery space to fit both the virtual artwork and the timeline based critical path that is of value.

Taking this idea of a critical path further was the *Timeline* project by Dr. Steve Guynup. In *Timeline*, critical path meets diagrammatic space. Diagrammatic space is simply an architectural and path structure laid out a diagram inspired floor plan. Visitors could also see their location in the diagram via a game-like mini-map that contextually situated them in the information space.

The *Timeline* gallery itself addressed the politics of the 1960s by starting the viewer out from either the 1970 or 1950 ends of a timeline. Politics of Liberal and Conservative views in the United States were expressed in paths on the left and right side paths. Given how the introduction to a set of facts shapes interpretation of them, it was hoped that visitor's meeting in the 1960s middle of the timeline would carry some of their views over from the 1950s or 1970s respectively.

10.3.4 Moving Architecture, Bringing Content to the User

There have been a number of virtual art galleries that work to bring artwork to the visitor, or change their structure to better engage a visitor. Three particular virtual galleries are of particular interest and they are: Sex Pistols *Navigable Database*, by Cristiano Bianchi, the *Virtual Guggenheim* by Asymptote, and the *Hayfield Isovista* gallery by Dr. Steve Guynup.

The Sex Pistols *Navigable Database* rewrites some of the ideas noted in the previous discussion of critical paths and diagrammatic space. Bianchi's virtual art gallery literally fixed its rooms in a two dimensional array. In a sense, like a chess board. In doing so, the gallery grid layout reinforced the relationships between installations and created a narrative revealed by travel.

The *Navigable Database* positioned and materialized 3D information along X and Y axis's of individual people and time (in years) respectively. The example project featured individual members of the band the Sex Pistols on one axis and their history on the other axis. Travel on either axis allows users to explore the band members individually over time or the status of the members in a given year.

Visually, abstract data rooms materialize on the X, Y coordinates of the user. This small room-like space lacks walls, which allows the user to see further information marked out long the respective axis's and encourages them to travel and create their own narrative of the band. The materialization is not a shared or networked behavior so everyone sees only the data space in their X, Y coordinates. If users are situated in the same location they see the same space.

The prototype *Virtual Guggenheim* by Asymptote uses the idea of a critical path, but remakes the rules by which rooms are placed on it. Although never completed, Asymtote's approach and throwback to ideas of liquid architecture and transarchitecture by Marcos Novak are worth further study. The *Virtual Guggenheim* was an online 3D building that moves and morphs. On the surface, this novel notion of a virtual building that morphs could be viewed as just a rebellion against the static physical world buildings and the laws of physical world reality. A closer look, however, reveals some interesting possible benefits from their novel approach.

The *Virtual Guggenheim* features arrangeable blood cell-like rooms that flow through an ever morphing frame and breaks the permanent travel paths between exhibition spaces. Conceptually, this breakage allows users search via their own keywords and created their layout of the gallery. The rooms, in theory, could be laid out in a design shaped by their cognitive understandings of the relationships of art objects in different rooms. 3D travel becomes similar to making choices and navigating a series of 2D pages. In a second and simpler HCI sense, the space facilitated the user's ability to search and view art by removing unnecessary, repetitive travel down fixed paths.

The last gallery discussed is *Hayfield Isovista*, an ongoing project by Dr. Steve Guynup. As mentioned at the end of Sect. 1.1, this gallery explored a PowerPoint-like 3D slideshow mechanism to bring artwork to the viewer, thus reducing the amount of travel needed to search the gallery site and allowing more time for

visitors to focus on the art. To hold the full range of virtual artwork two presentation areas were created. One area, a C shaped half ring approximately 15 m across was used for small to mid sized virtual installations. Here artworks would appear and if needed float in the floorless center of the C. The second presentation area holds large landscapes and 360 immersive works. This is a small island space, roughly 10 m wide and 30 m long placed some 100 m above the main gallery below In this second area the artwork would appear all around the island. It's fiction being a mini version of Second Life islands and whose rules are more like the control Arch of Star Trek's *Holodeck*.

Given that visitors missed the ability to roam and explore a larger gallery, more conventional gallery areas were added. Four large exhibition areas are present. Three of which lack visible floors, and instead use invisible ground is present The removal of the floors gives flexibility in presentation as the artist gets to control the full screen of the visitor. Floor removal also allows for the gallery curator to play with the vertical space in partitionable, travelable manner that can be useful for a single work of virtual art or grouping of art.

The removal of the floor is an extension of the removal of the fictional plants, chairs, and track lights of mimetic galleries. The guiding rules of the virtual art gallery do not require a visible floor and issues of presentation do seem to conflict with its presence. This editing of space, the removal of unneeded architectural elements is common in videogames. *World of Warcraft* has removed more doors in favor of open entryways and many buildings lack walls or railings that would hinder player movement.

The three virtual art gallery examples in this final section focus on the rules of design rather than the fiction of a physical gallery. The emergent forms reflect the functions of presentation, exploration, and to some extent sociability. The outcomes then are a manipulation of rules and fictions, akin to the playful work of Shigeru Miyamoto and games like *Donkey Kong*.

10.4 Closing

Worlds that exist within the computer screen are human-made, digital, and ethereal. Lacking physical substance, these worlds also need not employ the physical rules and natural laws that frame physical reality. In this sense virtual reality is a domain of language, of signs and symbols, and of fictions.

Fiction much like that which caused the painter René Magritte to write "Ceci n'est pas une pipe" (This is not a pipe) in 'The Treachery of Images' a painting of a pipe. Magritte's work, in essence sets forth an understanding of the complex relationships of language and imagery to that of physical reality. Our current virtual reality thinking is perhaps that of a domain of signs calling back to its physical referent roots. Treachery may be a strong word for this calling back, but at this early stage of virtual development, it might be appropriate to view some of the past difficulties of virtual reality through this lens.

Videogames and the discussion of narrative and interaction, or more specifically rules and fictions, has been exploring this space of physical referents and signs for decades. The issues of incompleteness and of conflicting goals resonate outside of this playful façade and into this new reality of digitally manipulated signs. The future may depend on how we prioritize user experience (the journey) and task completion (the destination).

In the virtual art gallery examples highlight a range of possible design futures for virtual reality. Mimetic mirroring of physical galleries to abstracted and edited worlds of artistic presentation, many options for future immersive architecture exist. Game design, and specifically constructs of rules and fictions, seems to form a useful, practical framework for making design choices for virtual art galleries and perhaps virtual reality as a whole. While it's unclear what long term trends will emerge, what can be truthfully said is that the future of virtual worlds, spaces, and realities lies in the hands those who are the curious, informed, and open minded.

Art and Gallery References

ArchiVision. EUseum/museum of the future. Accessed 3 Nov 2015. https://share.oculus.com/app/museum-of-the-future

Asymptote Architecture. Guggenheim virtual museum. OpenBuildings. Accessed 3 Nov 2015. http://openbuildings.com/buildings/guggenheim-virtual-museum-profile-2437

Bianchi C (1999) Navigatable database/sex pistols. Keepthinking. http://www.keepthinking.it

Catteneo H, Bekkers A. ArtFest 4/eclectic diversity. Accessed 3 Nov 2015. http://www.isovista.org/index.php/database/gallery/item/artfest-4-eclectic-diversity

Clifford M (1997) The ALEPH a Vrml presentation. Accessed 3 Nov 2015. http://rhoge.net/clifford/start-Aleph.htm

fabric|ch B, Andy CB, Guynup S. La Fabrique 00/01/10/11. La Fabrique. Accessed 3 Nov 2015. http://www.fabric.ch/La_Fabrique/

Fillwalk J. VBAM: Virtual Broad Art Museum commission – IDIA lab. IDIA

Guynup S (2014) Isovista. Accessed 3 Nov 2015. http://isovista.org

Guynup S. Kosovo unfinished/museums and the web 2003. Accessed 3 Nov 2015. http://www.museumsandtheweb.com/mw2003/papers/guynup/guynup.html

Guynup S. Timeline/diagrammatic space. Accessed 3 Nov 2015. http://noel.pd.org/~thatguy/portfolio/indexMyVirtual.html

Lab. 20 June 2013. Accessed 3 Nov 2015. http://idialab.org/vbam-virtual-broad-art-museum-commission/

Nash A. Memory plains returning – Yamanaka Nash. Accessed 3 Nov 2015. http://yamanakanash.net/3dmusic/mprexp.html

Oh B. Retrospective 2007–2014. Accessed 3 Nov 2015. http://www.isovista.org/index.php/database/gallery/item/retrospective-2007-2014

Thiel T, Houshmand Z. Beyond manzanar. Accessed 3 Nov 2015. http://www.mission-base.com/manzanar/

References

Aarseth E (2004) Genre trouble. Electron Book Rev 3:45–56
Adams E (2014) Fundamentals of game design. Pearson Education, New York, NY
Baudrillard J (1994) Simulacra and simulation. University of Michigan Press, Ann Arbor
Carroll N (1985) The power of movies. Daedalus 114:79–103
Csikszentmihalyi M (1997) Finding flow: the psychology of engagement with everyday life. Basic Books, New York
Csikszentmihalyi M (2014) The concept of flow. In: Flow and the foundations of positive psychology. Springer, Dordrecht, pp 239–263
Eskelinen M (2001) The gaming situation. Game Stud 1(1):68
Frasca G (2014) Ludology meets narratology: similitude and differences between (video) games and narrative. Originally published in Finnish in Parnasso 1999: 3, 36571. Online: ludology. org. Accessed 28
Gingold C (2003) Miniature gardens & magic crayons: games, spaces, & worlds school of literature, culture, & communication, Georgia Institute of Technology. Georgia Institute of Technology, Atlanta, p 123
Guynup S (2012) The design of virtual space: lessons from videogame travel. In: Interdisciplinary advancements in gaming, simulations and virtual environments: emerging trends. Information Science Reference, Hershey, p 120
Jenkins H (2004) Game design as narrative architecture. Computer 44(3):118–30
Juul J (1999) A clash between game and narrative. Danish literature
Juul J (2011) Half-real: video games between real rules and fictional worlds. MIT Press, Cambridge, MA
King G, Krzywinska T (2002) Screenplay: cinema/videogames/interfaces. Wallflower Press, London
Manovich L (2001) The language of new media. MIT Press, Cambridge, MA
Murray JH (1997) Hamlet on the holodeck: the future of narrative in cyberspace. Simon and Schuster, New York, NY
Schell J (2014) The art of game design: a book of lenses. CRC Press, Boca Raton, FL
Sutton-Smith B (2009) The ambiguity of play. Harvard University Press, Cambridge, MA
Wilson ML, Kules B, Shneiderman B (2010) From keyword search to exploration: designing future search interfaces for the web. Found Trends Web Sci 2(1):1–97

Chapter 11
Adaptable, Personalizable and Multi User Museum Exhibits

N. Partarakis, M. Antona, and C. Stephanidis

Abstract Two dimensional paintings were exhibited in museums and art galleries in the same manner since at least three centuries. However, the emergence of novel interactive technologies provides the opportunity to change this status quo. By 2006, according to the Institute for Museum and Library Services, 43 % of museum visits in the U.S. were remote. According to the Institute for the Future, "Emerging technologies are transforming everything that constitutes our notion of "reality" – our ability to sense our surroundings, our capacity to reason, our perception of the world". In the present age, that technology is becoming mixed to the fabric of reality to offer novel experiences in Cultural Heritage Institutions. This work presents the design and implementation of a technological framework based on ambient intelligence to enhance visitor experiences within Heritage Institutions by augmenting two dimensional paintings. Among the major contributions of this chapter is the support of personalized multi user access to exhibits, facilitating also adaptation mechanisms for altering the interaction style and content based on the requirements of each Heritage Institution's visitor. A standards compliant knowledge representation and the appropriate authoring tools guarantee the effective integration of this approach in any relevant context. The developed applications have been deployed within a simulation space of the FORTH-ICS AmI facility and evaluated by users in the context of a pilot study.

N. Partarakis (✉) • M. Antona
Foundation for Research and Technology – Hellas (FORTH), Institute of Computer Science, Heraklion GR-70013, Greece
e-mail: partarak.@ics.forth.gr; antona.@ics.forth.gr

C. Stephanidis
Foundation for Research and Technology – Hellas (FORTH), Institute of Computer Science, Heraklion GR-70013, Greece

Department of Computer Science, University of Crete, Voutes Campus, 700 13 Heraklion, Crete, Greece
e-mail: cs.@ics.forth.gr; cs.@csd.uoc.gr

© Springer International Publishing Switzerland 2016
D. England et al. (eds.), *Curating the Digital*, Springer Series
on Cultural Computing, DOI 10.1007/978-3-319-28722-5_11

11.1 Introduction

Ambient Intelligence (AmI) presents a vision of a technological environment capable of reacting in an attentive, adaptive and active (sometimes proactive) way to the presence and activities of humans and objects in order to provide appropriate services to its inhabitants (Stephanidis 2012). In the context of Ambient Intelligence, the need to adapt a distributed system to the requirements and preferences of a diverse user population is a major issue. This work explores the penetration of AmI technology within the domain of Cultural Heritage, and more specifically Heritage Institutions, through the proposal of an augmented exhibit that can either act as a standalone exhibit itself or supplement the actual physical artifact. In this context the need of personalization is important, so as to deliver the most appropriate information to visitors, thus making some form of adaptation a necessity. This work builds on and revisits the approach to UI adaptation proposed in (Stephanidis 2001a; Savidis and Stephanidis 2004), so as to provide dialogue and task adaptation, content personalization and reasoning within Heritage Institutions and facilitate novel means of accessing art, and in particular two dimensional paintings.

11.2 Background and Related Work

Nowadays Heritage Institutions strive to design and implement interactive exhibitions that offer enjoyable and educational experiences. However, designing such an exhibition is not an easy task for various reasons. Most visitors might visit only once, and a typical visit only lasts for a very short time (Falk et al. 1985; Serrell 1998). Furthermore several considerations should be taken into account that could affect the overall information and interaction quality. First, there is a need to address various usage contexts and diverse interaction techniques. Second, the diversity of the target user population makes mandatory some form of user profiling and UI adaptation. This work has the ambition to apply state of the art research in the domain of intelligent user interfaces in the context of CH sites so as to enrich the interaction of visitors with CH in the museum context while also taking into account the individual preferences of each user for optimally adapting interface and the provision of content. Relevant research work includes intelligent UIs, content personalization, interactive digital cultural resources and mobile devices for enriching visiting experiences.

Intelligent user interfaces are characterized by their capability to adapt at runtime and make several communication decisions concerning 'what', 'when', 'why' and 'how' to communicate, through a certain adaptation strategy (Stephanidis et al. 1997). The provision of these qualities within Heritage Institutions entails the need to address design issues far more complex than those faced by traditional HCI. To address similar needs the Universal User Interfaces (U^2I) development methodology (Stephanidis 2001a) has been proposed as a complete technological

solution for supporting universal access of interactive applications and services. This methodology conveyed a new perspective into the development of user interfaces, providing a principled and systematic approach towards coping with diversity in the target user requirements, tasks and environments of use (Stephanidis 2001b). Several UI adaptation frameworks have been proposed implementing the aforementioned development methodology such as for example the EAGER framework (Doulgeraki et al. 2008) that allows Web developers to build adaptive applications. In these prior approaches knowledge about users was either statically represented or acquired through formal specifications using special purpose programming languages (Savidis et al. 2005). These traditional ad-hoc approaches are currently replaced through the usage of knowledge modelled with the help of a web ontology language such as OWL. Such models store the appropriate information in the form of semantic web rules and OWL-DL (OWL Web Ontology Language Reference 2004) ontologies. At the same time, rule engines are employed to facilitate adaptation logic and decision making while mature UI frameworks are employed to ensure a smooth user experience (Michou et al. 2009).

Existing interactive exhibits can be broadly classified in four categories: (a) hybrid exhibits which aim at augmenting an artifact with graphics (Bimber et al. 2006); or audio commentaries (Kortbek and Grønbæk 2008), (b) side exhibits which are placed adjacent to a real exhibit, providing indirect exploration of, and interaction with, it (Hornecker and Stifter 2006), (c) isolated, but linked, exhibits having "a conceptual affinity with the original artwork"; they are related to a real exhibit but installed in separate, dedicated, locations (Kortbek and Grønbæk 2008; Ferris et al. 2004) and (d) stand-alone exhibits containing content related to an exhibition, but not directly linked to an artifact (Robertson et al. 2006).

Among the different ICT technologies used in the cultural heritage sector mobile devices have currently achieved the greatest amount of penetration. Existing mobile applications for Heritage Institutions fall into the following categories (Economou and Meintani 2011): (a) 45 % provide guided tours of the Heritage Institutions in general, (b) 31 % provide guided tours of temporary exhibitions, (c) 8 % provide combinations of the first two, (d) 8 % are applications devoted to a single object, (e) 4 % offer content creation or manipulation and (f) 3 % are games.

Taking into account the above technological solutions and employing the information that ambient intelligence can provide regarding the current situational context, it becomes possible to build user interfaces that employ adaptation to answer user requirements through implicit or explicit input and thus adjust the software part of the UI (single device or a distributed UI system) at runtime (Schmidt 2005). Especially for the CH sector this can be translated to novel interactive exhibits capable to adapting to the interaction and knowledge needs of all visitors.

Although much work has been done to date, there are several limitations towards fully exploiting the capabilities of using ICT in the context of Heritage Institutions. Major improvements are considered: (a) the support of multi user interaction, (b) content personalization, (c) facilitation of structured knowledge (based on existing domain standards) and (d) scalability and extensibility. To provide these qualities the augmented digital exhibit described in this Chapter was designed and

implemented to be: (a) generic build on top of an ontology meta-model extending CIDOC-CRM which is a model that provides definitions and a formal structure for describing the implicit and explicit concepts and relationships used in cultural heritage documentation (Definition of the CIDOC Conceptual Reference Model) to present two dimensional paintings including the appropriate tools to support the integration, annotation, and preparation of knowledge, (b) a full featured multi user exhibit that can be accessed by a great number of visitors concurrently (using smart phones, digital projections, interactive captions and hand held tablet devices), (c) personalizable using mobile devices for information displays but also to fill-in user profile so as to adapt content and presentation and (d) Adaptable facilitating a rule engine to execute UI adaptation rules resulting to the optimum UI variation for each user.

11.3 Scenario of Use

For the design of the interactive system presented in this chapter several scenarios were drafted each one presenting the interaction of a user with the system. The process was iterative and in each iteration the scenarios were fine tuned in order to meet end user expectations but also cope with the limitations of technology. The final scenario that meets the outcomes of this work is presented in this section.

Anna decides to take a visit to the local museum of Art. While entering the museum towards the exhibition, a notification appears on her mobile device prompting her to download the mobile client. She also takes a minute to fill in an anonymous profile. Within the museum her mobile device is used as a navigator allowing her to access information by scanning QR codes. When Anna approaches an exhibit, she notices that information is projected on the periphery of the painting, while a tablet is unobtrusively located in front as an interactive caption. Anna can use touch for navigating and browsing the vast collection of information available for the specific exhibit using the tablet. She also shows the QR code representation of her profile to the caption (or any other component of the exhibit) so as to access personalised information (Anna has painting as a hobby and loves learning about materials and techniques used by the old masters). She also notices that the UI of the caption is altered allowing her to slide through representations (because she is familiar with the usage of mobile devices and has declared her expertise in her profile).

When she stands in front of the digital painting, an interactive menu appears allowing her to start interacting with the specific exhibit. She can use her hands to indicate points of interest within the painting to obtain information regarding the selected points of interest. She can also use gestures for zooming in and out specific regions of the painting and therefore accessing details that are typically lost when digitized artefacts are presented in their entirety at low resolution. Anna also wonders what happens when more than one person is accessing the same exhibit. In the room she sees several people standing in front of a large painting and all

seem to be actively engaged. She also notices that an elderly user is required only to locate himself in front of a painting so as to get information. Alternatively, when approaching a physical exhibit she get informed that she can use one of the tablets located on a stand on each side of the exhibit to access personalised information based on her location in front of the painting.

Based on the aforementioned description of Anna's interaction with the system the appropriate components were identified and the required distributed architecture presented in the following section was structured. The architecture presented in the next section addresses the needs of the scenario but is generic enough to be scalable so as to easily cope with alternative instantiations of the concept in the future.

11.4 A Distributed Architecture to Support Content and UI Adaptation in Heritage Institutions

The architecture followed for the implementation of the proposed interactive digital exhibit is presented in Fig. 11.1. Four main goals were addressed through the proposed architecture: (a) model the knowledge facilitated by the system (artefacts, users and context), (b) provide facilities within a distributed environment (consisting

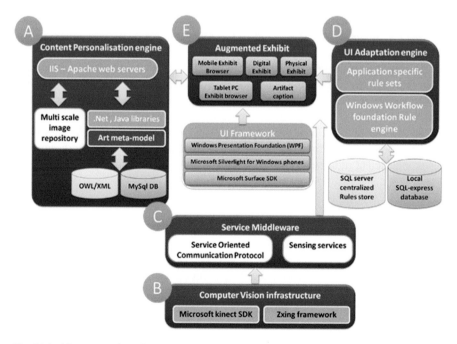

Fig. 11.1 Abstract service oriented architecture

of applications, devices and sensors), (c) provide personalised information to users based on their preferences and (d) perform task and UI adaptation.

The Content Personalisation Engine (Fig. 11.1 section A) employs the Art meta-model, which is an extension of the CIDOC CRM (Definition of the CIDOC Conceptual Reference Model), to represent two dimensional paintings. The model is populated by using an authoring tool and currently contains 300 paintings by 30 world known artists. Additionally, the User Profile model of the engine contains attributes used to personalise information to visitors. These models are exported to the higher levels of the architecture through a set of programming language classes (c#, java protégé data export facilities) and two sparql queries (c# using SemWeb.Net and java using Jena and Pellet). Finally, the multi-scale image repository stores and serves through an IIS web server images in extremely large resolutions and their representation in xml so as to be used for deep zooming into digital artefacts.

The Computer Vision Infrastructure (Fig. 11.1 section B) is built on top of the Microsoft Kinect SDK to support a number of alternative interaction styles (hand – skeleton tracking, gestures and postures recognition). At the same level lies the zxing library for generating and scanning of QR codes.

The service oriented communication protocol (Fig. 11.1 section C) built on top of the FORTH's Famine middleware (Georgalis et al. 2009) (a distributed service oriented middleware), provides a common dialect for applications to coexist and communicate in the context of the developed application scenarios while using sensing for decision making.

The UI Adaptation engine (Fig. 11.1 section D) has the responsibility of producing adaptation decisions using the Windows Workflow Foundation Rules. A set of rules has been defined for each application. These rules are modeled separately from the interface itself and the adaptation engine carries out the task of chaining an interactive application with its rules and user profile so as for adaptation to be performed.

Finally, the Applications (Fig. 11.1 section E), which extract functionality from services, are targeted to different devices and application frameworks and are interconnected at runtime to form personalized application scenarios.

11.5 The Augmented Personalised Exhibit

The Augmented Personalized Exhibit provides interaction where no interaction exists (making physical artefacts interactive) and provides interactive digital arte-facts where no artefacts exist (importing both an artefact and the means to interact with it within the Heritage Institutions experience). It comprises a number of devices for content provision as long as a number of modalities for interaction. As shown in Fig. 11.2, the main section of the exhibition wall is occupied by a digital representation of an exhibit in two variations. The first variation is a fully digital exhibit where the exhibit itself is projected through the usage of a short throw

projector, while the second one is an actual physical painting. In both cases skeleton tracking technology is installed on the exhibit in order to track the location and distance of visitors. The installed tracking technology supports the presentation of information about points of interest using body tracking (two visitors are supported on the body tracking mode while three are supported for the hand tracking). At the sides of the exhibit, two tablets are mounted on the wall or on two portable stands to act as the captions of the painting. The captions based on the visitor profiles present various information such as description, videos, points of interests, deep zoom representation of the painting, full artefact info and information from external sources. These tablets are also equipped with embedded web cameras for QR code recognition. Visitors' mobile phones are used for accessing information about the exhibit by scanning the QR codes (from the captions). Portable tablets, rented or carried by visitors can also be employed as information displays (Fig. 11.2).

11.6 Altering the Interactive Digital Exhibit in Accordance to User Needs

11.6.1 Content Personalization

The content personalisation workflow is initialised by the installation of the mobile client on a visitor's cell phone. When the application launches, the user is prompted to fill-in an anonymous user profile. User selections are stored in the smart phone's local storage. This profile is used for presenting personalised information from the smart phone. To do so, all queries to the ontology model formed by the mobile application carry with them the required profile attributes and the QR code of the exhibit scanned by the user. Users can use the mobile client to generate a QR code representation of the profile that is in turn scanned by other interactive applications so as to identify user preferences. For example, the user can show the QR code generated from his/her mobile phone to the mounted caption or the exhibit itself, and the exhibit personalises the information to the profile selections of the user.

11.6.2 UI Adaptation

Concerning UI adaptation, each interactive application comes to its initialisation state by retrieving and executing the application specific rules (the default application rules) from the rules store. A QR recognition service is initiated and runs on the background. Each of the users can in turn use their Smartphone to generate the QR code representation of their profile, and point this representation to the application so as to transfer their preferences to the application. The transmitted preferences are used to alter several application properties. This results in the re-evaluation of the

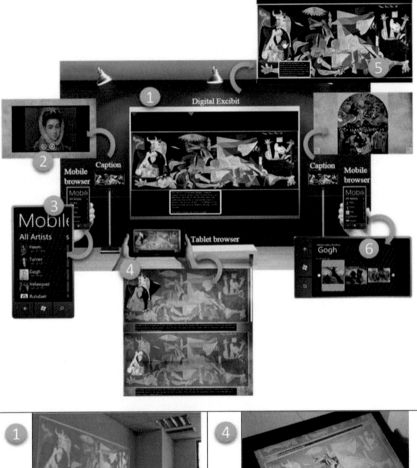

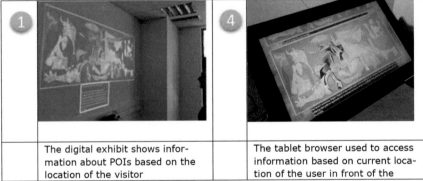

1	The digital exhibit shows information about POIs based on the location of the visitor	4	The tablet browser used to access information based on current location of the user in front of the

Fig. 11.2 The interactive digital exhibit

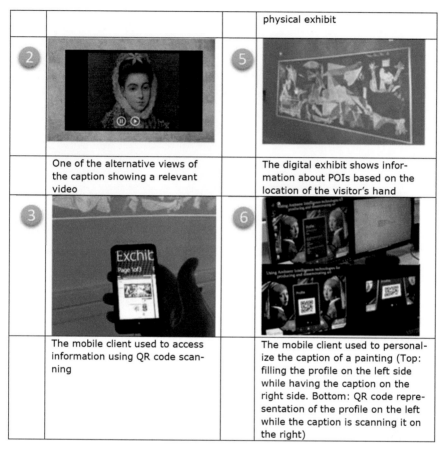

			physical exhibit
②		⑤	
	One of the alternative views of the caption showing a relevant video		The digital exhibit shows information about POIs based on the location of the visitor's hand
③		⑥	
	The mobile client used to access information using QR code scanning		The mobile client used to personalize the caption of a painting (Top: filling the profile on the left side while having the caption on the right side. Bottom: QR code representation of the profile on the left while the caption is scanning it on the right)

Fig. 11.2 (continued)

rules by the rule engine and the generation of adaptation decisions that are directly transferred from the Rules Engine to the application. The result is the generation of an adapted UI that matches the user preferences as recorded to the profile.

11.7 Evaluation

The evaluation methodologies was to test the exhibit with usability experts and then carry out usability tests with exhibit visitors. The expert based evaluation was conducted by three usability experts. A scoring scale from 0 (not a usability problem) to 4 (usability catastrophe) was used (Nielsen and Landauer 1993). Thirty issues were identified in total, and 12 of them were considered major usability problems. The user-based evaluation session was performed with the participation

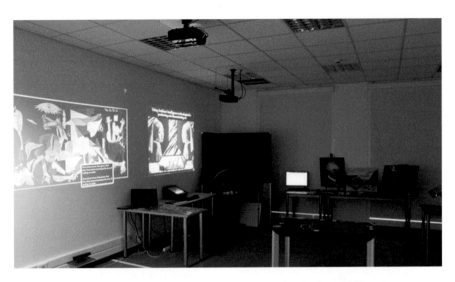

Fig. 11.3 The interactive digital exhibit deployed in the context of the FORTH's AmI facility

of ten users. Users were requested to fill in a pre-test questionnaire containing demographic information and questions to collect data regarding the usage of ICT technology within Heritage Institutions. Upon completion of this process users were requested to carry out a number of interaction scenarios and then fill in a post-test questionnaire. The user based evaluation was conducted within a room in the AmI facility of ICS-FORTH that was appropriately set up to host the implemented interactive digital exhibit as shown in Fig. 11.3. User interaction was recorded for offline processing.

The analysis of the **pre-test questionnaire** showed that 60 % of the users visit a Heritage Institutions once a year, 50 % declared their interest in painting but only 10 % follow some specific art styles or trends. More importantly, 50 % of the users have visited in the past a Heritage Institution with some form of interactive exhibits. Regarding their satisfaction, 90 % are not satisfied about the information gathered, while 60 % feel that Heritage Institutions visits are boring. To overcome this issue, in the past 10 % have hired a guide and 50 % an audio guide. Eighty percent of the participants had experience with other forms of interaction in addition to computer and mouse.

The results gathered through the **post-test questionnaire** were used to calculate four factors. The overall user satisfaction, the satisfaction of users when using the system, the quality of the provided information and the satisfaction regarding the interface provided by the system. Regarding overall user satisfaction ∼87 % of the users are within the range 5–7 while 30.56 % of the users provided a grade of 7 to all questions. However, ∼5 % of the users stated that they were not satisfied. Regarding user satisfaction when using the system ∼85 % of the users are within the range 5–7 while ∼37 % of the users provided a grade of 7 to all questions. However, there

are ~14 % of the users that state that were little to medium satisfied. Regarding the information quality ~88 % of the users are within the range 5–7 while ~25 % of the users provided a grade of 7 to all questions. However, ~43 % of the users scored 6, which implies that there is a substantial amount of users who faced some form of difficulty understanding the presented information. Finally in the case of satisfaction regarding the user interface of the system ~83 % of the users are within the range 5–7, while ~35 % of the users provided a grade of 7 to all questions. However, ~25 % of the users that scored 5 and ~24 % scored 6, which implies the existence of some form of usability barriers. The results of the aforementioned quality factors provided some initial indications about potential areas of improvement. To identify those areas more clearly further post processing was conducted. The questions where grouped into four categories, analysed both individually and by category:

- **General User Satisfaction:** Regarding the general user satisfaction ~22 % of the users score a medium satisfaction while also ~66 % of score 6 while only ~11 are fully satisfied. These results also empower the need of further investigation to identify areas of improvement. Analyzing the comments provided by users in the questions used to calculate general user satisfaction several new research directions became prominent. In some cases users may require specialized curation for some digital assets especially in the case where the digital asset is linked to a myth, or a historic event. In such cases the system should support the curators into the process of revealing the myth out of the artefact, providing extra historic information or even building a story to be told. These new directions highlight the need for concrete strategies towards curating digital assets.
- **Interaction metaphors:** The hand tracking interaction metaphor scored lower grades in relation to body tracking and touch (~55 % of the users scored 5 regarding hand-mirrored hand synchronizations and ~44 % scored 5 into hand based content navigation). On the contrary, body tracking and touch have better results.
- **Information representation and extraction:** Users were in general very satisfied (~85 % scored from 5 to 7 in all questions). Nevertheless there, is a percentage of ~55 % who are not fully satisfied regarding the way that information is browsed in general. In this sense 33 % scored 5 the way that information is presented using body tracking, ~44 % scored 6 for the mobile client, while ~55 % scored 6 in the caption.
- **UI Adaptation:** Regarding the ways that the UI of the system are adapted, users were in general satisfied (~70 % scored from 5 to 7 in all questions), but there was a substantial number of users that were not fully satisfied with the way that the system was adapted to map their selected profile. In their comments some of the users documented that for example they preferred to slide the different screens of the digital caption but based on their profile next and previous buttons appeared. Such cases are typical examples when performing profile based adaptation and are typically restored by integrating an additional personalisation layer to the system. In this layer the user overrides the default decisions made by the system to fine tune the interface to best suit his/her personal preferences.

Especially in the case of Heritage Institutions where visitors have limited time
to configure a provided interface integrating such a layer does not seams a good
idea. The usability experts proposed a more intelligent way of solving such issues
by introducing the possibility of runtime adaptation based on user input. For
example in the case of navigation buttons a message could appear to the user:
"Switch to slide by just sliding your finger over the screen". In such a case the
user can perform the personalisation part while browsing information.

11.8 Discussion and Future Work

This work expands the current state of the art in the context of augmented exhibits
within Heritage Institutions in a number of directions. The proposed digital exhibit
integrates a number of alternative devices and interaction metaphors to facilitate
simultaneous multi user access to art. Moreover, focus is put back to art itself
rather than providing just another exhibit. In the same context visitor's interaction
capabilities, technology expertise and art knowledge are facilitated for conducting
content personalisation and UI adaptation copping with the diversity of the target
user population. Finally, user acceptance and satisfaction factors were measured by
conducting a user based evaluation within an in-vitro installation of the proposed
approach. Regarding future improvements, the first step is the improvement of the
proposed work based on the feedback received by users while also considering the
possibility of practical exploiting the concept within Heritage Institutions.

References

Bimber O, Coriand F, Kleppe A, Bruns E, Zollmann S, Langlotz T (2006) Superimposing pictorial
 artwork with projected imagery. In: ACM SIGGRAPH 2006 courses. ACM, p 10
Definition of the CIDOC Conceptual Reference Model: http://www.cidoc-crm.org/docs/cidoc_
 crm_version_5.1-draft-2013May.pdf
Doulgeraki C, Partarakis N, Mourouzis A, Stephanidis C (2008) A development toolkit for unified
 web-based user interfaces. Comput Helping People Spec Needs 2008:346–353
Economou M, Meintani E (2011) Promising beginnings? Evaluating museum mobile phone apps.
 In: Rethinking technology in museums conference proceedings, pp 26–27
Falk JH, Koran JJ, Dierking LD, Dreblow L (1985) Predicting visitor behavior. Curator: Mus J
 28(4):249–258
Ferris K, Bannon L, Ciolfi L, Gallagher P, Hall T, Lennon M (2004) Shaping experiences in the
 hunt museum: a design case study. Proc Dis 2004:205–214
Georgalis Y, Grammenos D, Stephanidis C (2009) Middleware for ambient intelligence envi-
 ronments: reviewing requirements and communication technologies. In: Stephanidis C (ed)
 UAHCI 2009, part II. LNCS, vol 5615. Springer, Heidelberg, pp 168–177
Hornecker E, Stifter M (2006) Learning from interactive museum installations about interaction
 design for public settings. In: Proceedings of OZCHI '06. pp 135–142

Kortbek KJ, Grønbæk K (2008) Interactive spatial multimedia for communication of art in the physical museum space. In: Proceedings of the 16th ACM international conference on Multimedia. ACM, pp 609–618

Michou M, Bikakis A, Patkos T, Antoniou G, Plexousakis D (2009) A semantics-based user model for the support of personalized, context-aware navigational services. In: First international workshop on ontologies in interactive systems, 2008, ONTORACT '08, pp 41–50

Nielsen J, Landauer TK (1993) A mathematical model of the finding of usability problems. In: Proceedings of the INTERACT'93 and CHI'93 conference on human factors in computing systems, ACM, pp 206–213

Robertson T, Mansfield T, Loke L (2006) Designing an immersive environment for public use. In: Proceedings of PDC '06, ACM, New York, pp 31–40

Savidis A, Stephanidis C (2004) Unified user interface development: the software engineering of universally accessible interactions. Univ Access Inf Soc 3(3–4):165–193

Savidis A, Antona M, Stephanidis C (2005) A decision-making specification language for verifiable user-interface adaptation logic. Int J Softw Eng Knowl Eng 15(6):1063–1094

Schmidt A (2005) Interactive context-aware systems interacting with ambient intelligence. In: Riva G, Vatalaro F, Davide F, Alcañiz M (eds) Ambient intelligence, (part 3). IOS Press, Amsterdam, pp 159–178. http://www.ambientintelligence.org

Serrell B (1998) Paying attention: visitors and museum exhibitions. American Association of Museums, Washington, DC

Stephanidis C (2001a) The concept of unified user interfaces. In: Stephanidis C (ed) User interfaces for all – concepts, methods, and tools. Lawrence Erlbaum Associates, Mahwah, pp 371–388. ISBN 0-8058-2967-9

Stephanidis C (2001b) New perspectives into human – computer interaction. In: Stephanidis C (ed) User interfaces for all – concepts, methods, and tools. Lawrence Erlbaum Associates, Mahwah, pp 3–20, 760 pages. ISBN 0-8058-2967-9

Stephanidis C (2012) Chapter 49: Human factors in ambient intelligence environments. In: Salvendy G (ed) Handbook of human factors and ergonomics, 4th edn. Wiley, New York, pp 1354–1373

Stephanidis C, Karagiannidis C, Koumpis A (1997) Decision making in intelligent user interfaces. In: Proceedings of the 2nd international conference on intelligent user interfaces, ACM, pp 195–202

OWL Web Ontology Language Reference (2004) W3C recommendation, 10 Feb 2004. http://www.w3.org/TR/owl-ref/

Chapter 12
Disruption and Reflection: A Curatorial Case Study

Deborah Turnbull Tillman and Mari Velonaki

Abstract New Media Curation is a research initiative and small business directed by practice-based researcher, Deborah Turnbull Tillman. In reflecting on past collaborations, she has contributed book chapters on prototyping within museums and curating digital interactive art using Museum, Government and Independent funding models to analyze curatorial processes. This chapter focuses on the processes Turnbull Tillman follows in curating digital interactive art, introducing variables such as disruption and reflection to the traditionally disparate disciplines of fine arts, responsive systems, and business theory. Recent collaborations and a reflective practice case study shows that the New Media Curation methodology takes the interdisciplinary design of interactive art exhibitions outside labs/studios and into institutions and urban landscapes in the form of experimental, often prototype exhibitions. Through an examination of past and current collaborators and influences, and a reflective practice curatorial exercise, collaborating artists and curators are led through critical and creative spaces by speculative design, audience engagement and evaluation, and analysis of Turnbull Tillman's curatorial experience as a practice-based researcher.

12.1 Introduction

This chapter examines the curatorial technique of testing exhibition processes based on "disruptive ideas" within a practice-based research [PBR] framework. It will introduce variables to explore the main research question:

Can contemporary curators disrupt exhibitions featuring digital interactive art at various stages in order to discover new systems for curating digital interactive art?

D. Turnbull Tillman (✉)
New Media Curation, Sydney, Australia
e-mail: deborah@newmediacuration.com

M. Velonaki
The Creative Robotics Lab, National Institute of Experimental Art, University of New South Wales, Sydney, Australia

© Springer International Publishing Switzerland 2016
D. England et al. (eds.), *Curating the Digital*, Springer Series
on Cultural Computing, DOI 10.1007/978-3-319-28722-5_12

The framework for this study will introduce the variables prototyping, elicited response (as in responsive systems) disruptive technologies (as understood in business theory), and reflective practice in the form of field research. The prototyping process is shown as a disruptive force in the making/exhibiting of digital interactive art, with audience response being a sought after result. It will also consider the audience's role in both curating and experiencing interactive art systems and the ability to analyze this phenomenon via evaluation.

Situating this curatorial study across traditionally disparate media and creative making practices will help in establishing specific criteria. Any outcomes will assist in establishing a common language for the experience of this hybrid art form. If this task can be accomplished, the disruptive nature of the curatorial process in light of new – and arguably disruptive technologies made by disruptive practitioners – can at this point in visual and art histories, assist in establishing curating as a revolutionary act rather than an evolutionary constraint.

As a practice-based researcher, I am interested in the audience's role in interactive art, particularly regarding contemporary curatorial practice. To broaden the context of this interdisciplinary interest and situate New Media Curation as a research initiative and small business[1] we will first examine the emergence of disruptive technologies on the larger global digital market, as in business theory. We will then transfer this understanding and application in a contemporary art context by including a reflective practice case study produced during *ISEA2015: disruption.* This analysis of the participation by artists and technologists in a prototyping project will be put forward as a disruptive variable to the way that a curator would normally work with artists in the capacity of exhibiting finished, rather than in-progress works. This discussion will provide the specific context in which I am currently working to examine curatorial practice within experimental environments. Within this context, I will demonstrate how New Media Curation can begin to formally develop exhibitions in the way that artists and technologists collaboratively develop the work, through a series of iterative exhibitions that may cause discomfort or anxiety on the part of both creators and consumers of digital interactive art. This discomfort, based on the experimental nature of the process, will hopefully lead to the discovery of new knowledge.

In exhibiting digital interactive works at the prototype phase with ISEA2015, I am participating in a disruptive practice for all parties concerned (artist, technologist, exhibitors and audience members). I also posit possible solutions to fallouts based on refining the methodologies that have formed my curatorial practice, this time with reflective practice. Disruptive technologies as understood in a broader context, are rather exciting in terms of the evolution of materials for generating thought about them. The term 'disruptive technologies' was coined by businessman and technologist Clayton M. Christensen in 1995 (Bower and Christensen 1995). Throughout the end of the 1990s and 2000s, Christensen wrote with and in response to various researchers on this topic, posing dilemmas

[1] www.newmediacuration.com. Accessed 29 February 2012.

and offering solutions through various publications. Where he argued for market stability by keeping disruptions minimal and offering explanations when markets were interrupted by what he later termed 'innovations,' there were several theorists who countered that disruptions were totally negative to any marketplace. Oliver Gassman describes technology as being considered "a form of social relationship," that is "constantly evolving." In fact he defines these ecologies and the variables within them as unfixed (Gassman 2006).

It is at this point that the authors are reminded of the very nature of speculative design, in which experimental practice, and perhaps even prototyping and reflective practice, may be disruptors that find a common purpose. There may be some merit in articulating that the way the materials of interactive art (digital technologies) and the processes for exhibiting (prototyping), designing (speculative), and critical thinking (reflective journaling) about exhibitions featuring digital interactive art overlap and interweave. Where speculative design tends to find a provocation to start from rather than a design problem to solve, prototyping is a scenario- or event-based type of testing where each iteration is either a little or a lot better than the previous model. The critical thinking component that comes from reflective practice lends a personal development edge to the professional aspect of the work, found in Sect. 12.5 of this chapter. The development of the digital component of these works are further outlined below.

As Gassman states, "Technology starts, develops, persists, mutates, stagnates and declines – just like living organisms." Within this particular ecology are different technologies battling it out with each other for the label of high technology (in comparison to the creative practice of different aesthetics battling it out for the label of high Art). Life-cycles emerge as new technologies are created and utilized by target markets. When a high technology is determined as the best and most used it challenges the current Technical Support Nets (TSNs) which facilitate and govern market value in terms of technology. Instead of dying out, the governing system has the option of co-evolving (Ibid). Where Christensen is critical of this interpretation, colleagues of Gassman and Christensen argue for the power of disruptive technologies. For example, Joseph Bower speaks to how disruptive technologies can transform an industry (Bower 2002), and Milan Zeleny speaks of how disruptive technologies can cause resistance, not to the technologies themselves, but to the change they bring to people already reliant on the current dominant system to thrive in the changing of language and practice (Zeleny 2009).

When one thinks through disruptive technology theory and then introduces its techniques to traditionally ordered processes, like administering and curating art exhibitions, a space opens up wherein experimental inquiry can take place. In collaboration with artists and curators, as director of New Media Curation, I am performing research and operating my business in this newly identified space. Many cross-disciplinary practitioners write in this way about the emergence of technology and its effects on aesthetics. As with any emergent technology, some fear it (for example, the later writings of Sherry Turkle 2007), others embrace it (Julienne Greer 2013), and eventually a co-existence emerges that challenges the previous dominant norm. The effects of technology on the body and on works created performatively

(ie/interactive artworks) are of particular significance to this study, and are examined in particular by artists like Erin Manning who featured with Nathaniel Stern at ISEA2015 (Armstrong 2015).

Many of these disruptive techniques were previously initiated and observed by myself and the artists, researchers and curators I worked with through the Beta_space project through Creativity and Cognition Studios and the Powerhouse Museum. Of course, I also see examples in my current research environment at the Creative Robotics Lab (CRL) at the National Institute of Experimental Art (NIEA) at the University of New South Wales (UNSW), and particularly during my own reflective practice, including field research producing the Art Program for the International Symposium of Electronic Art *[ISEA]2015: disruption* in Vancouver, BC, Canada.

12.2 Beta_space: A Disruptive Force for Curating in the Museum

The problems associated with digital interactive art include its immateriality and repositioning of time and space, thus making the act of evaulating one's interaction with it problematic. As discussed in Graham and Cook (2010), these problems place a particular need on the curator to revise traditional practice. Relevant recent work in this field includes that of Ernest Edmonds' research group the Creativity and Cognition Studios. Through their work in Beta_space, a publicly housed laboratory that was established at the Powerhouse Museum, Sydney, they have set up an infrastructure, a methodology for measuring experience and emotion in digital interactive art. The writings about this work form an important basis for my practice-based research. Reports on the curatorial practice of Lizzie Muller, Matthew Connell, and myself all detail the making and evaluating of interactive art at various iterative phases in a public laboratory. Lizzie Muller's PhD and related writings report the core research that forms the background to this study (Muller 2010). The significance of the Creativity and Cognition Studios work was innovation in:

1. bringing the work out of a university lab and into the public domain before it was finished (Muller et al. (2006);
2. establishing a set of criteria for measuring audience experience (Bilda et al. (2007); Costello (2007));
3. offering this process to the public as an exhibition on display for public consumption (Turnbull and Connell (2011) p. 79–93).
4. taking these processes out of the realm of culture and into the community as creative practice for corporations and institutions as well as artists and curators (Muller et al. (2006); Turnbull and Connell (2011, 2014)).
5. producing three models for curating digital interactive art, two of which hold preliminary criteria for exhibiting digital and interactive art (Turnbull and Connell (2014) p. 221–241).

These activities are best captured en masse in Candy and Edmonds' book *Interacting: art, research and the creative practitioner* (Libri, UK: 2011). This publication not only details the methodologies followed during the 7 years Beta_space was actively programmed in the museum, but provides a history of digital interactive art, with Candy and Edmonds outlining the current categories, aesthetics, influences, paradigms, creative spaces, and cultural shifts in relation to the artist and audience; the producers and consumers of art (Turnbull et al. 2015).

12.3 Inside the Creative Robotics Lab, National Institute of Electronic Art, University of New South Wales

Where my work at the Creativity and Cognition Studios strongly informs my independent practice, it is but one of many places interested in investigating the potentially disruptive nature of prototyping in the making of interactive art. In my current research environment at the Creative Robotics Lab at the National Institute of Electronic Arts [NIEA], University of NSW [UNSW],[2] I have again found that artists and technologists are working closely together to create technically sophisticated, but artistically subtle, prototype artworks that engage and respond to the humans interacting with them. Dr. Mari Velonaki, co-author and director of the CRL, is and artist currently collaborating with the Object Design Centre in Sydney on a prototype curatorial project through CUSP.[3] CUSP, curated by Object's Creative Program Manager Danielle Robson, is a platform whereby artists can present their design ideas regarding the way we inhabit the world as humans within a complex set of digital systems. Sometimes in institutions, sometimes out in the urban landscape, CUSP is pushing the boundaries of experimental design practice to see what designing the future might be like for artists, technologists, engineers, and architects.[4]

Where Velonaki has previously participated in CUSP in presenting talks on a train that runs from Central Station to Casula (the Talks in Transit series[5]), a more recent work of hers is being presented in a prototype way as "chapters" across several venues, the first currently exhibiting at the State Library of Queensland.[6] The work that Velonaki and her technological collaborators are staging at various stages in CUSP is called *Blue Iris*. This is an interactive work that presents like digital wallpaper, but acts as a both a repository and narrator for audience members

[2]http://www.crl.niea.unsw.edu.au/- accessed 17 October 2015.

[3]Mari Velonaki. CUSP. http://cusp-design.com/designer/mari-velonaki/. Accessed 8 December 2014.

[4]CUSP. http://cusp-design.com/about/. Accessed 8 December 2014.

[5]http://cusp-design.com/event/talks-in-transit-session-2/- accessed 14 October 2015.

[6]CUSP @ State Library of Queensland. http://cusp-design.com/event/cusp-state-library-of-queensland/. Accessed 19 December 2014.

who participate with it. It activates the histories of buildings and their occupants by occupying space and recording how spaces and surfaces are experienced by audience via engineered screens comprised of thermochromic/thermoresistive patterns and a gold nano-particle-based floral motif.[7]

Velonaki finds the prototyping process disruptive in the making of digital interactive art. The physical disruption, however, takes a backseat to the rewards gained from discomforting herself and her team. This discomfort extends to the exhibition phase, where she feels no one is really happy with the prototype being on display because it is not yet representative of the bigger picture everyone has in mind. In living this discomfort, she also finds the process invaluable. In being exposed in this way, in exhibiting a raw model of her aesthetic ideal, in fashioning a "good enough" version of the idea and then standing back and releasing the concept as a simpler version/form of the whole idea to the audience, she, as the designer, becomes removed from it. Velonaki can let it be experienced this way because she knows that the feedback from this process will inform future design decisions across the team. Together everyone, the artist, the engineer and the computer scientists, have all taken a step back and viewed how the audience engages with the work. Velonaki now finds this incremental processing so fundamentally helpful that she would not do it differently. The discomfort has become more ideologically disruptive, with the rest becoming and remaining her process.

One of Velonaki's collaborators, mechanical engineer David Silvera-Tawil, considers the prototype process to be incredibly disruptive, particularly in terms of construction briefs. In the engineering world, prototypes are built to test an idea and can be 'quick & dirty' with minimal consideration to aesthetics. Alternately, one of the predominant concerns of any collaborating artist would be aesthetics, so ensuring a prototype system looks cohesive enough to both exhibit and engage/hold an audience is a challenge. In participating in this interdisciplinarity, Silvera-Tawil thinks of research outcomes first and what they might learn from the project as a whole. Where he finds creative prototyping "incredibly disruptive" to his engineering practice, he also finds much value in approaching these challenges differently then he would traditionally, with the end goal of producing a different kind of data set or a different kind of new knowledge.[8]

[7]Blue Iris. https://www.sites.google.com/site/silveratawil/Research. Accessed 18 December 2014.

[8]Views expressed by David Silvera Tawil in an interview with Deborah Turnbull Tillman on 8 December 2014, 11 am–12:30 pm.

12.4 Curating as a Disruptive Technique: A Methodology

12.4.1 Introduction

As a curator, representing institutions and funding bodies whilst also working quite closely with the above mentioned artists, technologists, institutions and curators, disruptions come in different forms. They can be revealed through observing, recording and analyzing the intentions, actions, and reactions of artists, technologists and audience members, the creative practitioners that digital arts curators tend to collaborate with. My research methodology proposes to move through a series of steps that I generally follow when curating/production interactive art exhibitions. In reflecting on past and present collaborations, I can begin to hone my own appreciative system (Schön 1983; Muller 2011) treating theses experiences as curatorial prototypes for analysis in order to form the foundation of a larger iterative cycle involving practice-based research and curatorship.

12.4.2 Professional vs/Creative Practice

It is worth mentioning at this stage, that there is a clear distinction between professional and creative work for most practice-based researchers. It seems so especially for curators, who are often administrators as well as specialists, authors, editors, archivists and producers. In situating myself within Donald Schön's reflection-in-action as a function of practice-based research after John Dewey (Leddy 2013) and Muller (2011), I am engaged in a tension between creating and producing, where one practice starts, and the other intervenes, or even encroaches to create disharmony and disruption. The result is an internal appreciative system created by feeling your way forward as a creative practitioner, evolving your practice in creating an experience archive you can draw on at different stages of your research. Upon reflection, some things work and are appropriated into your appreciative system; other things don't and are set aside, perhaps to be utilized another time. But in experimenting and reflecting on this experimentation, I am starting to hone my own 'live' practice. Similar to the metaphor of technology as a living organism as posited earlier by Oliver Gassman, John Dewey tracks the experience of the "live creature" as below:

> Life overcomes and transforms factors of opposition to achieve higher significance. Harmony and equilibrium are the results not of mechanical processes but of rhythmic resolution of tension. The rhythmic alternation within the live creature between disunity and unity becomes conscious in humans. Emotion signifies breaks in experience which are then resolved through reflective action. Objects become interesting as conditions for realising harmony. Thought is then incorporated into them as their meaning. (Leddy on Dewey 2013).

Where the tension and resolution of creation vs/production could likely be articulated by any contemporary curator, in the New Media Curation case studies for reflection and analysis I am examining exhibitions that I both conceived and supported others in realizing. As a curator, representing institutions and funding bodies whilst also working quite closely with artists and technologists, disruptions come in different forms; those of observing, recording and analyzing the intentions, actions, and reactions of artists, technologists and audience members. The first part of this study proposes to reflect on a series of my exhibitions, starting here with ISEA2015, treating them as curatorial prototypes for analysis in order to form the foundation of a larger iterative cycle involving practice-based research and curatorship.

12.4.3 Methodology (UNSW Ethics Approval HC15109)

> ... in order to understand the aesthetic in its ultimate and approved forms, one must begin with it in the raw ... (Dewey 1934).

This next part of this chapter contains a current case study which utilizes the proposed curatorial methodology I generally follow, depicted below. The methodology is practice-based, drawing upon the action research approach (Stringer 2003) (Fig. 12.1).

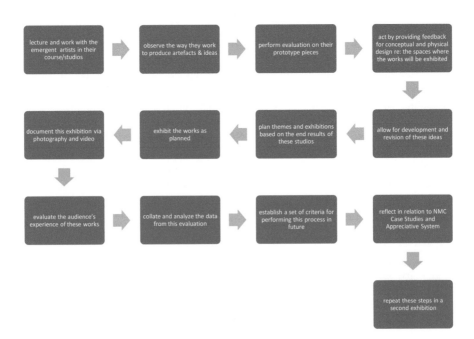

Fig. 12.1 Turnbull Tillman's practice-based research methodology, 2015

Stringer's approach of LOOK -> THINK -> ACT is based in social reform and draws on Lewin's "spiral of steps" that attempt to depict "comparative research on the conditions and effects of various forms of social action, and research leading to social action." (Smith 1996). Johnson, a social scientist from the 1970s, has revised Lewin's spiral utilizing words such as UNFREEZING -> CHANGING -> REFREEZING. A more contemporary take on these approaches is outlined in Lizzie Muller's close reading and application of Donald Schön's reflection-in-action approach to curating that I am appropriating and experimenting with here. In learning to curate under Muller at the Beta_space public laboratory, I am a product of her own experimental approach to curating interactive art via her documented process of experimenting -> protoyping -> reflecting -> iterating -> publishing (Muller 2011).

In measuring the experience of interactive art across disciplines and groups, conceptual development takes place with the curator offering a brief and the practitioners responding to it. This is not to say the curator is the catalyst of an artist's creative idea or a technologist's animation of that idea, but they are definitely becoming a participant in new media and interactive practice. In meeting with, evaluating, iterating and exhibiting prototypes with an emerging or established practitioner, this will feed the reflective curatorial process, as will the evaluation of audience experience. Each of the above steps in the curatorial, exhibition and evaluation process represents the creative and professional progression of my practice-based research. The newest, and most unfamiliar to New Media Curation, is to perform curatorial tasks for the purposes of a reflective case study. The first exercise of this kind within my own practice is outlined in the next section.

12.5 Reflection on ISEA2015: A Disruptive Curatorial Case Study

12.5.1 Introduction: May–August 2015 | Sydney | Vancouver

In January 2015 I was recruited as Exhibition Production Manager for the ISEA2015 art program in Vancouver, BC, Canada. I began to think about how I might approach this paid contract as a reflective case study for practice-based research, experimental curating, prototyping, and the business side of New Media Curation. I saw the potential for ISEA2015 as a platform for further working through a reflection-in-action approach to curating.

In researching models to augment and extend the Creativity and Cognition models for journaling reflective practice (Candy 2006) and Muller's close reading of Schön's Reflective Practitioner (2011), I came across a cyclic model that fit my experience with ISEA2015 quite well. University of Newcastle librarian Narelle Hampe (2013) has established a model for continuous reflective practice based on Schön's reflection-in and reflection-on-action (1973; 1983; 1987), and Killion

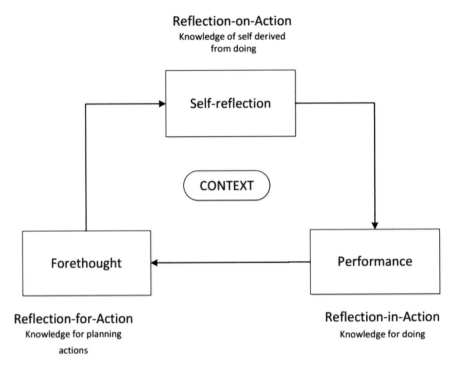

Fig. 12.2 Hampe's reflective cycle model, 2013

and Todnem's reflection-for-action (1991). She argues that these three modes set up a way to continuously reflect on and develop your professional skill set based on critically examining your personal experiences. The model is found above (Fig. 12.2).

I found that in replacing Hampe's terms *Forethought, Self-Reflection,* and *Performance*, and rearranging the order of Schön and Killian & Todnem's phrases, I now had a more curatorial outline with which to frame my case study. I chose to utilize terms relating to contract curatorial production, terms that refer to digital works, tight time frames, distance communication and a quick turnaround. I chose: *Pre-Production, Production,* and *Post-Production*. The revised model can be found below (Fig. 12.3).

12.5.2 Pre-Production: Reflection-for-Action | Knowledge for planning actions

I joined the ISEA2015 production team as the Exhibition Production Manager after I had been accepted to the symposium as presenter of a long paper. On the recommendation of a colleague, I wrote to one of the directors (Phillip Pascale) to

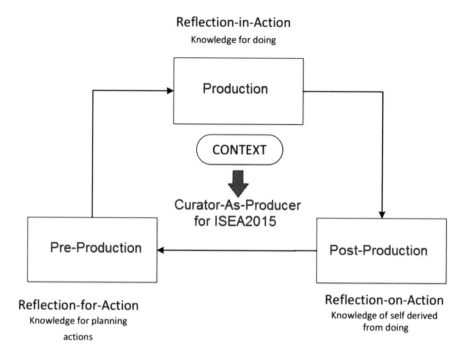

Fig. 12.3 Turnbull Tillman's reflection cycle for producers-as-curators, 2015

volunteer for the Art Program. When my CV was passed on to the Art Directors (Kate Armstrong and Malcolm Levy), they contacted me, said they could use my expertise in large scale interactive arts production, and offered me a short contract at a set fee. I was very happy to accept and a contract through Simon Fraser University was drawn up for May–August 2015.

Three months of the contract would be performed remotely, and one month in situ. Many members of the team were already situated in Vancouver, BC (the site of the conference), but were independent contractors, staff at partner universities, and often travelling or living in other countries. As a shared network drive in the form of Google Folders had already been established, I was invited to join in, and began reviewing the processes for production as provided by the Conference and Art Directors (as above, plus Thecla Schiphorst). At this stage, I was heavily reliant on the Art Directors, Armstrong and Levy, and Program Manager, Kristina Fiedrich, to feed me information and images collated from individual applications through this shared system. These processes were augmented by daily emails and weekly Skype calls to cover all bases.

I augmented this system by setting up a folder for Production Processes in the networked Google drive, and began drawing up a template for operating across disparate countries, venues and professionals. This process was directly derived from my previous experience with the UK-based ISEA brand, ISEA2013,

when I was Assistant Curator in Art and Technology for Matthew Connell at the Powerhouse Museum. That year the theme was *Resistance is futile*... The Museum was only 1 of 35 exhibition venues in Sydney, for what was possibly the largest realization of the ISEA brand. Hosted by the Australian Network for Art and Technology and lead by their director, Vicki Sowry, Sydney was an electronic arts playground for in and around 2 weeks of openings and exhibitions. Our own installment at the Powerhouse Museum (8 June–21 August 2013) boasted 2 floors of interactive art featuring Experimenta's *Speak to Me*, ANAT's own *Synapse: a selection*, and Symbiotica's *Semipermeable*(+).[9] Bio-art, robotics, and integrated screen and sculpture works took over the Museum much to the delight of a diverse range of school, family and arts audiences, including staff and volunteers. Reflection on this experience with the brand fueled my confidence in working with the Vancouver installment of ISEA2015: *Disruption*.

From quite early on, I could detect that a key challenge over the course of this project might be personnel and communication. As with any large, transient arts festival, once strong processes are in place, elements of those processes are quite subject to change. Due to past working relationships, some finessing was involved to ensure the preferred staff was secured and felt confident in their roles. At the pre-production stage, some time went by before I realized that key members of the production team felt comfortable working without contracts, due to their close working relationship with Levy, who has also lead the New Forms Festival[10] out of Vancouver for the last 15 years. As I had secured my own contract before starting work, I assumed other independent practitioners would do the same. After one of them tendered their resignation due to feeling unclear about his role within ISEA2015, including what his title, pay and tasks might be, I was able to suggest that clarity could come in the form of a contract, with the requested titles tasks laid out for them in black and white. Once this key member of staff was re-secured, many of his colleagues were happy to follow suit. When the contract was in place, confidence in the arrangement could be measured through improved communications and meeting attendance by this particular key member of staff. It was at the time that I realized we required a Plan B for all key members of staff. Upon reflection of this occurrence, I realized this also happened with ISEA2013, when Alessio Cavallaro replaced Marcus Westbury as Executive Creative Producer. Knowing that this could happen at a more senior level then we were experiencing reassured me that change of staff happens, and the best thing we could do was be prepared.

12.5.3 Production: Reflection-in-Action | Knowledge for Doing

The second biggest challenge in performing this contract was the relocation aspect. Where I was used to travelling internationally for a week to present and attend

[9]http://www.powerhousemuseum.com/exhibitions/isea2013/- accessed 17 October 2015.

[10]http://newformsmediasociety.org/- accessed 17 October 2015.

academic conferences, this contract required that I live and work for 5 weeks in Vancouver. Arrangements for affordable accommodation and other daily costs of living such as travel, offices, food and entertainment were factored into my ISEA2015 experience. This wasn't a short hotel stay or quick stint in student housing over a conference. With this contract came a sort of immersion into the Vancouver city scape, a re-immersion if it is considered that I grew up in Vancouver and on Vancouver Island. Knowing the area and coming from the culture, as well as having family and lifelong friends nearby, contributed greatly to my confidence in the realization of the exhibition and another factor in my eventual acceptance of the contract.

Outside of personal comfort and professional accommodation (Levy was good enough to provide me with a desk in the New Forms offices), I came to realize I was completely reliant on the highly experienced staff I was provided with that were local to the area. Levy, as producer of New Forms for the past 15 years; his staff, his colleagues and his reach in the creative community were instrumental to the success of the project. The technical directors, Elisha Burrows and Matt Smith, between the two of them there was no piece of equipment we couldn't source, no show we couldn't produce, no environment we couldn't ease into and out of in the space of a few days. In turn, their technical staff was loyal, friendly and incredibly skilled for the precise tasks we needed completed, from institution and artist management, to materials sourcing. The resources made available to me as I stepped into the role of Exhibition Production Manager were invaluable, and are a credit to Levy.

The other important factor leading to the success of realizing the Art Program was the Program Management, handled by Armstrong and Fiedrich. The planning, assessment, and management of the sheer volume of people, information and eventually data across platforms, media and venues showed me quite quickly that the seamlessness with which I was able to assimilate into the ISEA2015 environments was due in large part to the incredible preparation these two women did, both in support of the artists and documentation (catalog and website). Again, the way the staff was chosen for their tasks was incredibly well done, and made 5 weeks of living and breathing, in Armstrong's words, "quite an ambitious art program" highly possible. To provide an example of the schedule we were working to, I include a photo of our drafted and actual production schedules over install week above and below (Figs. 12.4 and 12.5).

Initially the production crew took photos and distributed the draft install plan, but it soon became apparent that we would need to update tasks and the staff assigned to them, especially the task of driving. Shared Google calendars made the schedule accessible on everyone's smart phones, ensuring that if I kept the processes updated, they had the relevant information at their fingertips. The technical director, Burrows, preferred to have paper copies of the rosters that he could write notes onto. As such, I printed up copies of the above roster and utilized Daily Install Task Sheets for each major venue. Levy, Armstrong and Fiedrich appreciated these sheets as well, as they knew where we were on each day at a particular time.

Again, the key challenge leading up to and during this production phase was staff expectation and availability. About a month out from Install Week, technical director

Fig. 12.4 Dry-erase 'draft' production calendar, 2015. Photo credit: Steven Tong, 2015

Fig. 12.5 Turnbull Tillman's sample of networked Google calendar for ISEA2015 production

Matt Smith was forced to leave the team due to an ill parent in Europe. As such, we needed to enact a Plan B. Who would replace such a qualified and connected AV technical director that also worked at the Symposium launch site, the Vancouver Art Gallery? Due to the layered nature of relationships between local staff, technical director Burrows was already aware of and had organized a replacement for this scenario. Into his shoes stepped local community curator Steven Tong. Integrated

into the Vancouver Art scene for the last decade and curator of CSA Space[11] in the Mount Pleasant neighborhood of Vancouver, Tong was able to quite seamlessly step into the team and pick up some of the slack. His particular gifts included artist management, materials sourcing, and acceptance of any situation put before him. Tong's calm professionalism and dedication to the tasks before him certainly changed the way we did things. But it changed them for the better. Upon reflection, not all surprise staff changes are bad leading up to production.

The final challenge during this production period was the artists' in-situ responses to the way their works were displayed. This is, in fact, one of the major stressors on artists and curators working with prototype platforms. On a whole, artists were absolutely delighted to have their work included in the exhibitions across the major venues, particularly the artists exhibiting in the Vancouver Art Gallery and the Museum of Vancouver. We were dealing with experimental ideas, artworks, and in this process, most of the artists understood that some of the venues would be re-claimed spaces usually used for other purposes. For example the SFU Woodward's Building[12] was the site of the conference, but still a functioning university office building. Artworks were exhibited in claimed spaces such as hallways, entryways, hidden or junk architectural spaces, and in the instance of Shannon Novak's AR vinyl adhesives, scattered across the floor. Another claimed space was the Alsco Linen Factory's Fur Vault housing David Cotterall's abandoned technologies and Khan and Andrew Lee's incredible, multi-level immersive sound piece. In fact it was often in the nooks and crannies of these alternative spaces that one could have that engaged experience. Away from the conference, away from the sheer size or qualification of a gallery or museum, one could actually connect with interactive art on a level that is successful, pleasing, and leaves the audience member wanting to return.

Of course, explaining this to the artists and having them agree to exhibit away from the action is another story. In some instances, as with works featuring mobile devices (5 of which were programmed as 60 min walking tours leaving from the main conference venue), or works that needed to be shifted from a gallery to these experimental places, artists experienced frustration at coming a long way to present for an hour, or suddenly found themselves without funding from their research faculties or software sponsors because they weren't exhibiting in a major gallery or museum. As we were often producing on top of having just produced, there was little time for discussion or mollifying the few artists in these situations. What we could do was offer them the space available and they would decide if they could make it work. In each instance alluded to above, we were able to find quite amazing resolutions. Volunteer assistance gave the walking tour artist more presence outside of his scheduled time; an artist moved from the Rotunda of the Vancouver Art Gallery to a multi-level chamber of the SFU Woodward's building was requested to stay on for the arts event after our own; and a work unable to be exhibited in the courtrooms of the Vancouver Art Gallery made an amazing statement on abandoned

[11] http://csaspace.blogspot.com.au/- accessed 17 October 2015.

[12] http://isea2015.org/for-attendees/venues/- accessed 17 October 2015.

technology in the Fur Vault of an antiquated, but still operational, linen factory. What I learned from these quite confrontational experiences as point of contact for the artists, and staff member ultimately responsible for realizing their works, was that experimenting with people's ideas, time, and finance is incredibly anxiety inducing for all parties. What we got in the end, was some of the best art from the most disruptive of circumstances.

12.5.4 Post-Production: Reflection-on-Action | Knowledge of Self, Derived from Doing

Where Pre-Production was meticulously planned out, sketched, mapped, shared, communicated and augmented as necessary over 4 months, Post-Production came about as a series of quick discussions between myself and Fiedrich and was largely realized by the production team as dictated by Burrows and myself in collaboration with partner institutions, and then completed by Levy's manager, Aidan Ferris. The exhibitions themselves were planned as a series of launches, or pop-ups almost; quite sophisticated pop-ups, but essentially between 1 and 4 day exhibitions. Much of the balance and cadence of the installation schedule happened in the pre-production phase in terms of human and technical resources.

 As much of the install work was realized by staff and through rented or sourced screens, computers and projectors, a lot of the bump-out simply involved those same staff members, unplugging, packaging and returning those objects to rental agencies and collaborators. To a lesser extent, artists came and collected their works a few days after the launch or at the end of the night they were scheduled to present. A few works moved on to other venues in Vancouver to exhibit after ISEA2015. As the ISEA2015 production teams were reliant on institutional processes to advise both our teams and the artists of procedures, much of the necessary information was communicated a bit too late in the day as the institutional staff were unclear on exactly what the processes were. This was largely due to the experimental nature of the pop-up exhibition design. As a result, much of the bump-out planning changed on a day-to-day basis, particularly with the Vancouver Art Gallery and the Museum of Vancouver. These more traditional platforms felt the disruptive nature of ISEA2015 more than perhaps the SFU Woodward's Building. Similar to the Powerhouse Museum, the staff at the Vancouver Art Gallery and the Museum of Vancouver were used to planning, sourcing for, and executing exhibitions in a certain way, usually over time, usually with more support from their own institution. In this way, they found the pop-up ethos too rapid, too subject to change, and it brought to me the words of Silvera-Tawil, an exhibition that was a bit 'quick & dirty', but still needed to uphold the name of the exhibiting institution by exhibited polished prototypes. With the SFU Woodward's building, the challenges lay in competing room bookings and uses for re-claimed spaces we as the production team assumed we could use for installing. These issues caused confusion and frustration on the part of both ISEA2015 and collaborating staff, and at times trickled down to the artists.

Another task I found particularly challenging involved six works that had arrived by international courier and needed to be returned by international courier, again, within quite a tight timeframe. After discussions on how this might occur and with our experience inside university administration (Fiedrich with Simon Fraser University and myself with Creativity and Cognition Studios, University of Technology, Sydney), we decided to approach the finance staff and request their assistance in utilizing SFU preferred couriers where they held corporate accounts, which could then be charged back to ISEA2015 research accounts. With the production schedule ending on 19 August and my contract concluding on the 20 August, I was able to steal a few hours across the 18, 19 and 20 August to arrange with SFU's finance department to have the works collected via Ferris at the New Forms Offices, and shipped back to the artists. In articulating what was missed in the pre-production and production phases of this reflective cycle, I was able to work with Fiedrich in this instance to provide this necessary post-production care for the artists and their works. Once we were in possession of the university's account codes for their International and National Couriers, we were indeed able to facilitate a multiple pick up and distribution and have it charged back to the ISEA2015 account. Again, without complete reliance on local staff, both at the university and in the production offices, these fairly essential tasks would have been left undone.

These post-production 'returns' task illustrate some of the biggest challenges at this time: Post-Production tasks were not assigned to any one person to take charge of. It seemed that everyone from the Directors to Production and Programming levels were so focused on the event happening well, that consideration for what would happen afterward could come later. Myself, Fiedrich, Technical Director, Burrows, and our production team understood what needed to be done from having done it previous, but there didn't seem to be enough time. Tasks like co-ordinating bump-outs were assumed by local production staff to happen the night after a launch, with equipment being re-used at the next event. This made for 10 incredibly long days of last minute planning, sourcing, installing and bumping out. Fatigue was apparent on almost everyone. Exhaustion, burnout, forgetfulness and resisting the urge to flee with tasks unfinished became the main concern of most of the production team, with receipts and reimbursement procedures for emergency production costs incurred by the team members another pressing concern. These tasks were again separated into essential tasks that had to happen before my contract concluded (ie/vacating spaces, artwork collection and returns) and less essential tasks like petty cash and personal reimbursements that could happen over distance due to technology. Thankfully, and with the assistance of production team members Fiedrich, Burrows, Tong and Ferris, these tasks were quickly nutted out, communicated, prototyped, corrected, re-scheduled and eventually carried out.

12.5.5 What Did I Learn?

Over the course of this contract, I became intimately acquainted with my own appreciative system. Stepping into an environment where I knew no one and needed

to trust everyone was a test of my experience to date as an independent Curator-as-Producer. When feeling especially challenged, I would enact that appreciative system, automatically reflecting on where I had experienced this particular challenge in the past. I would think about working with Beta_space at institutions like the Powerhouse; or working with artists and technologists as independent practitioners to realize prototype works for different institutions, as with Velonaki and Silvera-Tawil; and even, at times, returning to my methodology to understand why reflecting on my own practice was important to being a practice-based researcher in an experimental environment. In every way, treating this contract as a reflective practice case study allowed me to step back and observe, as well as perform within, the study. Surprisingly, this conscious disconnect minimized my stress levels, and eased my usual need to control the outcome of exhibitions I am involved with. This acceptance of my place as observer and social scientist allowed me room to really stop, think, and look at what was happening at any given time. In this way, I could quite quickly come to accept any situation as either solvable or irrelevant.

In the situations that fell under the solvable label, I had to think fast and be ready with multiple solutions for whomever I had come into contact with. This was usually technical director, Burrows, who lead the production team I managed. Alternately it could be Tong, Fiedrich, or any of the 80 artists we were responsible for. Most of the time the person on the other end of the phone or email required permission, approval or for some form of decisive action to occur. What I found most challenging overall, is that when we were finally done installing four shows over four nights, we were immediately faced with the artists responses and feedback. Everything else, I felt could be solved, but the [dis]satisfaction of the artists I found particularly difficult to administer. Luckily, these instances were incredibly minimal. Previous experience with staff, artists and institutions became invaluable, and I was able to utilize the distance of a researcher with the experience and confidence of a Curator-as-Producer.

In the situations that I couldn't control, or that became classed with an irrelevant outcome on my appreciative system, I came to understand that not every environment is suitable to experimentation. Where making and displaying interactive art is becoming more mainstream, doing it well while utilizing emerging technologies is still in its experimental phases. In mimicking the experimental nature of prototyping and applying it to working with artists to exhibit their work, there are many gray areas that require black and white solutions. For example, with the ISEA2015 symposium model, artists need to know what their funding is in order to travel internationally and exhibit their work. A change in production plan due to late communication from an institution partner could be viewed as a challenging experiment on the part of myself or the Art Directors, but to the artist could have the quite practical impact of them losing their funding and suddenly either finding an alternative source, requesting it from the hosts, or funding the work themselves. In a situation like this, extoling the virtues of experimental practice becomes difficult when the negative impacts are made apparent during this particularly 'ambitious' install week.

In considering ISEA2015 as a reflective practice case study, I was able to more closely examine Dewey, Schön and Muller's approaches to action- and practice-based research. In thinking through and revising Hampe's model for production based curatorial practice, I was able to extract elements of knowing for planning actions (Reflection-for-Action, or Pre-Production), knowledge for doing (Reflection-in-Action, or Production), and knowledge of my own practices derived from doing (Reflection-on-Action, or Post-Production) in order to hone and develop my appreciative system. This in turn caused me to reflect on current and past collaborations such as with the Creativity and Cognition Studios, the Powerhouse Museum and Beta_space, and within my current research environment at the Creative Robotics Lab in the National Institute of Experimental Art. This close reflection results in a kind of internalization of technique, a physical knowing of what works and what doesn't when I approach my next exhibition of similar scale, subject matter, and clientele.

12.6 Conclusion

The key outcomes of the larger study will be a set of criteria for curating digital interactive artworks, this time taken from prototype exhibition and reflections. These criteria will be determined by applying an iterative and practice-based approach to analyzing techniques disruptive to an already experimental curatorial practice situated within the contexts of experimental fine art, responsive systems research and business theory, as with the ISEA2015 reflective case study presented here. The main aim of this chapter is to better understand the benefits and drawbacks of the disruptions of iterating, evaluating and modifying within a curatorial framework. Though discomforting, these techniques are already assisting artists, curators, and institutions in embracing their own disquiet around engaging with prototype and speculative design practices at any stage in the iterative cycle. This will ultimately provide practitioners with innovative methodologies that though disruptive, hold the potential to generate new knowledge, some of which is already be embedded in and revealed through the action research of New Media Curation.

References

Armstrong K (2015) Nathaniel Stern and Erin Manning 'Weather Patterns: the smell of red.' In: ISEA2015 Art and Disruption, catalog for the 21st international symposium on electronic art. New Forms Art Press, Vancouver, pp 99
Bilda Z, Candy L, Edmonds EA (2007) An embodied cognition framework for interactive experience. CoDes: Int J Co-Creat Des Arts. Taylor & Francis Group, UK: 3(2):123–137
Blue Iris. https://www.sites.google.com/site/silveratawil/Research. Accessed 18 Dec 2014
Bower J (2002) Disruptive change. Harv Bus Rev 80(05):95–101
Bower JL, Christenson CM (1995) Disruptive technologies: catching the wave. Harv Bus Rev 73(1):43–53

Candy L (2006, November) Practice-based research: a guide. Creativity and Cognition Studios, University of Technology, Sydney. http://www.creativityandcognition.com/resources/PBR%20Guide-1.1-2006.pdf. Accessed 6 Sept 2015

Candy L, Edmonds EA (2011) Interacting: art, research and the creative practitioner. Libri Publishing, Oxford

Costello B (2007) A pleasure framework. Leonardo J 40(4):370–371

Creative Robotics Lab. http://www.crl.niea.unsw.edu.au/. Accessed 17 Oct 2015

CSA Space. http://csaspace.blogspot.com.au/. Accessed 17 Oct 2015

CUSP @ State Library of Queensland. http://cusp-design.com/event/cusp-state-library-of-queensland/. Accessed 19 Dec 2014

CUSP: designing into the next decade. Object Gallery, Sydney. http://cusp-design.com/. Accessed 8 Dec 2014

Dewey J (1934) Art as experience, reprinted in 1989. In: Boydston J (ed) John Dewey the later works, 1925–1953, vol 10. Southern Illinois University Press, Carbondale

Gassman O (2006) Editorial: "Opening up the innovation process: towards an agenda.". R D Manag 36(3):223–228

Graham B, Cook S (2010) Rethinking curating: art after new media. MIT Press, Cambridge, MA

Greer J (2013) Digital companions: analyzing the emotive connection between players and the NPC companions in video game space. Part 4, Article 1. In: Webber N, Riha D (eds) Exploring video games. E-book with Inter-Disciplinary Press: ISBN 978-1-84888-240-9

Hampe N (2013) Reflective practice and writing: a guide to getting started. Australia Library and Information Association: 2013. http://www.alia.org.au/sites/default/files/documents/Reflective.Practice.Writing.Guide20130409JB.pdf. Accessed 4 Sept 2015

ISEA2013: resistance is futile… (2013) Powerhouse Museum, Sydney, Australia. http://www.powerhousemuseum.com/exhibitions/isea2013/. Accessed 9 Sept 2015

ISEA2015: disturbance (2015) Vancouver, BC, Canada. http://isea2015.org/for-attendees/venues/. Accessed 17 Oct 2015

Killion J, Todnem G (1991) A process for personal theory building. Educ Leadersh 48(6):14–16

Leddy T (2013) Dewey's aesthetics. Stanford encyclopedia of philosophy. The Metaphysics Research Lab, Centre for the Study of Language and Information (CSLI), Stanford University. ISSN 1095–5054: 5–7

Muller L (2010) The experience of interactive art: a curatorial study. PhD thesis, University of Technology, Sydney

Muller L (2011) Learning from experience – a reflective curatorial practice. Book chapter, In: Candy L, Edmonds E (eds) Interacting: art, research and the creative practitioner. Libri Publications, Oxford, pp 94–106

Muller L, Edmonds E, Connell M (2006) Living laboratories for interactive art. CoDesign: International Journal of Co Creation in Design and the Arts. Special Issue on Interactive Art Collaboration, Routledge Publishing, Taylor & Francis Group, UK, Australia, USA. Vol 2(4):195–207

Museum of applied arts and science. Powerhouse Museum. http://www.powerhousemuseum.com/exhibitions/isea2013/. Accessed 17 Oct 2015

New Forms Media Socity (Formerly New Forms Festival). http://newformsmediasociety.org/. Accessed 17 Oct 2015

Schön DA (1983) The reflective practitioner: how professionals think in action. New York: Basic Books – reprinted Aldershot, Hants: Ashgate Publishing Ltd 1991 and 2003

Smith MK (1996, 2001, 2007) "Action research", the encyclopaedia of informal education. www.infed.org/research/b-actres.htm

Stringer ET (2003) Action research in education. Prentice Hall, Upper Saddle River

Turkle S (2007) Authenticity in the age of digital companions. In: Interaction studies, vol 8(3). John Benjamins Publishing Company, Philedelphia, pp 501–517

Turnbull D (2008) New media curation. www.newmediacuration.com. Accessed 29 Feb 2012

Turnbull D, Connell M (2011) Prototyping places: the museum. Book chapter, In: Candy L, Edmonds E (eds) Interacting: art, research and the creative practitioner. Libri Publications, Oxford, pp 79–93

Turnbull D, Connell M (2014) Curating digital public art. Book chapter, In: Candy L, Ferguson S (eds) Interactive experience in the digital age. Springer Publications, London, pp 221–241

Turnbull TD, Velonaki M, Gemeinboeck P (2015) Authenticating experience: curating digital interactive art. First printed in the conference proceedings of *Tangible, Embedded and Embodied Interfaces 2015 [TEI'15]*, January 16–19, 2015, Stanford, CA, USA.

Zeleny M (2009) Technology and high technology: support net and barriers to innovation. Acta Mechanica Slovaca 13(01):6

Index